Essential
VAN GOGH

This is a Parragon Book
First published in 2000

Parragon
Queen Street House
4 Queen Street
Bath BA1 1HE, UK

Created and produced for Parragon by
FOUNDRY DESIGN AND PRODUCTION,
a part of The Foundry Creative Media Co. Ltd,
Crabtree Hall, Crabtree Lane,
Fulham, London, SW6 6TY

ISBN: 0-75253-485-8

Printed and bound in Indonesia

Essential
VAN GOGH

JOSEPHINE CUTTS AND JAMES SMITH

Introduction by Lucinda Hawksley

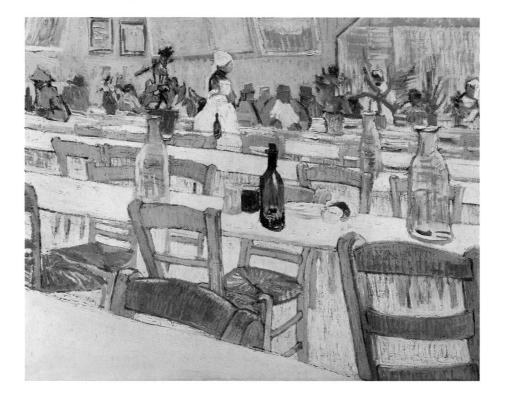

P

CONTENTS

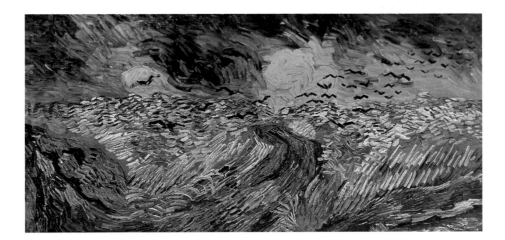

INTRODUCTION

*V*INCENT VAN GOGH has become known as one of the art world's most tragic figures. Although he was little recognised in his lifetime, within just a few years of his early death his distinctive style was influencing the artistic movements of the future and today his works sell for record sums. Vincent was an intelligent, articulate man, who spent much of his adult life dogged with depressive anxiety, caused by an unfathomed illness, currently attributed to either syphilis or porphyria (the illness that caused the famous 'madness' of King George III of England). This unstable mind helped Vincent to create some of the most incredible works of fine art ever produced – but also led to his tragic suicide at the age of 37. Van Gogh's work remains some of the most exceptional ever produced by one artist. His diverse works encompassed radical changes in style, colour and subject matter, which was perhaps indicative of his varying states of mind.

Vincent Van Gogh was born on 30 March 1853 in the small Dutch village of Groot-Zundert, to a parson, Theodorus, and his wife, Anna Carbentus. Anna had actually given birth to stillborn son, also called Vincent, on 30 March 1852, a coincidence which the surviving

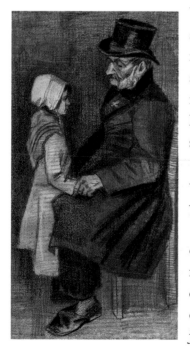

Vincent must have been conscious of throughout his life; and possibly one of the reasons for his excessively morbid imagination in later years. His childhood was, to all appearances, a happy one, spent in a forward–thinking family environment, surrounded by one of his greatest loves – the beauty of the countryside. He was the eldest of six siblings: Anna (b. 1855); Theo (b. 1857); Elizabeth (b. 1859); Wilhelmien (b. 1862) and Cornelius (b. 1866), who also tragically committed suicide, at the even younger age of 34.

Vincent's career in the art world began at the age of 16 – at which time he was selling other peoples' art, not creating his own. His father's three brothers were all dealers in fine art, so it was an unsurprising choice of career, and one at which he originally excelled. His first job was with his uncle Vincent, who worked at the

Hague offices of a famous French art dealers, Goupil and Company. The young Vincent was employed as an apprentice in 1869. In 1872, his brother Theo began working at Goupil's Brussels office.

In 1873, Vincent was promoted – with the promotion came a move to the London offices of Goupil, in Stockwell. It was there that the first great emotional crisis occurred in his life: the unrequited love he felt for the daughter of his landlady, who was already engaged. It was after Eugenie Loyer's rejection of him that he experienced his first fits of melancholia, which later graduated into severe depression. As a result of his erratic behaviour, Vincent's work began to suffer irredeemably. He no longer cared for his job and threw himself into a religious fervour, becoming less and less rational and causing his family and employers increasing alarm. He was eventually sent to the Paris offices – the firm's attempt to restore his equilibrium by taking him away from London. However, in Paris 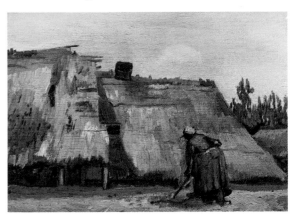 his behaviour deteriorated further. He became something of a hermit, retreating from his work as much as possible, living an almost totally isolated life and devoting his life to studying the Bible fanatically. After several incidents of rudeness to customers, Vincent was permanently dismissed from Goupil and Company in April 1876.

Despite the heartbreak suffered in London, Vincent had developed a strong affection for England and decided to return there on leaving Paris. He took an unpaid teaching job at a school in Ramsgate, Kent, but the situation became intolerable as he became increasingly poverty stricken. After two months, this was alleviated by a parson from London, who offered him bed, board and a paid teaching post. This began a contented period for Vincent, living and working with the Reverend and Mrs Slade-Jones, a couple with whom he forged a deep affection. During his time in London, he lived and worked in several areas; these include the Bedford Park area (around Turnham Green),

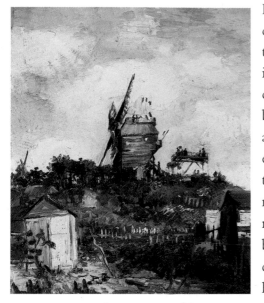

Isleworth and Brixton. In the late 19th century, these areas were far less urbanised than they are today and his letters home include detailed sketches of the local countryside, buildings and wildlife, as the budding artist strove to express in pictures the areas he had grown to love. Vincent was an extremely faithful correspondent, particularly to his favourite sibling, Theo, and to his mother. During his time in London, Vincent's religious and social conscience expanded. He became deeply troubled by the poor of the city, a sympathy which was to remain with him throughout his life and to become incorporated into many of his greatest works.

At the end of 1876, Vincent returned to the Netherlands; he worked in a bookshop for the first few months of 1877, thus maintaining the love of literature that stayed with him throughout his life. This is expressed in his own fluid and eloquent style of prose, exhibited in surviving letters to his family and friends. At this time, his intention was to become a minister, for which purpose he enrolled at the University of Amsterdam in May 1877. However, he did not complete the academic training, leaving university in July 1878 and moving to Brussels to undertake three months of studying to become a missionary. After completing his training, he moved to a poverty-stricken coal-mining area in South Belgium called the Borinage, which is not far from the town of Mons. His fervent belief that he had a vocation to help the poor, had taken hold during his time in London and continued upon his return to the Netherlands. For his first six months as a missionary he lived in the village of Paturges, before moving to the town of Wasmes. Over these last few years, Vincent had begun to pay more attention to his artistic skills. This continued throughout his preaching years and into his time in Borinage; many sketches and works, inspired by the Belgian coal-mining area, remain extant.

During his time at the Borinage, Vincent threw himself into preaching; sadly he was considered strange because of his overpowering religious zeal and he became distrusted by the community. The longer he spent as a missionary, the more zealous he became, with his actions bordering on insanity. He began to live a rigidly ascetic lifestyle; he gave up all his possessions, stopped eating properly and lived in a squalid, insanitary hut in an attempt to become more Christ-like. The church found this too much to take and dismissed him from his post. His failure to succeed in the church, following his failure in the art world, affected Vincent deeply, and it appears to have begun a second crisis in his life, though exactly what happened is uncertain as he, normally such a prolific correspondent, stopped all communication with his family, even with his adored brother Theo. After a few months, Vincent, seemingly rejuvenated, suddenly reappeared, writing to Theo and telling him that he had come out of his despair and had realised that his true vocation lay with painting. He made this decision in September 1880: 'I am taking up my pencil again, I am putting myself to drawing anew and since then everything for me has been changed'.

The many manual workers whom Vincent encountered during his time in Belgium inspired him to make many drawings and etchings of labourers seen in a religious atmosphere. His time at the Borinage inspired many sketches of the miners and he began looking to the work

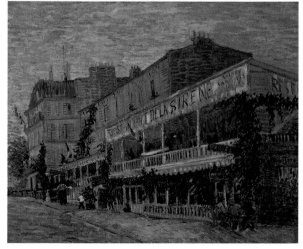

of Jean-François Millet (1814–75) for inspiration and style. As part of his self-taught technique, Vincent made copies of several of Millet's works, attempting to recreate the latter's themes and techniques. This theme, that of the god-fearing, hard-working people, the 'salt of the earth' being more deserving of salvation, was to permeate his work. perhaps the most famous example of this philosophy is espoused in his painting *The Potato Eaters* (1885).

Vincent's first home as an artist was in Brussels, where, from October 1880 until April 1881, he shared a studio with the Dutch painter Anton van Rappard. Vincent began this new career as a book illustrator; his lifestyle was financed by Theo.

Later, in 1881 Vincent returned home, spending several months living with his parents in their new parish of Etten, not far from Groot-Zundert. Here he continued his studies of rural life and the local workers. The time at his parents' home provoked a second unrequited passion – this time for a widowed relative. Not surprisingly, his very recently bereaved cousin Kee Vos-Stricker was unmoved by his declarations. Vincent followed her and her family to Amsterdam where Kee, in exasperation, made it explicitly clear that she was not interested in him, and never would be.

Dejected and depressed, Vincent nonetheless had the ability to move on after this second unrequited passion, and settled in the Hague,

where he began studying art in earnest under the tutelage of one of the foremost artists of the day. Anton Mauve (1838–88) was a prominent member of the Hague School, as well as being related to the Van Gogh family. By this time Vincent had fallen out with his father and was now totally dependant on any money he could earn from his art and the meagre allowance sent to him by Theo. His time in the Hague began promisingly enough: Mauve introduced him to the celebrated painters of his acquaintance and Vincent began moving in the most important artistic circles of the time. He began to study the styles of many different painters and to read voraciously. He loved the works of contemporary

novelists such as Charles Dickens, Emile Zola and Victor Hugo. The months he spent working and studying were extremely formative in the creation of his particularly unique style.

Just as Eugenie Loyer's rejection of him had caused him to shut himself away in London, Kee's rejection led Vincent to look elsewhere. Within a few months of settling in the Hague, he met and moved in with a local woman, Sien Hoornik. She was a single mother, a prostitute, and pregnant with her second child when she met Vincent. She appears in several of Vincent's sketches, including a poignant drawing entitled *Sorrow,* in which she is depicted sitting naked, with her head bowed. Vincent's mastery of the human form can be seen in these drawings, which are depicted in a style unlike any of his later oil paintings.

Van Gogh's unconventional behaviour added fuel to the already prevailing rift with his deeply Christian father, scandalised Hague society, and effectively cut him off from what could have led to a more prosperous lifestyle and important financial patronage. During this tempestuous period in his life, the elder van Gogh considered having his son committed to an asylum for the insane, although his ever-faithful brother Theo stood by him.

By the end of 1883, Vincent and Sien had parted company. Leaving her behind, he moved to Drente in the north-east of Holland, where he lived from September to November. Here, guilt about Sien and frustration with his inability to make his way in the world without Theo's financial assistance depressed him, heralding another period of deep melancholia.

The depression led him to return, in December, to the new home of his parents, who had moved to a parish at Nuenen, in the east of North Brabant. The rift remained between him and his father and the Van Goghs lived in an extremely strained atmosphere for the first few months after his arrival. This was resolved when his mother suffered a debilitating accident and Vincent became her nurse, tenderly guiding her back to health. The reconciliation this brought about with his father was timely, coming just weeks before the latter died suddenly, in the spring of 1885.

The rural area of Nuenen inspired Vincent and his work became more prolific. Between 1883 and 1885, he produced more than 50

sketches of local people, which he used as preliminary drawings for his 1885 masterpiece, *The Potato Eaters*. In to this work he pushed all his creative energy, which was fuelled by the emotion caused by his father's death. He was also fired by the energy of the peasants, particularly by the hard-working women of Nuenen. *The Potato Eaters* was his paean to the working classes; the social group he considered to be the closest to Christ. He wrote the following comments about his painting in a letter to Theo, 'I thought of what had been said of those [peasants] of Millet, that they seem to have been painted with the very earth that they sow'. As he was later to do with *The Sower* (1888), he followed Millet's example in the pastoral subject matter chosen.

In November 1885, Vincent travelled to Antwerp, where he enrolled as a student at the Academy of Fine Art. He remained only a few months, due to disagreements with his tutors – his drawing tutor insisted he be moved to the preparatory class as his standard of drawing

was not high enough. These few months at the Academy were to have a lasting effect on his art, introducing him to the works of Rubens and changing his previous conceptions about colour. His palette became lighter and paintings executed after this time often show a brightness not seen formerly.

In spring 1886, after leaving the Academy, Vincent moved to Paris. He had been ill and craved the calming, loving force of Theo, who was now working at the offices of Goupil and Company from which Vincent had been dismissed. Never able to cope with rejection, Vincent also sought reassurance from Theo after the blow of relegation at the Academy. The brothers spent two years living together, during

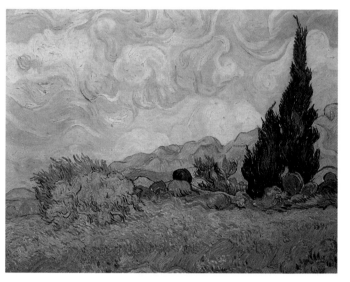

which time Vincent's artwork became more and more prolific. He saw the new exciting works of art that Theo was selling, works by painters such as Camille Pisarro (1830–1903), Alfred Sisley (1839–99) and Armand Guillamin (1841–1927). He also became acquainted with Toulouse-Lautrec and grew increasingly interested in Japanese art; the influence of these can be seen in several of his paintings dating from this time. By now Vincent had mastered several media, including etching, watercolours, oils and pencil. It was an exciting time for art, with Impressionism and Pointillism making a strong impact on the worlds of both artists and collectors. Van Gogh was fascinated by these styles and spent much time studying the techniques and palettes of the radically new schools. Alongside Millet he began to study the works of Rubens, Degas, Signac, Delacroix, Doré and Daumier, among others.

In February 1888, Vincent left Theo and Paris, longing to return to the countryside. He moved to Provence, where he created some of

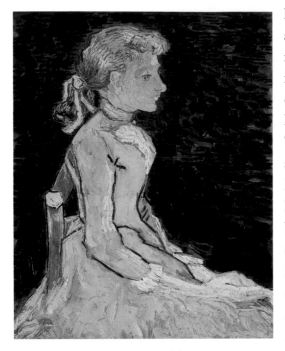

his most famous works, such as *Sunflowers* and *The Harvest*. He lived in Arles, near the mouth of the River Rhône, for ten months, in what is now seen as the pinnacle of his career. Provence inspired him in a way he had seldom felt inspired before; he wrote to Theo of the 'limpidity of its atmosphere' and raved about 'the brilliance of its colour'. His works from this time are mesmerising; he worked prolifically and lept wildly between styles, often veering from one direction to another within a single week. In 1888, for instance, he produced, amongst others, *The Sower at Sunset*, *Street in Saintes-Maries*, *Peach Trees in Blossom* and *Harvest in Provence*. At times his style appears strongly influenced by Impressionism: a strong sense of natural light merging the colours together and blurring the edges; the brushstrokes are heavy, leaving the canvases encrusted with a richly tactile layer of paint, the edges of shadows and objects blurred, to give the viewer an indistinct impression of looking at a scene in full sunlight. Yet, in stark comparison, his work can also be bitingly sharply defined in bold primary colours. In this latter style, he uses fine, unbroken lines, thinner paints, strong blocks of colour and finer brush strokes. Both styles are equally masterful in content and construction, and both evoke the same sense of a reality of light, albeit through wildly differing methods.

During Vincent's time in Provence, he was visited by fellow artist Paul Gauguin (1848–1903), with whom he had developed a close, but tempestuous, relationship. Gauguin was intending to make the move to Provence permanent, thereby beginning Vincent's long-held dream of creating a commune of artists, all living and working in the same area, feeding off one another's artistic energy and providing a close-knit community of assistance and understanding. Sadly, after a couple of months of living together, the two men had fought and Gauguin left.

This had contributed to Vincent suffering a severe mental breakdown – the fit of madness that led to his cutting off part of his ear. One of his most poignant self portraits shows himself with the ear bandaged. Terrified by this fit of insanity, he admitted himself to St Paul's Asylum, situated not far from St Rémy, the bills footed by Theo. For a year he vacillated wildly between fits of madness (including one suicide attempt) and lucid periods of sanity. The progressive-thinking asylum was set amid beautiful grounds, and the intense experience of being here – both anguishing and calming – proved an artistically productive time for Vincent, who created over 200 works during this period. One of his most memorable works of 1889 was the evocative oil painting *Starry Night*. The words Vincent used to explain his painting to his brother indicate his state of mind: 'Why should those points of light in the firmament ... be less accessible than the dark ones on the map of France? We take a train to go to Tarascon or Rouen and we take death to reach a star.'

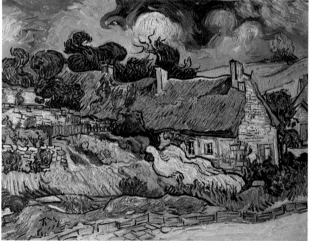

January 1890 saw the first positive artistic review of Vincent's work, which was written by the critic Albert Aurier. This may have contributed to Vincent's return to positivity. By May 1890, he felt revitalised and able to return to the outside world. Discharging himself from the asylum at St Rémy, he returned to live with Theo, who had now married. The artist's life seemed heading back on track and soon he had moved 20 miles north of Paris, to the countryside of Auvers-sur-Oise. In the weeks that followed he painted constantly, producing more than 70 works between May and July. Tragically his mental recovery proved only temporary and, on 27 July 1890, Vincent shot himself. It took two days for him to die. Befittingly, Theo was with him for his last hours.

LUCINDA HAWKSLEY

WOMAN SEWING (1881)
Courtesy of AKG

AFTER a brief early career as an art dealer in London, Van Gogh devoted the greater part of his time to the church, preaching and helping the poor. However, in 1881, he moved from Brussels to Etten to live with his parents. It was to prove the major turning point in Van Gogh's working life. His religious fervor now turned to art. Whilst retaining his strong religious convictions, he now felt that the most effective way for him to evangelise was not via formal institutions but through painting. *Woman Sewing* is one of Van Gogh's very first paintings. As such it does not seem particularly reverent or infused with the spirit of the Almighty but its concern with simple everyday events such as sewing was, for Van Gogh, in itself spiritual.

Up to now Van Gogh had tended only to make sketches and drawings – a medium he never completely abandoned and which can be

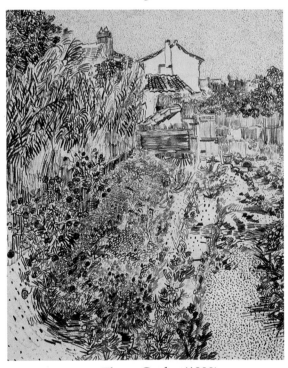

Flower Garden **(1888)**
Courtesy of Christie's Images.
(See p. 130)

seen in works such as *Flower Garden* (1888) – but in Etten he started using watercolours for the first time. *Woman Sewing* was created using just this technique. He enthused about the new medium thus: 'What a wonderful thing watercolour is for expressing space ... so that the figure is in the atmosphere and it comes to life'. Whether the sitter here was actually painted from life is a moot point. Models were hard to come by in Etten, and peasants proved particularly resistant to posing in anything but their 'Sunday suits', therefore this image was probably copied from a book.

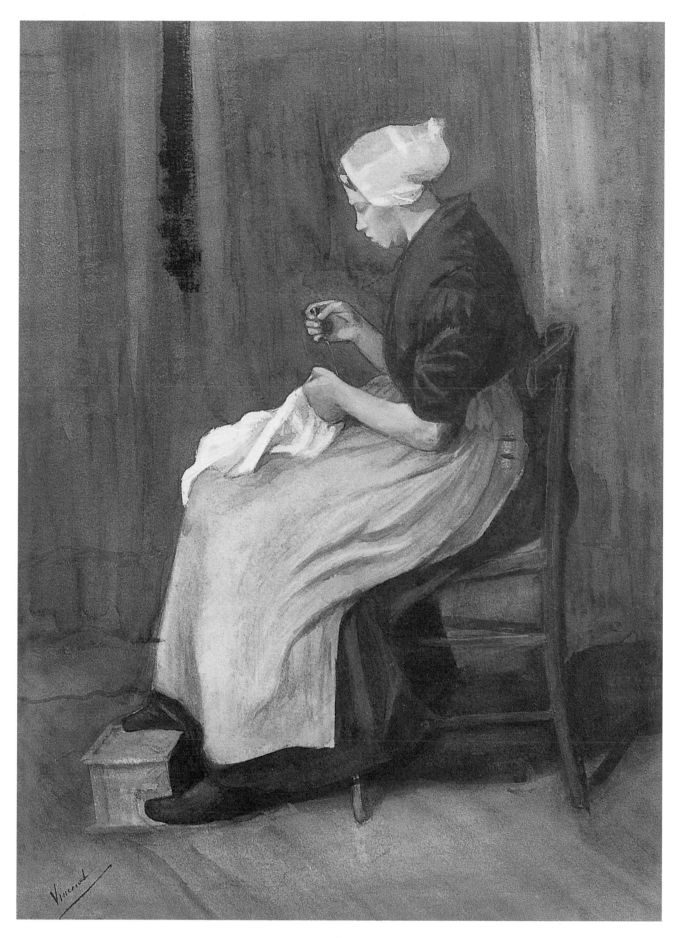

SEATED MAN WITH YOUNG GIRL (1882)
Courtesy of Christie's Images

*V*AN GOGH was largely a self-taught artist with no formal training, but with strong views on how best to learn his 'trade'. One of the most important things to acquire before embarking on painting proper was, in Van Gogh's view, the basic skill of drawing. He considered the use of monochrome to be a fundamental preparatory tool before committing himself to oils and watercolours. Furthermore, he believed sketching was an art form in its own right and railed against its denigration. 'In my view,' he bemoaned, 'too little work is made of black and white, even to such an extent that there is a certain antipathy towards it'. Van Gogh's diligent use of 'black and white' was, therefore, in self-conscious contrast to other artists whom he deemed to be 'muddling along' with paints that they could not handle. He regarded them as 'daubing all kinds of things on to the canvas at random ... then holding it away from them and putting on a very pensive, sombre look in order to find out what in God's name it may possibly resemble'.

Van Gogh's determination to master the essential tools of draughtsmanship found him spending a large proportion of his time in

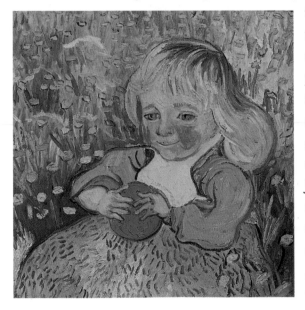

the Hague drawing from models such as those featured here. The old man appears in many of his works from this period. It is very likely that they were supplied with their costumes to create a particular effect – emphasising the girl's youth and the man's status as a dignified elder. The resultant juxtaposition between innocence and experience, between the beginnings and ends of life, is rendered with compassion and sobriety.

Child with Orange (1890)
Courtesy of AKG. *(See p. 242)*

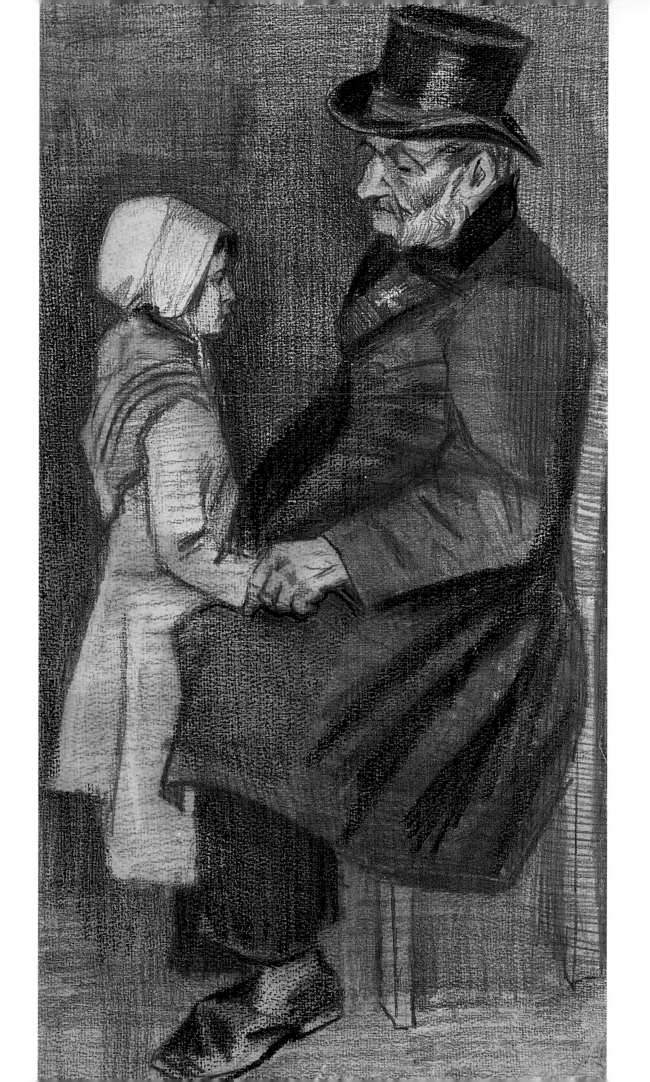

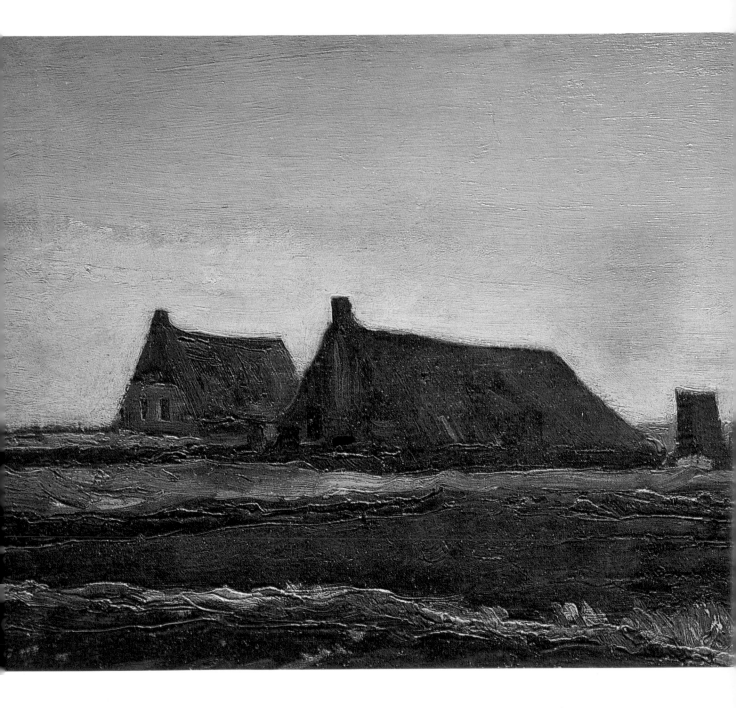

TURF HUTS (1883)

The Van Gogh Museum, Amsterdam. Courtesy of AKG

*I*N 1883 Van Gogh spent a short period of time in the Hague. It was here that he made oil studies, of which this is one. In Etten he had usually used watercolours, but his transition to the new medium was a happy one. Indeed, he was so positive about his first attempts in oils that he mentioned them in all his letters to his brother Theo. Critics have suggested that this relentless enthusiasm might have had more to do with Vincent encouraging his brother's continued philanthropy than any feelings of genuine breakthrough. Oil paint was more expensive than watercolour paint and it was Theo, as benefactor, who would incur the increased charges.

Turf Huts, like most of Van Gogh's work from the Hague, was typical of the 19th-century orthodoxy in painting. Peasant landscapes in almost exaggeratedly dark tones were very much the flavour of the day. Where Van Gogh departed from convention was in his working method. Typically, artists would complete all their work in the studio, but Van Gogh took his easel with him and painted directly from nature. Furthermore, he rejected the trend for smooth, flawless finishes, choosing instead to squeeze the paint directly on to the canvas and layer it on the surface quite freely and thickly.

FARM HOUSES AMONG TREES (1883)
Museum Kolekcij, Warsaw. Courtesy of AKG

*V*AN GOGH'S move to the Hague marked a significant step in his development as an artist. The political capital of Holland was also the centre of the Dutch art world and Van Gogh was keen to become a part of it. Despite the fact that he had moved in with an ex-prostitute and her two children – all of whom he took on the burden of supporting – his specific aim became to embark seriously on an artistic career. He managed to get a studio and his first paintings were influenced by Anton Mauve, a cousin of Van Gogh and a celebrated contemporary Dutch artist. Mauve was a member of a group of artists who painted 'en plein air' (outside), and Van Gogh took up this example with all the enthusiasm of one eager to learn. Tapping into the rich landscape tradition of his native Holland, Van Gogh's choice of subjects also showed his willingness to take lessons from the old 'Dutch masters'.

This canvas is typical of Van Gogh's early work and reveals all his initial influences, as well as his break with them. It may be a landscape in the great Dutch tradition but, unlike the remote and detached vistas of the past, it shows significant evidence of human intervention. The grim reality of subsistence farming (revealed here by old farm houses and dilapidated barns) dominates the scene, consigning the hauntingly beautiful forest to a mere blurry backdrop.

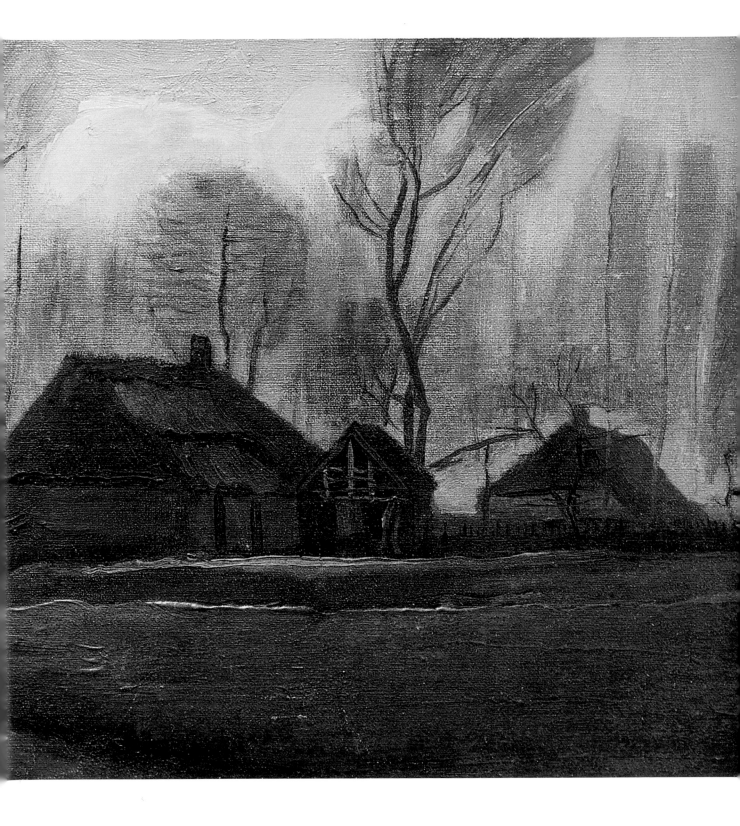

MAN AT WORK (1883)

Private Collection. Courtesy of Christie's Images

WHILE in the Hague, Van Gogh pondered his future direction as an artist. Perhaps surprisingly, in view of his obvious love for the countryside, he wrote to his brother at the this time: 'Theo, I am definitely not a landscape painter; if I paint landscapes there will always be something figural in them'. In this picture, then, he turns his hand to the human form, albeit situated within a landscape of sorts. Even here though, man and nature are fused together as if the figure has been planted in the earth. The strong suggestion is that the labourer's cultivation of the land is an immutable fact throughout history.

Technically, this painting would have been completely at odds with that of Van Gogh's fellow artists in the Hague. Its crude, roughly worked surface would have horrified his contemporaries, the vast majority of whom all aimed for a 'perfect' finish. The jibes he probably received as a result of being different may well have been what prompted him to say 'they [other artists and society in general] would repeatedly conclude that I don't really understand what I'm doing'. Van Gogh's impetuous temperament would have given added strength to these accusations. His character was as subversive of society's strictures as his painting was of art's limitations.

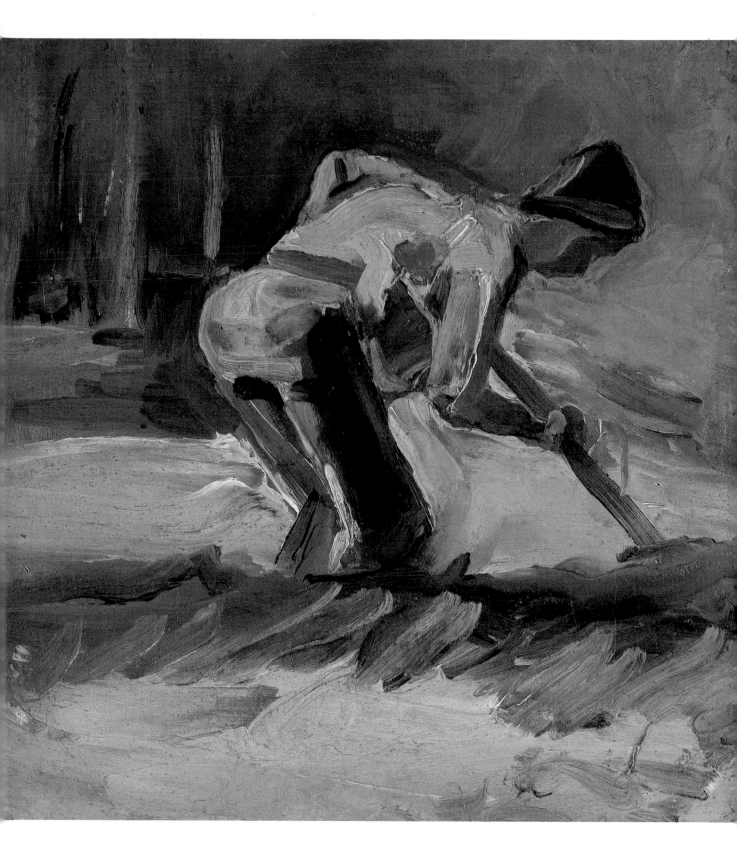

TWO WOMEN IN THE PEAT FIELD (1883)
The Van Gogh Museum, Amsterdam. Courtesy of AKG

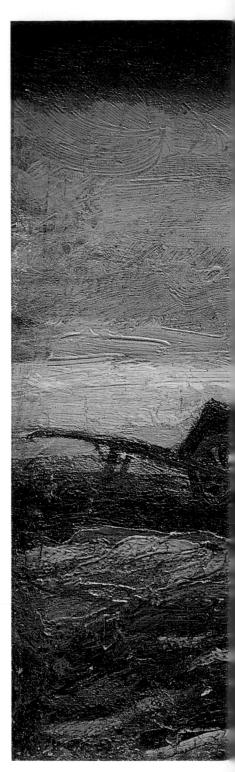

*I*N 1883 Van Gogh escaped from the affair he was having with Sien, the woman he had saved from prostitution, and chose to isolate himself in the inhospitable countryside of Drenthe. There he became more lonely and depressed than ever. He had left the woman he loved and her child to devote his life to art – and, more precisely, what art had the power to convey; in his words: 'simplicity and truth'. This picture is typical of his Drenthe period in that it attempts to portray both these elements by representing peasants as seen through the filter of Van Gogh's own melancholic mood. His mental anguish finds its physical equivalent in the two figures' real, back-breaking pain. The blocks of dark and light green used to depict a looming northern sky press down on their backs with a further unbearable force. Connected to the land that is formed by two bands of parallel colours, the figures are silhouetted by a thin yellow strip of sunlight that runs across the middle of the picture.

Although the whole image is infused with a strong sense of personal distress, it could be argued that Van Gogh was almost wallowing in self-pity at this time. Of his home in Drenthe, where he only stayed three months, he wrote '... the loft I've set up in is remarkably gloomy; the light, entering by a single glass tile, falls on an empty paint box, a bundle of brushes the hair of which is practically useless now, in a word: it is all so wonderfully bleak ...'.

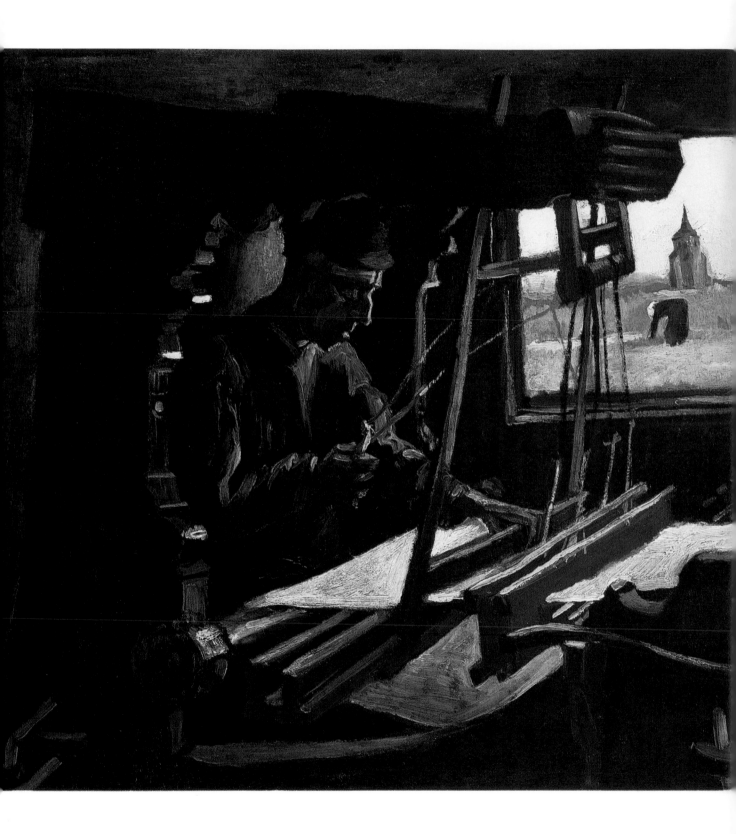

THE WEAVER (1884)

Neue Pinakothek, Munich. Courtesy of AKG

WEAVERS were the first theme that Van Gogh tackled after returning to Neunen, a farming town and now his parents' home, in December 1883. His father suffered from the typical anxieties about a son who did not seem to be 'settling down', so an offer of a room and studio to paint in was presumably made reluctantly by him. Relations between Van Gogh and his parents did not improve though, and one year later the 'errant child' acquired a studio of his own.

Van Gogh painted several different versions of this subject, whose central motif also featured strongly in many 17th-century Dutch pictures. This parallel was of course by no means incidental; Van Gogh would have been acutely aware of how the loom not only evoked a craftsman past, but also connected with a great tradition in European art. For all his supposed radicalism and desire to break from the past, this was an artist deeply steeped in history and not a little self-conscious about his position within it.

The Industrial Revolution had had a massive effect on European weavers, who became exploited and marginalised as never before. The scenes Van Gogh painted were the last remnants of a cottage industry whose workforce had escaped the inexorable march of industrialisation, capitalism and the concomitant lifestyle. To witness workers humming and daydreaming while employed in labour struck Van Gogh, the romantic bohemian, as truly poetic. The melancholic atmosphere of this picture, in which the loom becomes a trap and the weaver a prisoner, only serves to heighten this perception.

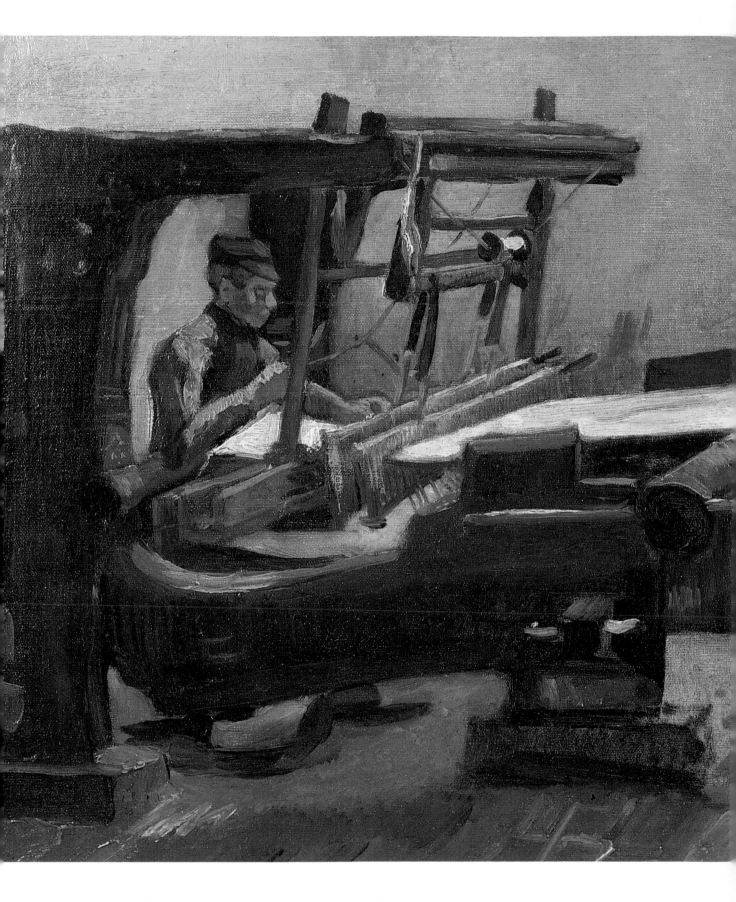

WEAVER FACING RIGHT (1884)
Private Collection. Courtesy of Christie's Images

VAN GOGH believed that contemporary artists had wrongly overlooked the potential of weavers as a valid and interesting subject, and so decided to set the record straight. His enthusiasm for the results, however, was not shared by Theo who sarcastically pronounced them as being 'almost marketable'. Van Gogh was not amused at his brother's lukewarm appreciation and accused Theo of 'not even trying' to sell his work.

In spite of his dealer's ambivalent attitude towards the genre, Van Gogh persisted with painting weavers. He went on to complete a total of ten pictures (and many more sketches and watercolours) featuring weavers during his stay in Neunen. In all of them it was the weaver, and not the loom, that Van Gogh intended to be the 'heart' of picture. Here, at least, the result was at odds with the aim. Although Van Gogh claimed 'that little black spectre in the background should be the centre ...', here it is the loom that dominates. Van Gogh has deliberately created a sombre, almost reverent atmosphere, with the weaver dressed in typical peasant blue and lost in his own quiet thoughts.

PEASANT WOMAN WORKING OUTSIDE COTTAGE (1885)

Art Institute, Chicago. Courtesy of AKG

*V*AN GOGH'S preoccupation with peasants initially saw him concentrate his attentions on the weavers, but soon broadened out to become a virtual obsession. In his own words: 'Through seeing peasant life so continually at all hours of the day I have become so involved in it that I certainly almost never think of anything else'. The daily reality of peasant life became the central theme in Van Gogh's entire artistic output at this time.

Scenes such as this formed part of the long and difficult struggle Van Gogh underwent in order to attain a technical grounding for his art. Having taken up painting at a relatively late stage in his life, Van Gogh had no formal artistic training behind him when this picture was painted. His subsequent achievements owed much to the hard work he put in during this period.

The scene itself features two thatched houses, which Van Gogh compared to the birds' nests he was collecting, calling the cottages 'human nests'. In his choice and treatment of subject, he was very much inspired by the artist he admired most, Jean-François Millet (1814–75). Millet's scenes of social realism were copied more directly in later works such as *La Sieste* (1889).

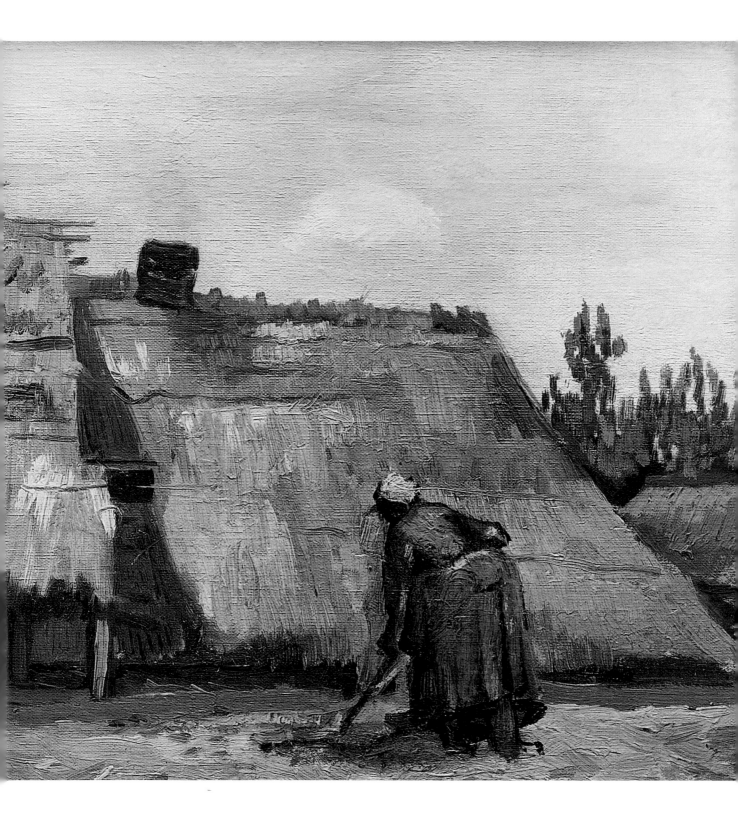

HEAD OF A PEASANT WOMAN WITH DARK CAP (1885)

Courtesy of Christie's Images

I N 1885 Van Gogh embarked on a series of portraits, of which this is one. He had been encouraged to do so by friend and fellow artist, Anton Van Rappard, who thought it would be a good form of preparation for Van Gogh's imminent trip to Antwerp. The advice was taken up wholeheartedly: 'To get more experience,' Van Gogh pronounced, 'I must paint fifty heads because right now I am hitting my stride. As soon as possible, and one after the other ...' A while later, he was keeping his promises: 'as you know,' he wrote to Theo, 'I have painted scarcely anything but heads of late'.

Van Gogh's confidence with painting portraits grew to such an extent that he soon considered a career as a portraitist. His declared aim now became to convey the sitter's 'character' rather than their more superficial appearance. Whether he achieved his goal is difficult to judge, but by his own strict criteria *Head of a Peasant Woman with Dark*

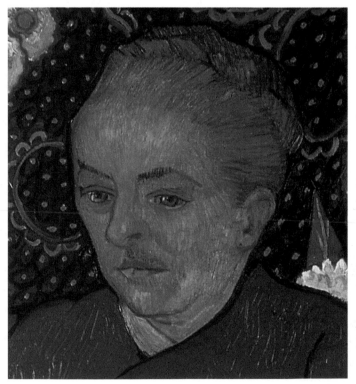

Cap failed the test. In fact he deemed none in the series to be worthy of exhibiting, and this painting in particular he considered little more than a study. This is despite the fact that the figure it represents seems to fit perfectly with the models Van Gogh had in mind when he wrote: 'If I could only get suitable models, of just the type I want, rough, flat faces, with low foreheads and thick lips, not sharp but full and Millet-like'.

Detail from *La Berceuse* (1889)
Courtesy of The Bridgeman Art Library.
(See p. 196)

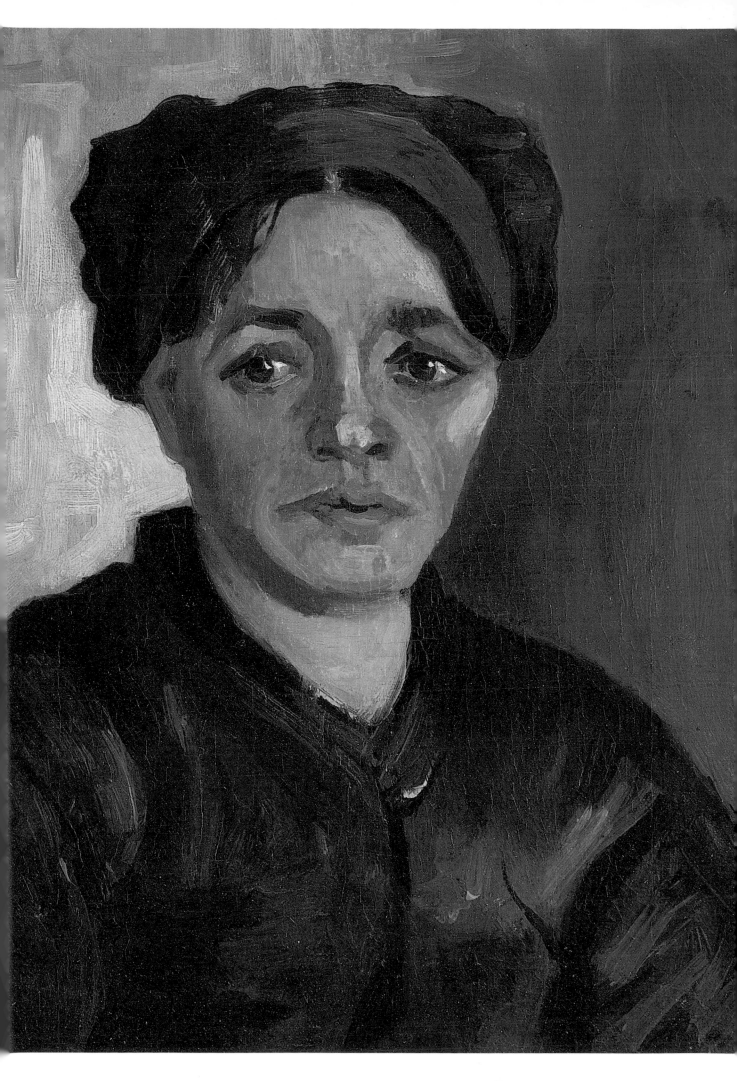

PEASANT WOMAN AT FIRESIDE (1885)
Musée d'Orsay, Paris. Courtesy of AKG/ Erich Lessing

*V*AN GOGH'S affinity with peasants and their *modus vivendi* again makes itself plain in this painting. It was an iconography that he turned to time and time again. Here a woman prepares the evening meal, an event itself depicted in the famous *The Potato Eaters* of the same year. A plain straw chair on the left is the same type of furniture with which Van Gogh furnished his own room in the Yellow House at Arles three years later. The attachment Van Gogh felt, therefore, with this whole milieu was familiar and intimate. Van Gogh related to this kind of person as 'one of his own'.

For all his empathy, however, Van Gogh did not actually want to *be* a peasant. His ambition to launch upon a successful career as an artist saw him send paintings from this time to Theo in Paris. He, in turn, would show them to art dealers who, so the brothers hoped, would buy them for large sums of money. It was the latter part of this scheme that ran into difficulties.

As a profit-seeking art dealer, Theo did want to sell his brother's paintings, if only he could find a buyer. The problem, typical of *fin de siécle* Paris, was one of fashion. Excessively dark, provincial peasant scenes such as this were never going to compete with the latest colourful, airy trend to hit the capital around this time – Impressionism.

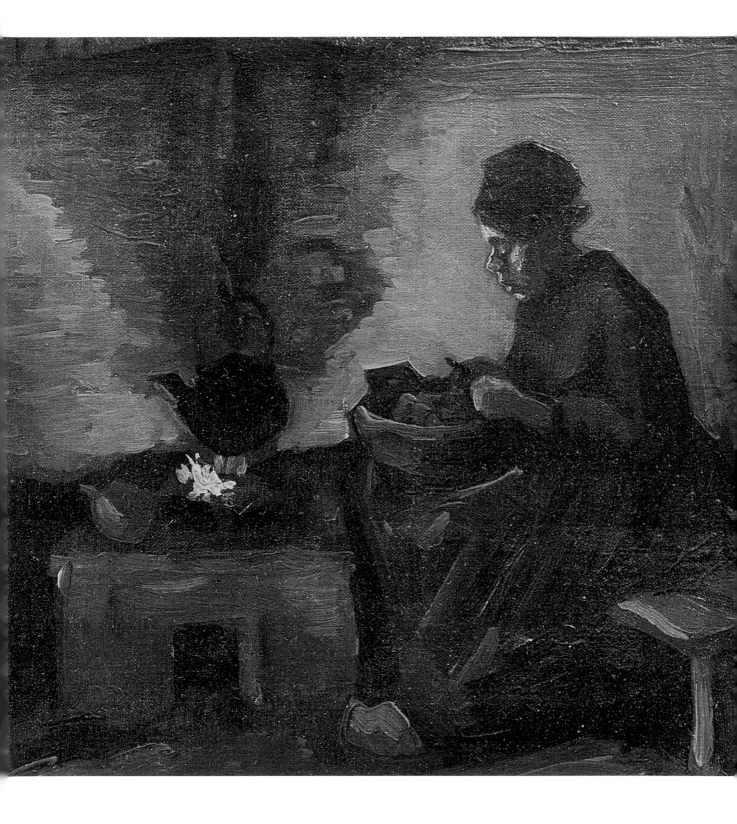

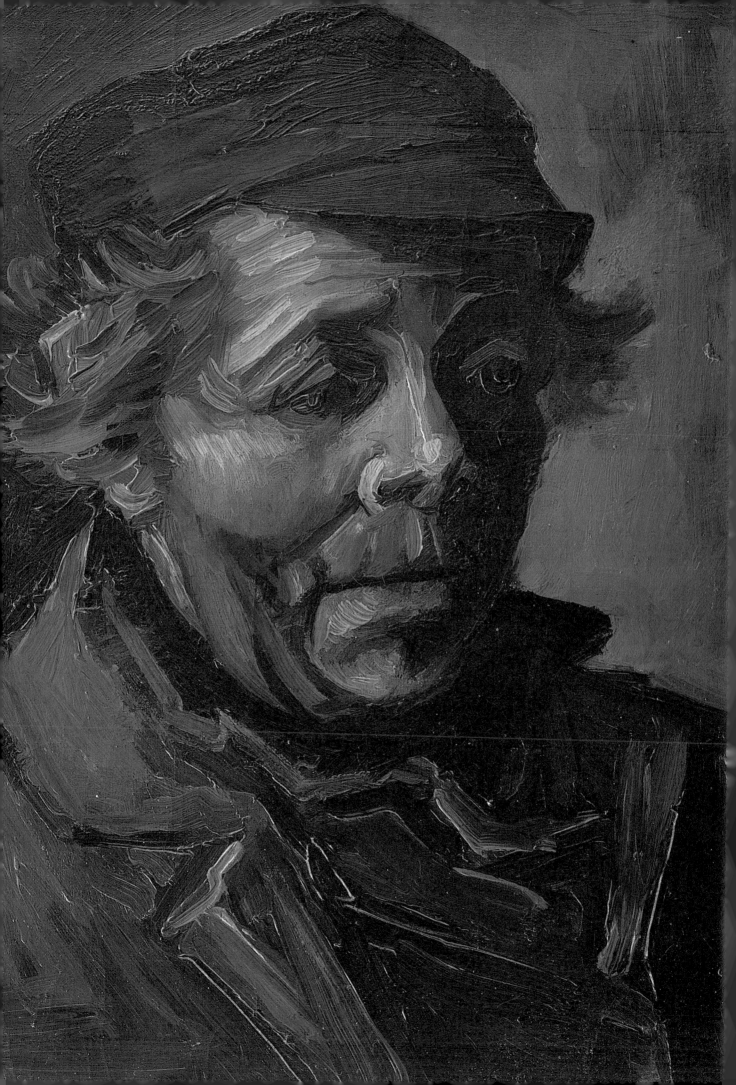

PEASANT'S HEAD
(*STUDY FOR* THE POTATO EATERS) (1885)

Courtesy of Christie's Images

*T*HIS is one of many studies Van Gogh made for *The Potato Eaters* (1885), a key work in his early development. The importance Van Gogh himself attached to the painting can be gauged by the number of letters he wrote to Theo about it. In them he outlined his intentions to depict a scene 'from the heart of peasant life'. Strangely, it turned out to be the only time he ever painted a composition featuring a large number of people. He evidently felt more at ease with singular portraits such as this one or peasant figures engaged in solitary endeavour. The intensity of one-on-one confrontation suited his temperament more than the painting of groups. Indeed, this particular study is reminiscent of Rembrandt's (1606–69) self portraits in its emotional depth. The predominant use of browns and blacks with marked highlights is a further reminder of the great Dutch master. The similarity was not accidental; Van Gogh was keenly aware of his heritage. He wrote at the time: 'It is perhaps not superfluous to point out how one of the most beautiful things done by the painters of this country has been the painting of black, which nevertheless has light in it'. Although, arguably, studies such as this fall some way short of achieving Rembrandt's stunning technical effects, they were a brave early effort at learning from the very best.

Detail from *The Potato Eaters* **(1885)**
Courtesy of AKG. (See p. 40)

THE POTATO EATERS (1885)

The Van Gogh Museum, Amsterdam.
Courtesy of AKG

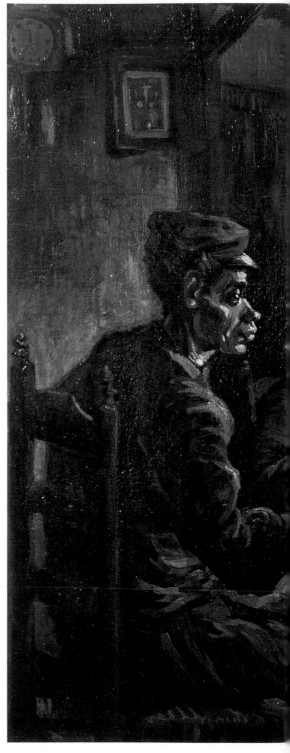

REPRESENTING the artistic climax of Van Gogh's stay in Neunen with his parents, this is a work which was unusual for the amount of time spent both in its preparation and execution. Usually he preferred to paint quickly and complete a canvas at one sitting. In this case Van Gogh made a long series of preliminary portraits and studies featuring peasants whose large, coarse features and weathered, work-worn skins are pronounced emphatically.

Like his most favourite artist, Jean-François Millet, Van Gogh's principal aim at this stage in his career was to represent the lives of those who toiled on the land with realism. Here that realism manifests itself in a domestic interior which almost resembles a cave or an animal's burrow. Everything, from the character's peasants' basic meal of boiled potatoes and coffee, to their dark skins and highlighted bones, serves to emphasise the brutalisation of hard labour – so much so in fact that the painting seems to be almost a caricature. But there is no doubt of the serious purpose that Van Gogh intended it to serve: 'I have tried to emphasise that those people, eating their potatoes in the lamplight, have dug the earth with those very hands they put in the dish, and so it speaks of manual labour, and how they have honestly earned their food'.

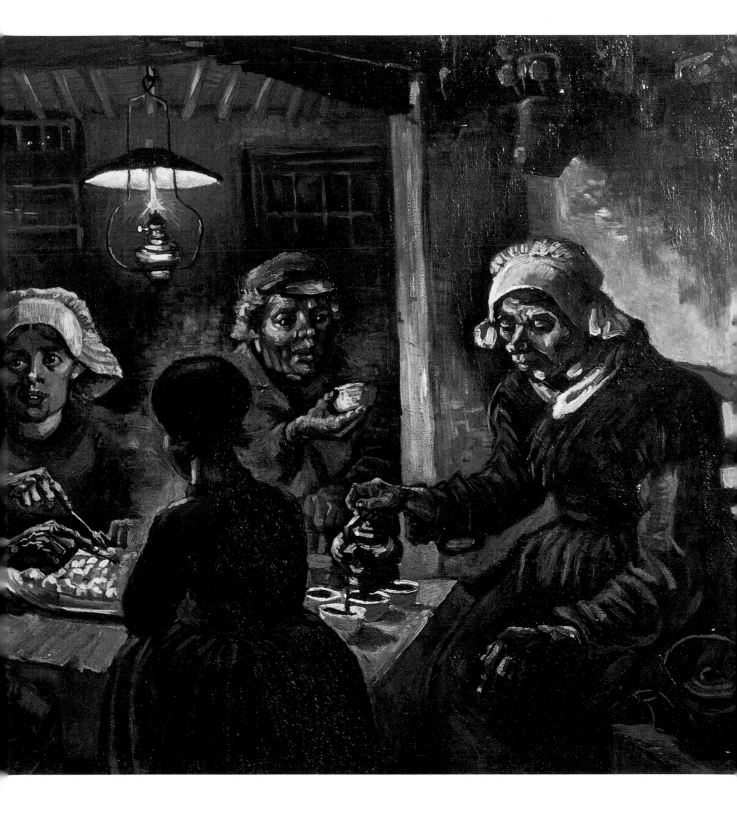

WOMAN DIGGING (1885)

Barber Institute of Fine Art, Birmingham. Courtesy of The Bridgeman Art Library

BY the end of his stay in Neunen, Van Gogh's paintings were becoming distinctively lighter; a trend that has often been attributed to the influence of Impressionism. However, the transition was a slow one, especially considering that the movement had begun to emerge in 1874. The fact is, however, that Van Gogh did not really comprehend the term; a situation which is made more understandable when we understand that neither travelling exhibitions or colour reproductions existed at that time. Dismayed at the continually sombre colours of his brother's paintings, which were proving impossible to sell, Theo tried to describe the bright new Impressionist pictures in his letters to his brother. Perhaps due to the third-hand way in which Van Gogh came to understand the term, what initially struck him about Impressionism, more than its gay colouration and sparkling vistas, was the idea of realistic representations of everyday scenes.

Woman Digging is a typical example of Van Gogh's attempts at Impressionism as he understood it at this time. With her back bent over completely, the figure becomes literally faceless – not an individual, but a 'type'. Her blue dress, a famous colour amongst Neunen peasants, further emphasises this notion of a genetic typology. Van Gogh loved the colour, saying, 'The people here wear the most beautiful blue I

have ever seen. It is a coarse linen which they weave themselves'. This last observation ties in with another theme which fascinated him. This picture, like *The Weaver* (1884), betrays an idealistic and romanticised view of poverty and the dignity of labour.

The Weaver (1884)
Courtesy of AKG. *(See p. 29)*

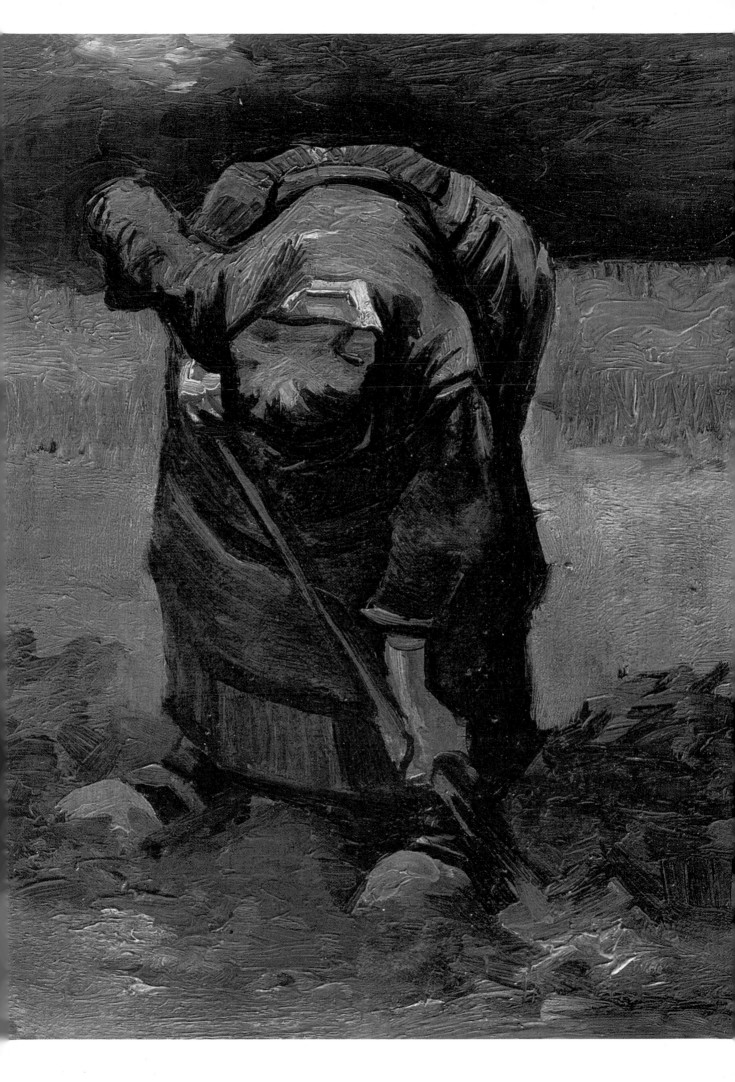

AUTUMN LANDSCAPE (1885)

Fitzwilliam Museum, Cambridge. Courtesy of AKG

I N November 1885, Van Gogh painted a series of autumnal scenes that were to mark the finale of his 'Dutch period'. As with nearly all his landscapes, he leaves us in no doubt as to which season he was working in. No other artist's *oeuvre* harmonises so completely with the cycle of the seasons. Van Gogh made it a key part of his 'artistic project' to record man's changing relationship with nature as it developed throughout the year. He did this by living and working with the peasants and farmers he depicted. In a further parallel with the method actor's dedication to realism, he would often risk his own health by siting outside for hours on end in chill winds or blazing sunshine. Like other landscape artists before him, Van Gogh felt in awe of nature's constant flux and justified his suffering in the name of art.

For all the novelty of having been painted 'en plein air', *Autumn Landscape* is a relatively traditional painting. Both its composition and colour scheme are very academic. This is nature under control and in balance; the trees do not overwhelm the landscape. The picture's realism is not slavish, however, and its slightly lighter palette, compared to his earlier work, suggests a new, more delicate direction.

VIEW OF AMSTERDAM FROM CENTRAL STATION (1885)

P&N de Boer Foundation, Amsterdam. Courtesy of AKG

IN October 1885, Van Gogh left Neunen for Antwerp, stopping off in Amsterdam for a few days on the way. The principal reason for his detour was to visit The Rijksmuseum where he spent many hours in front of famous paintings such as *The Night Watch* (1642) and *The Jewish Bride* (1664–65). Of the latter he wrote to Theo: 'I would give ten years of my life if I could sit here before this picture for a fortnight, with nothing but a crust of dry bread for food'. Significantly, what struck Van Gogh as among the most valuable attributes of Rembrandt's work was the way in which 'these great masters ... dashed off a thing from the first stroke and did not retouch it so very much'. The same could clearly be said of this image, which seems to have been painted with even more speed than was usual for Van Gogh. Its broad brush strokes are, depending on taste, either crude and unsophisticated or bold and ebullient. The sketchy, unfinished look was again something Van Gogh took from the old masters whose work, he believed, would not have found favour in the French salons of the 1880s.

QUAYSIDE WITH SHIPS IN ANTWERP (1885)
The Van Gogh Museum, Amsterdam. Courtesy of AKG

*I*T has been suggested that Van Gogh's move to Antwerp was precipitated by a family conflict in the wake of his father's death. After a short break in Amsterdam to study the Dutch masters at first hand, he decided to further his artistic training in a more formal way by enrolling at the Academy of Fine Art in Antwerp. Van Gogh was keen to become immersed in art and to lose himself in the anonymity of a large port town putting his domestic problems behind him. To this end, he combined both concerns by painting plaster torsos, as well as the city, in studio lessons. He wrote to Theo of his new home town's attractions: 'The various bonded warehouses and sheds on the quays are very beautiful. I have already walked along these quays several times … Particularly when one comes from … the silence of a peasant village … it is a curious contrast'.

As with *View of Amsterdam from Central Station* (1885), what stands out most strongly here is the picture's exuberant brushwork and overall coherence in terms of colour and style. It is only a small work but it conveys an evocative impression of a large scene: the Antwerp docks on a gloomy, rainy day.

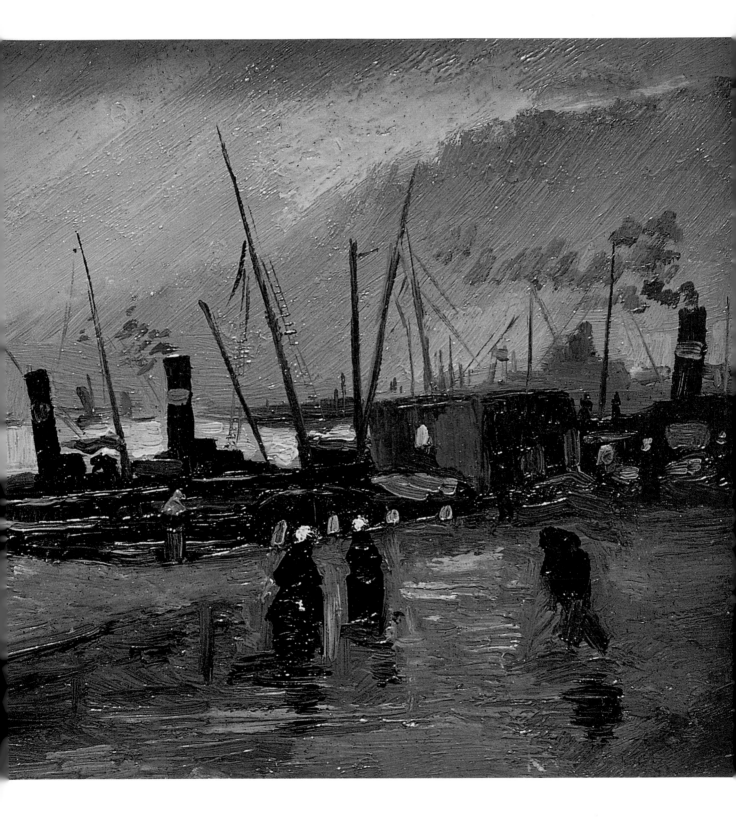

BACKYARDS IN ANTWERP (1885)

The Van Gogh Museum, Amsterdam. Courtesy of AKG

VAN GOGH found Antwerp to be in sharp contrast to Neunen, where he had previously been staying with his family. For the first time he was living in a bustling metropolis with all the new opportunities that this afforded his art. He was determined, for example, to take advantage of the city's relatively numerous population and start drawing the human figure in earnest. However, models were not cheap and so he realised that to afford them would require painting other things first. Townscapes were an obvious choice of subject, which he painted mainly for the tourist trade. At one time, in fact, Van Gogh was one of many thousands of young hopefuls trying to ply their trade with passing visitors. This is one of the scenes he chose to depict. He enthused to Theo: 'The colours in Antwerp are beautiful and it is worthwhile for its subjects alone...I am very happy to have come here'.

Technically the brush work in this painting is much more delicate than, say, *Quayside with Ships in Antwerp* (1885); some broad, swift strokes remain, but generally it is a more precise, less sketchy work. The colours are less muted; already Van Gogh's palette was lightening in anticipation of his move to Paris. Significantly, it is one of the few snow scenes that he ever painted.

Detail from *Quayside with Ships in Antwerp* (1885) *Courtesy of AKG. (See p. 48)*

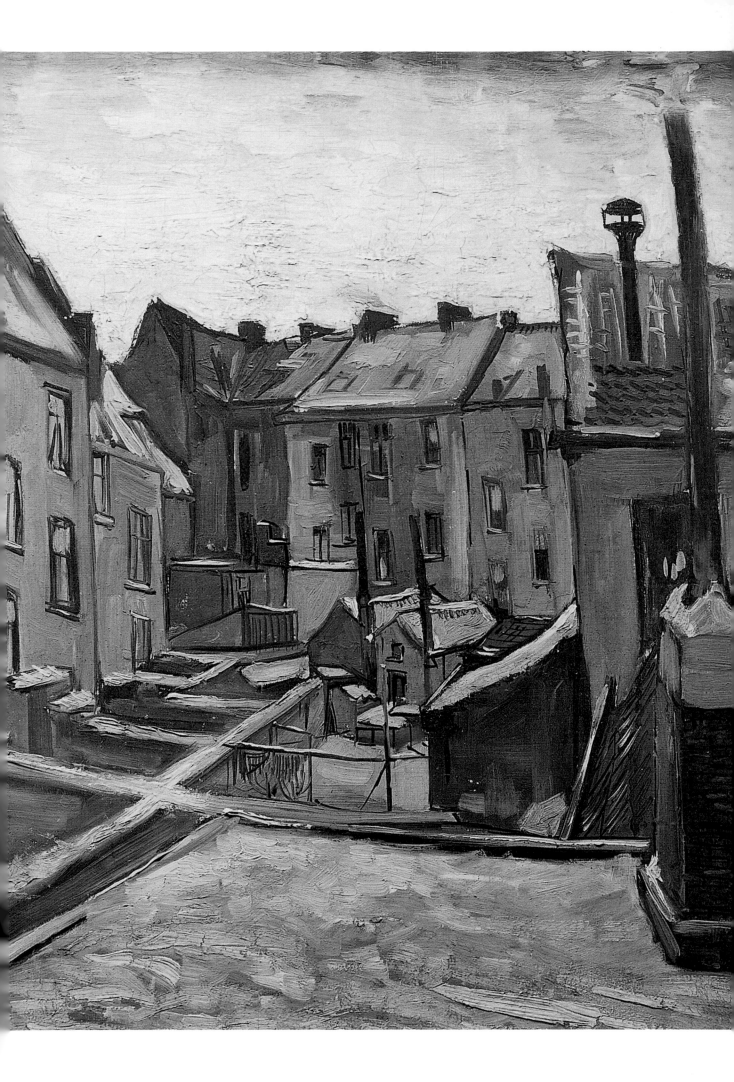

MOULIN DE LA GALETTE (1886)
Art Gallery and Museum, Glasgow. Courtesy of AKG

HAVING fallen out with the authorities at the Academy of Fine Art in Antwerp, Van Gogh moved to Paris in 1886. At first Theo was hesitant about the move, put off no doubt by his brother's famously difficult temperament. Ultimately though, the capital's lure proved irresistible. As Paris was the home of Impressionism, Theo must have also been hopeful that Van Gogh's work could only benefit from closer proximity to this movement. Indeed, the Impressionists' revolt against moralistic history painting, as institutionalised by the French Salon, France's official art exhibition, was a cause Van Gogh joined wholeheartedly – albeit as a relative latecomer.

In opposition to the established hierarchies of subject matter, the Impressionists deliberately treated ordinary scenes as important and serious. *Moulin de la Galette* is just such an example of this iconographic democratisation; it was to become one of Van Gogh's favourite subjects whilst staying in Paris, painting it as he did from various angles. Some reveal a neighbouring quarry, but none suggest its status at the time as a working-class dance hall. This reluctance to embrace the portrayal of urban pleasures was at odds with one of Impressionism's central edicts, as was the painting's technique. The strong earthy tones in which the canvas is rendered highlight Van Gogh's slowness to break with his Dutch past. It also demonstrates his ambivalent attitude to joining what was essentially a middle-class grouping of artists.

Detail from *Quarry at Montmartre* (1886)
Courtesy of AKG. (See p. 61)

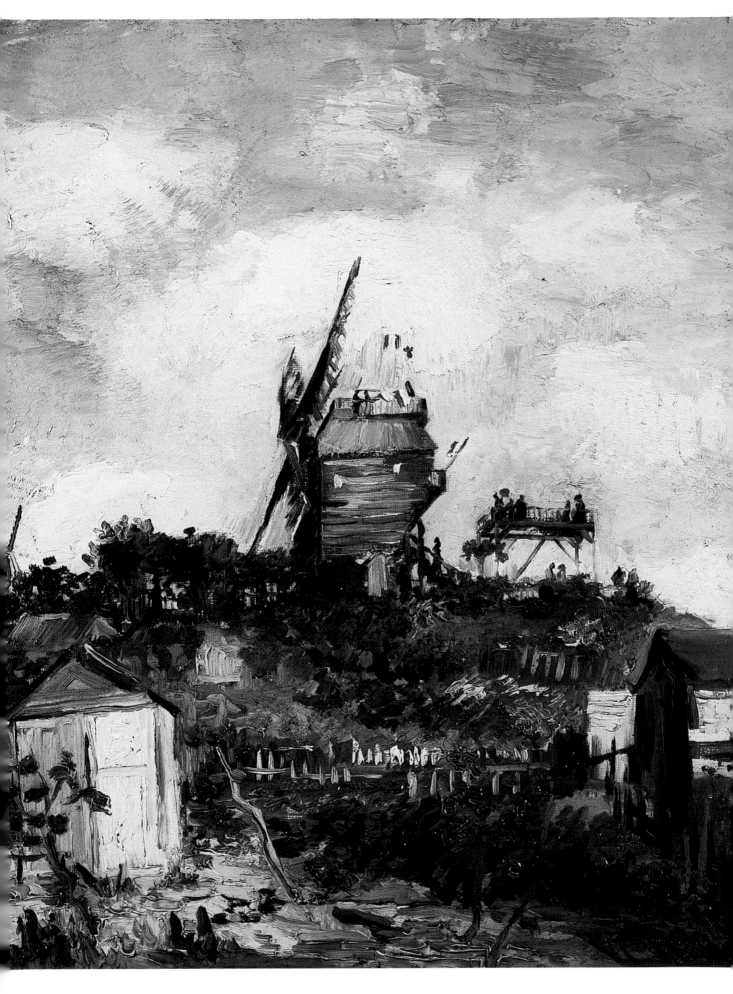

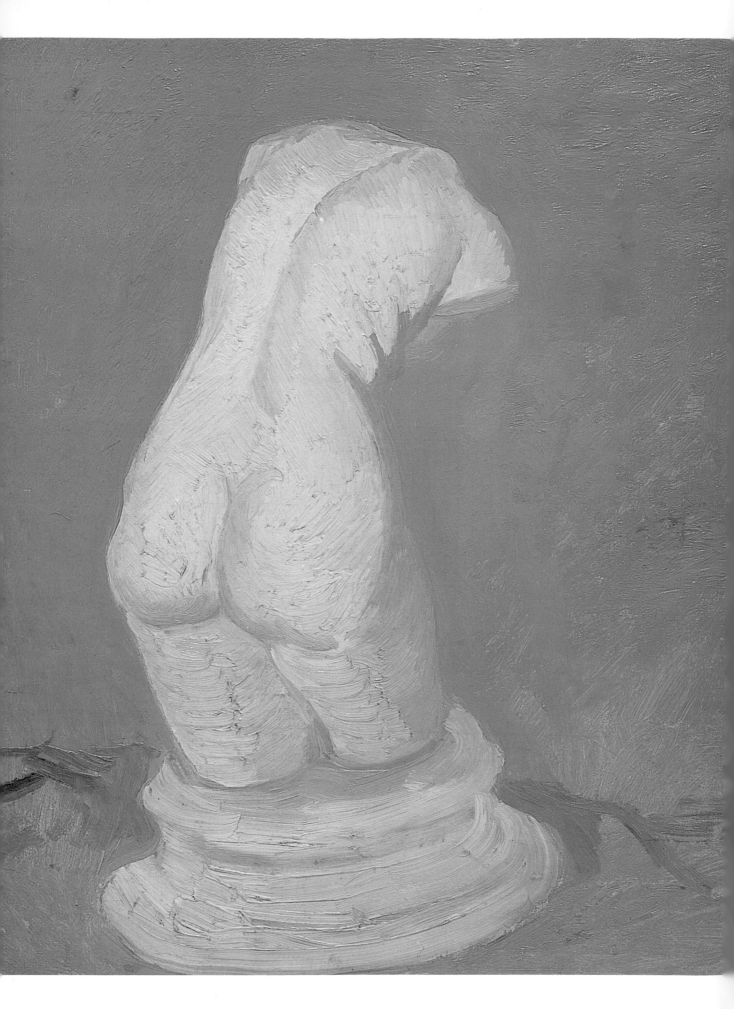

PLASTER TORSO (1886)

The Van Gogh Museum, Amsterdam. Courtesy of AKG

O N moving from Antwerp to Paris, Van Gogh enrolled in a private studio run by an eminent academic artist of the time, Fernand Corman (1845–1924). Corman encouraged his pupil to continue the practice he had begun in Belgium of painting from plaster casts. Mastery of the human form was considered an essential skill for any aspiring artist in the 19th century, and this was the cheapest way to gain it. It is impossible to say with certainty whether this particular image – drawn after a classical statue – was produced in Paris or Antwerp. Stylistically there is little difference between the models painted in both periods. Indeed a change in style would have been highly unlikely, given the fact that this picture and others of plaster torsos were all painted within a relatively short space of time. Furthermore, plaster-cast models such as this were equally available in the two cities, and their use was widespread throughout Europe. In fact, Van Gogh's representation here was certainly not much different to those that had been produced for decades by European artists pursuing a tradition long since moribund. Indeed, apart from its startling turquoise background, when seen in comparison with later nudes this painting is curiously lifeless.

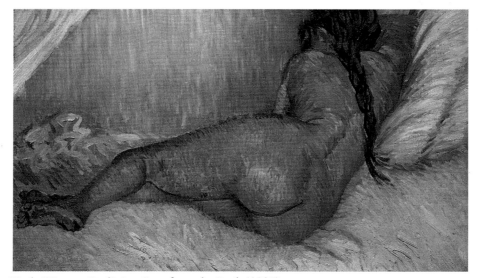

Nude Woman Reclining Seen from the Back (1887)
Courtesy of AKG. (See p. 68)

OUTSKIRTS OF PARIS (1886)
Courtesy of Christie's Images

LIKE so many artists of his generation, Van Gogh was very keen to paint 'modern life'. The problem he, and his peers, confronted was where to find this elusive phenomenon and, when it had been located, how to paint it. This rather unusual image provides some answers while, at the same time, triggering a whole new set of questions. Particularly problematic was the issue of modernity itself: how could the nondescript scene depicted here be reconciled with the notion of modernity as something bright, new and progressive?

In choosing to represent the outskirts of Paris, Van Gogh was focusing on one side of a coin. The flip side of romantic boulevards and bustling cafés also entered his work's ambit, but here it is the middle ground – neither city, nor country, nor even really suburb – that comes in for scrutiny. The solitary lamp-post, placed almost dead-centre, stands out as a conspicuous marker of nearby civilisation. Its fixed stolidity is in stark contrast to the various figures who are moving away from it at seemingly different rates. They, like the world they inhabit, are in significant transition.

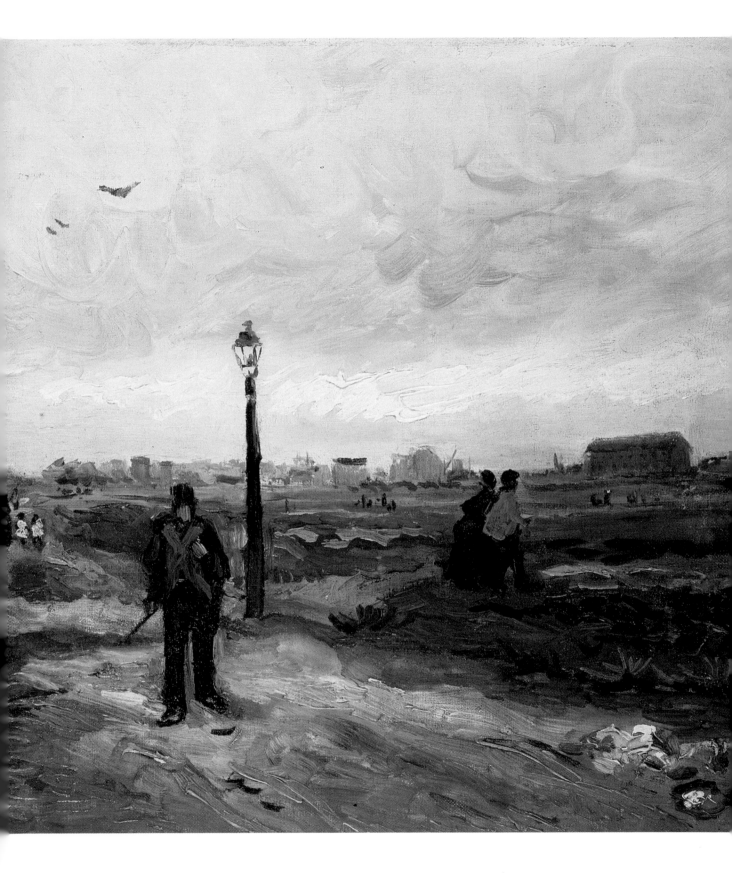

TERRACE OF A CAFÉ ON MONTMARTRE (1886)

Galerie du Jeu de Paume, Louvre, Paris. Courtesy of AKG

BY the late 19th century, Paris had long overtaken Italy as a site of pilgrimage for artists and other creative types. The longing for a rustic idyll and Roman arcadia was displaced by the vogue for all things modern. Contemporary Paris was widely regarded as the best place to experience this modernity in its most unadulterated form. Van Gogh, like many other artists of the time, rejected historical pictures in favour of the 'brash' new reality. *Terrace of a Café on Montmartre* represents a scene that epitomised modern, everyday, life in the city. However, Van Gogh generally tended to steer clear of urban subject matter and, indeed, his palette here harks back to Holland. With its predominantly earthy colours and roughness of technique, the only evidence of an Impressionist influence is in the painting's theme.

Painted very quickly, Van Gogh chose to ignore the minutiae of faces and features in this picture, to concentrate instead on the scene as an integrated whole. Perspective is treated with similar perfunctoriness. It is the painting's status as a physical object, with an identity distinct from the outside world, that counts. This was, of course, a highly modern concern and lends meaning to, among other things, the bold green vertical streak of paint in the picture's centre. As a means of giving three-dimensional form to the foreground lamp-post, it is barely credible, but as evidence of the artist's process it is a highly pertinent mark.

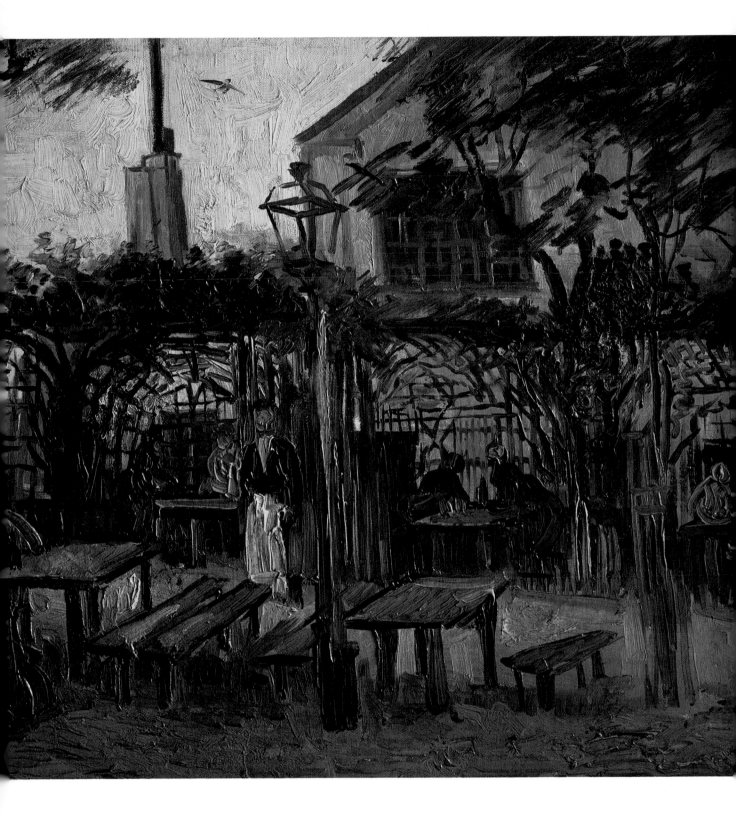

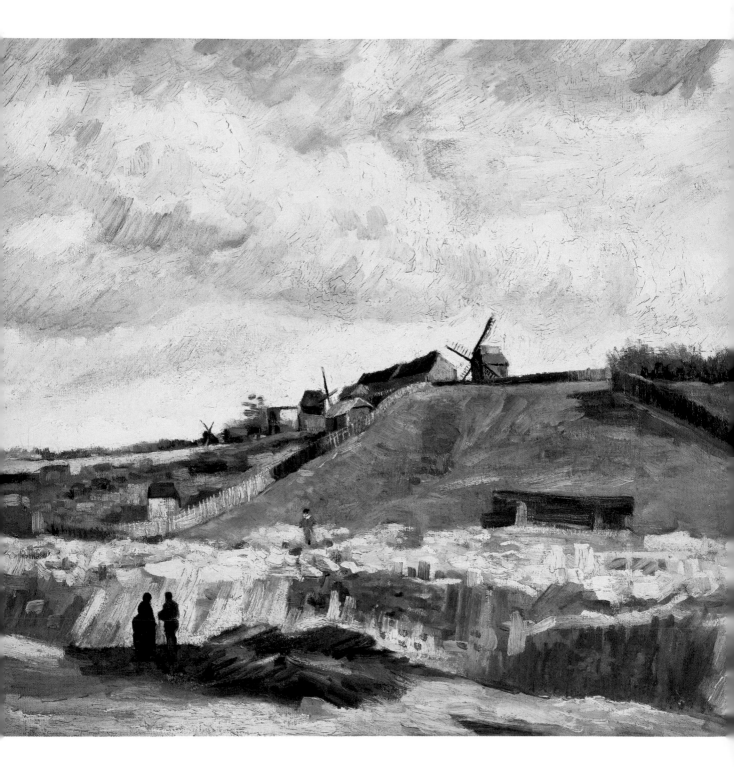

QUARRY AT MONTMARTRE (1886)
The Van Gogh Museum, Amsterdam. Courtesy of AKG

*T*HE famous windmills of Montmartre depicted here were a popular holiday destination at the time and perhaps reminded Van Gogh of his native Holland. They were certainly one of his favourite subjects while in Paris. In this picture, Van Gogh emphasises their status as relics of a rural age by contrasting them with the surrounding area, which was a place of urban renewal. Indeed, large tracts of Montmartre were, at the end of the 19th century, little more than extended building sites; quarries such as this were a common feature.

Van Gogh makes little attempt to beautify the scene, deploying muted colours throughout and a realism that harked back to his Dutch days. His only obvious concession to the imagination is the inclusion of two small, silhouetted figures in the foreground. They stand dark and anonymous in an otherwise deserted landscape, facing a panoramic view and expansive sky that lend them more than a touch of mystery. Van Gogh hinted at their inclusion when describing his working methods to Theo: 'When a painter goes out into the open country to do a study, he tries to copy what he sees as exactly as possible. It is only later, in his studio, that he permits himself to re-arrange Nature and introduce attributes that may to some extent be absurd'.

SELF-PORTRAIT WITH DARK FELT HAT (1886)

The Van Gogh Museum, Amsterdam. Courtesy of AKG

AGED 30, Van Gogh had this to say about his appearance: 'My forehead is marked with wrinkles, the lines on my face are those of a forty-year-old, my hands are furrowed'. He certainly looks older than his years in this, his first portrait of himself on arrival in Paris. However, just like his eccentricity in the face of chic Parisian society, the serious and solemn expression which he presents us with here was part genuine, part manufactured. Indeed the whole composition – from its conventional pose to the clothes he has chosen to wear – is highly reminiscent of an old Dutch master portrait. Maybe Van Gogh was reasserting his roots, or simply could not shake them off.

As always in Van Gogh's self-portraits, the eyes are a particularly important feature. They are the tools with which he relentlessly interrogated himself, in this case at the start of a whole new phase in his life. The neck scarf that peeks through his large overcoat is perhaps, however, the only sign of fresh beginnings. Even here, however, it is only a nod at the dandyism which he was to flirt with more overtly in coming years. Possibly more indicative of his regeneration and new found contentedness, are his calm brushstrokes. Living with Theo during this period, he certainly was not lonely or short of entertainment in the big city. He said of Paris in a letter to a friend in Antwerp, 'however hard living may be here, and if it became worse and harder even, the French air cleans the brain and does a world of good'.

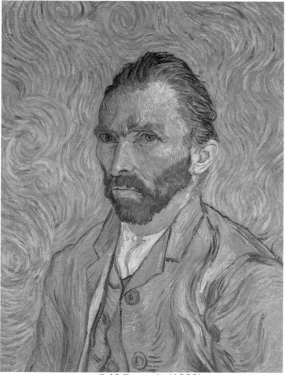

Self-Portrait **(1889)**
Courtesy of AKG/Erich Lessing.
(See p. 208)

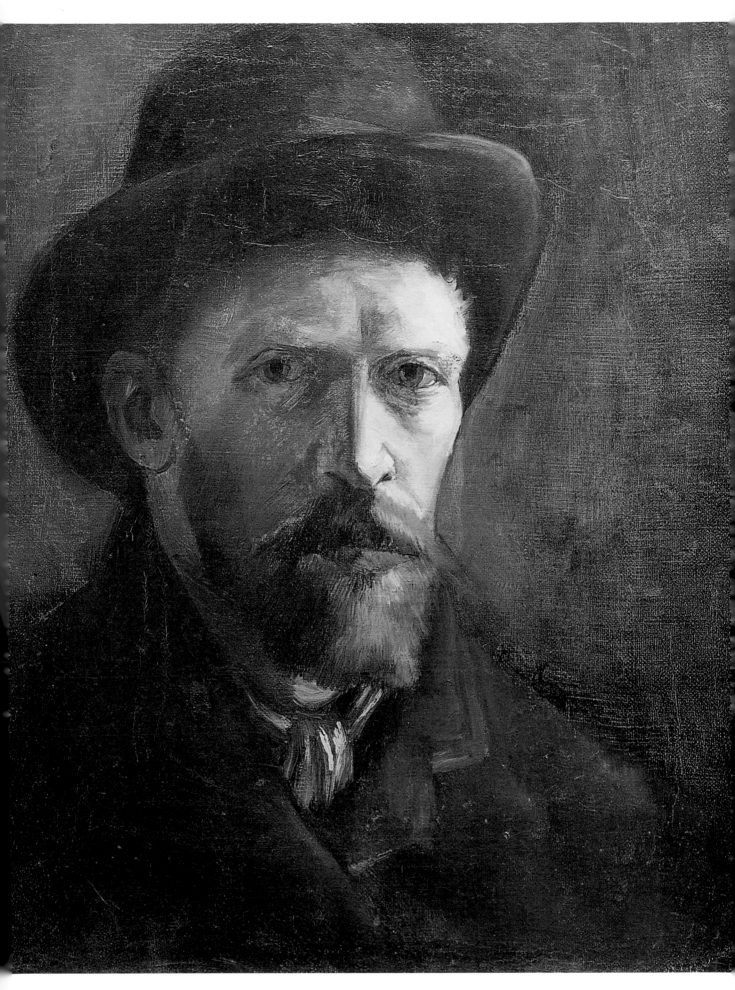

INTERIOR OF A RESTAURANT (1887)
Courtesy of Christie's Images

*O*NLY a short while after arriving in the French capital, Van Gogh's colour palette began to lighten. As Theo had hoped, the influence of the Impressionists was beginning to have a marked impact on his brother's work. Gone were the murky, earthy hues of northern Europe, and in their stead sprang the light, airy colours seen here in the delicate shade of pale yellow. Van Gogh was, however, less willing to shake off his peasant subject-matter and he failed to embrace the modern urban themes so favoured by the Impressionists. He only completed a few images and those he did choose were tackled in a more personal manner than those painted by other contemporary artists. *Interior of a Restaurant* is just such an example of a simple, homely, working-class eatery. This isn't the chic Parisienne establishment that one might expect a northern foreigner – freshly arrived in Paris – to be attracted to. On the contrary, it sports long tables of the sort that gives strangers no choice but to sit together, and the hatted figures in the background (it was unheard of at the time to eat with one's hat on) further reinforce the relaxed ambience. As with *Night Café in the Terrace du Forum* (1888), painted a year later, the foreground seats are empty, welcoming us to join in the fun. But this painting, unlike the later one, could almost be a study for a more refined, larger painting.

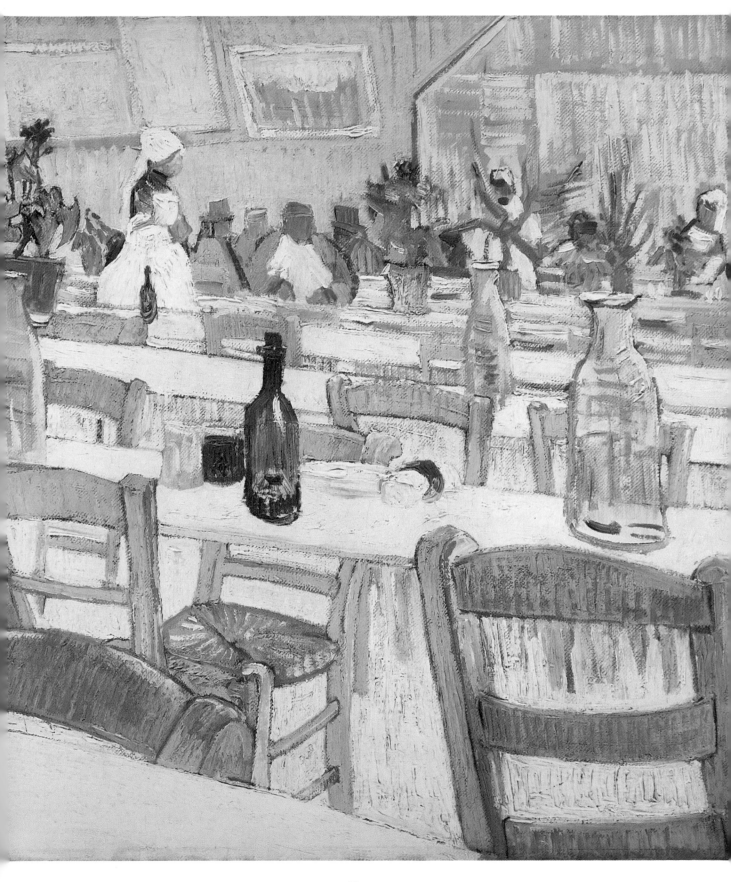

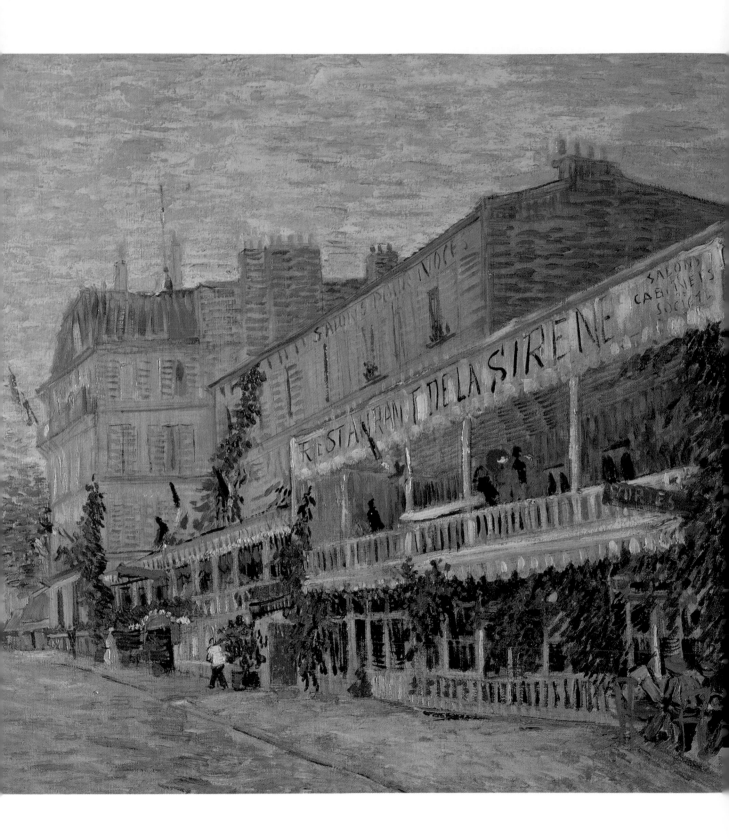

RESTAURANT DE LA SIRENE (1887)

Musée d'Orsay, Paris. Courtesy of AKG/Erich Lessing

BY 1886 Impressionism had all but faded out as a coherent or clearly discernible movement, replaced by a series of new trends in painting. However, it continued to exert a significant influence on the next generation of artists, most notably a group whose very name indicated their debt to the old school. The 'Neo-Impressionists', or 'Pointillists', took some of Impressionism's theories to their logical scientific conclusions. 'Points' is French for dots, and these were exactly what the new style consisted of – applied by its strictest adherents in a painstakingly slow and precise manner over the entire canvas. Furthermore, colours were used only in accordance with the latest chromatic theories, all of which resulted in an effect that was more classical than Impressionistic.

However, such a technique was not really suited to Van Gogh's volatile temperament, and so *Restaurant de la Sirene*, whilst doubtless influenced by Neo-Impressionism, is far rougher and more energetic than a painting by, say, Pissarro. It is as if Van Gogh is working through a style before reaching his own distinctive and original language. Already, for example, we can see the more patterned, almost decorative, brushwork that was to become a regular feature of his more mature works. The subject matter also points forward, away from his dour Dutch beginnings and towards a bright French future.

NUDE WOMAN RECLINING SEEN FROM THE BACK (1887)
Private Collection. Courtesy of AKG

IN Holland Van Gogh had trouble getting female models, largely because he could not afford to pay them. In Antwerp, the Academy where he was a student did have sufficient funds for the purpose, but was too prudish to run life classes with anything but plaster torsos. Therefore it was not until Van Gogh arrived in Paris that he painted nudes in the flesh with any regularity. Now that the opportunity presented itself, he was keen to master the human form – even if it meant putting off his recently begun 'plein air' exercises. He informed Theo: 'As I have already told you, there is no reason to start working out of doors again for the first year. That for the entire future it is infinitely better to draw classical and nude models in the town'. Confronted with real women, as opposed to inanimate statuettes, Van Gogh's nudes of this period were quite different to his plaster-cast drawings. This painting – with its languorous sensuality bordering on the pornographic – is a good example. The woman is clearly luxuriating in her 'den' of cushions and drapes, and almost melts into them. Her hips, thighs and buttocks are suggestively emphasised; her head is turned provocatively away. The colours are muted, but still lighter and softer

69

than those from his Dutch period. The short brushstrokes emphasise the figure's undulating body. In other nudes from this series, the model is even more sensual, wearing nothing but stockings and a knowing post-coital look.

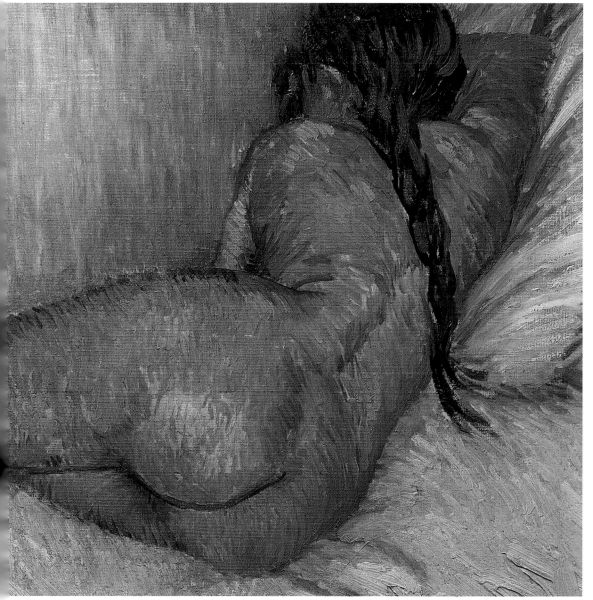

VIEW OF MONTMARTRE (1887)

Kuntsmuseum, Basel. Courtesy of AKG

DURING 1886 and 1887 Van Gogh painted various views of Paris, particularly Montmartre. These were either from the hill looking down over Montmartre (as seen here), or of the hill itself. It was an area that Van Gogh came to know well while staying at his brother's flat near by. Attracted by low rents and a strong sense of community, many artists set up their studios in and around the 'quartier', a trend which continues to this day. What was once a strong bohemian sub-culture has now, however, become little more than a pseud's corner for gullible tourists. This is not to say that in some ways 'twas ever thus', but simply an observation that the credibility of contemporary Montmartre is almost entirely sustained by glorious memories of what went before. Past luminaries, such as Van Gogh, are exploited for all they are worth. One hundred years ago, Montmartre was a mere village but now it is very much a part of the urban metropolis and a key stop on all sightseeing tours.

Stylistically, Van Gogh's palette is significantly more airy than it had been hitherto. Gone are the looming skies and gnarled peasants, replaced by the much lighter atmosphere of Paris which by now was influencing Van Gogh greatly. However, the relatively muted tones remain and the harmony of earthy colours so visible in works such as *Woman Digging* (1885) are still in evidence. It is the capital as seen through the eyes of a northern foreigner.

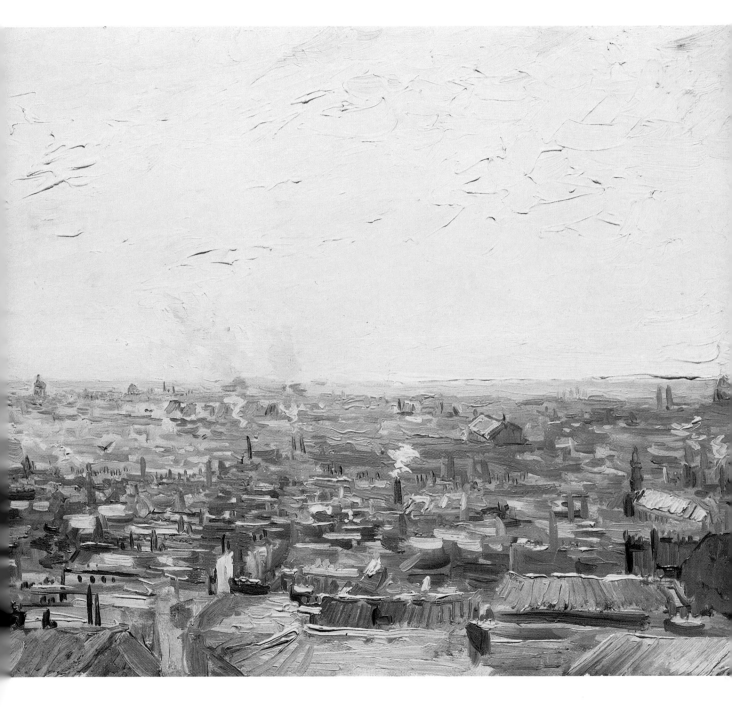

FOUR CUT SUNFLOWERS (1887)

Rijksmuseum Kröller-Müller, Otterlo. Courtesy of AKG/Erich Lessing

SUNFLOWERS have of course become synonymous with Van Gogh, but they only began to pre-occupy him as a potential subject for his art as late as 1887. Ironically, perhaps, it was only on moving away from the countryside to Paris that this interest became awakened. However, any apparent paradox involving the newly urbanised Van Gogh 'turning back' to nature is perhaps explained by a simultaneous influence: that of Adolphe Monticelli. Well-known in the capital during the 1860s, Monticelli was a Provençal artist whose thick impasto surfaces and pure colours (which Van Gogh has deployed here) impressed the Dutch artist to the point of hero-worship. Meeting Monticelli in Paris also sowed the seeds of Van Gogh's desire to move south, where he eventually painted the more famous 'live versions' of sunflowers.

Van Gogh's tendency to look back to the past for inspiration has prompted some critics to compared *Four Cut Sunflowers* to 19th-century Dutch still lifes, and particularly the *vanitas* (flower) theme so favoured at that time. Probably more dominant among Van Gogh's thoughts in 1887 were the popular decorative arts, where sunflower motifs appeared regularly. Van Gogh's idea of nature was always mediated by culture.

CROWN IMPERIALS IN A COPPER VASE (1887)

Musée d'Orsay, Paris. Courtesy of AKG/Erich Lessing

A S well as sunflowers, irises and lilacs, Van Gogh painted a whole host of other less-celebrated flower pictures – mainly in Paris – of which this is one. Nearly all of them feature evidence of contemporary colour theories and this is no exception. A mutual friend of Theo and Van Gogh testified to Van Gogh's preoccupation with chromatic concerns at the time: 'The ensemble of the flower pieces is very cheerful and colourful, but some are flat, of that I cannot convince him. He always answers me "But I was trying to introduce this and that colour contrasts." These 'colour contrasts' were a characteristic of Van Gogh's work from this time onwards. Here it is the yellowy orange of the flowers that complements the speckled blue of the background. The Pointillist technique used to depict the latter is also reminiscent of Japanese prints, as can be seen in *Margaret Gachet at the Piano* (1890).

The two drooping flowers on the left were probably added later to enliven the composition. Their brushwork and colour are both slightly

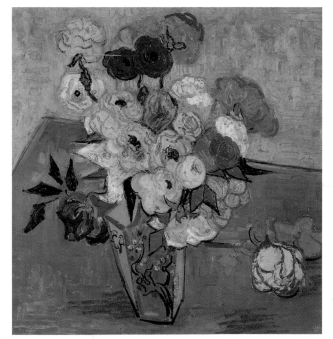

different from the rest of the picture, whose symmetry and stiffness they alleviate. The strangely distorted vase and table perspective is a pictorial strategy possibly picked up from Paul Cézanne (1839–1906).

***Still Life with Roses and Anemones* (1890)**
Courtesy of AKG/ Erich Lessing. (See p. 248)

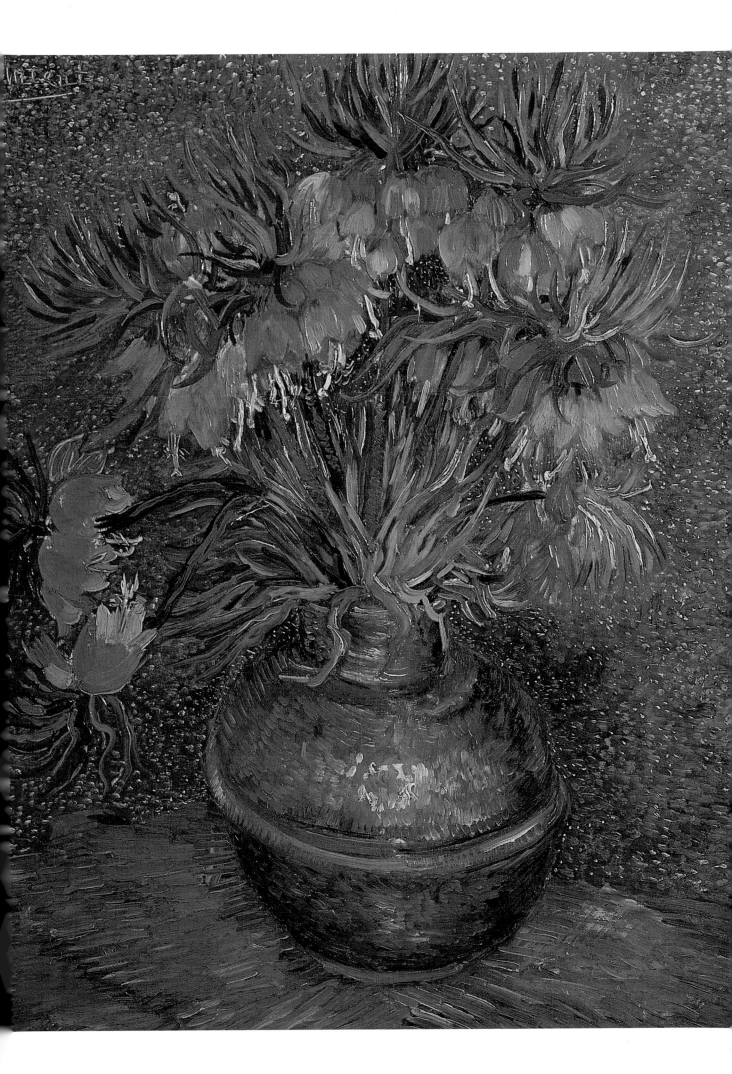

THE ITALIAN WOMAN (1887)

Musée d'Orsay, Paris. Courtesy of AKG/Erich Lessing

*V*AN GOGH'S difficulty in finding female models to pose for him lasted throughout his working life. However, his searches were not entirely motivated by artistic concerns. As he confessed: 'The female figures I see among the people here leave a most marked impression on me; I should far rather be able to paint them than to have them, although I do indeed wish I could do both'.

Detail from *Still Life with Books* **(1887)**
Courtesy of Christie's Images. (See p. 78)

With the figure represented here, Van Gogh may well have had his wish granted. *The Italian Woman* is generally considered to be Agostina Segatori, with whom Van Gogh was rumoured to have had an affair. He wrote to his sister that whilst in Paris he had 'the most impossible and rather unseemly love affairs from which I emerge, as a rule, damaged and shamed and little else'. Whether this was the case with Segatori we simply cannot be sure. What we do know is that she ran a café that Van Gogh and his friends often frequented, and that he met her by dint of exchanging his pictures for her meals.

Stylistically, this painting is a curious mixture of two influences: the cheap colour prints widely available at the time, and the rarer, more refined Japanese prints that had recently entered the country. The result is one of the brashest canvases that Van Gogh completed during his stay in Paris. The figure is framed on two sides by a border of complementary reds and greens, which adds to the picture's generally flat and decorative effect. The flower she clutches is a traditional symbol of hope and faith. Van Gogh's affair with Segatori did not last long, however, and it is possible that this portrait was in fact painted in reminiscence.

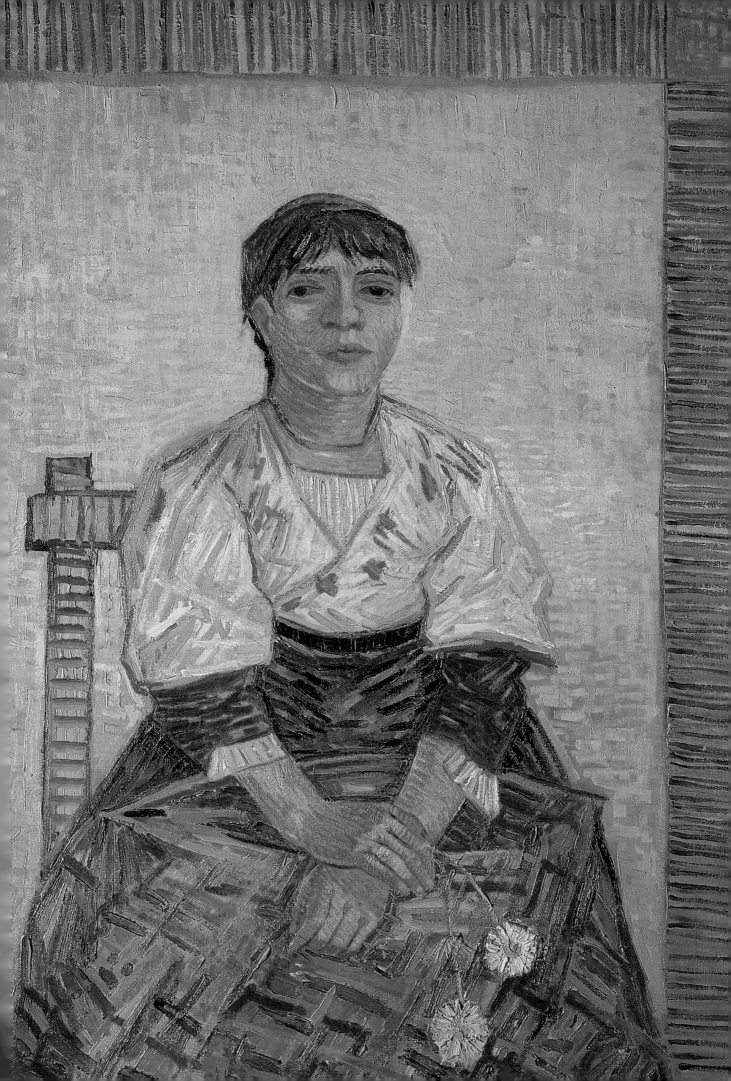

STILL LIFE WITH BOOKS;
ROMANS PARISIENNES (1887–88)

Courtesy of Christie's Images

ALTHOUGH it is unsigned, Van Gogh rated this picture highly. He even let Theo exhibit it at an Indépendants show in the spring of 1888. However, a contemporary, seeing the work at the exhibition, said of it: 'This motif, fine for a study, should not provide a pretext for a painting', The objects Van Gogh chose to depict in *Still Life with Books* were indeed rather unelevated, but not without personal significance. Unusually, he gave the painting a specific title, *Romans Parisiennes*, which as well as being a further indication of the value he placed on it, hinted at the subject's relevance. Van Gogh felt that the budding rose, for example, represented some sort of consoling influence. The books, similarly, stood in as metaphors of one of life's few comforts in the modern world with its infinite sadness. Van Gogh developed these somewhat bizarre theories whilst looking at a painting by Pierre Puvis de Chavannes, of which he said: 'Puvis has painted a very beautiful portrait: the serene old man ... reading from a book with a yellow cover, a glass of water beside him containing an aquarelle brush and a rose'. He went on to say, in another letter: 'These are consoling things; to see modern life as bright, despite its inevitable melancholy'. Consolation was a recurring theme in Van Gogh's art; here it takes on the form of a collection of books and a solitary flower; banal things maybe, but nonetheless reasons for living.

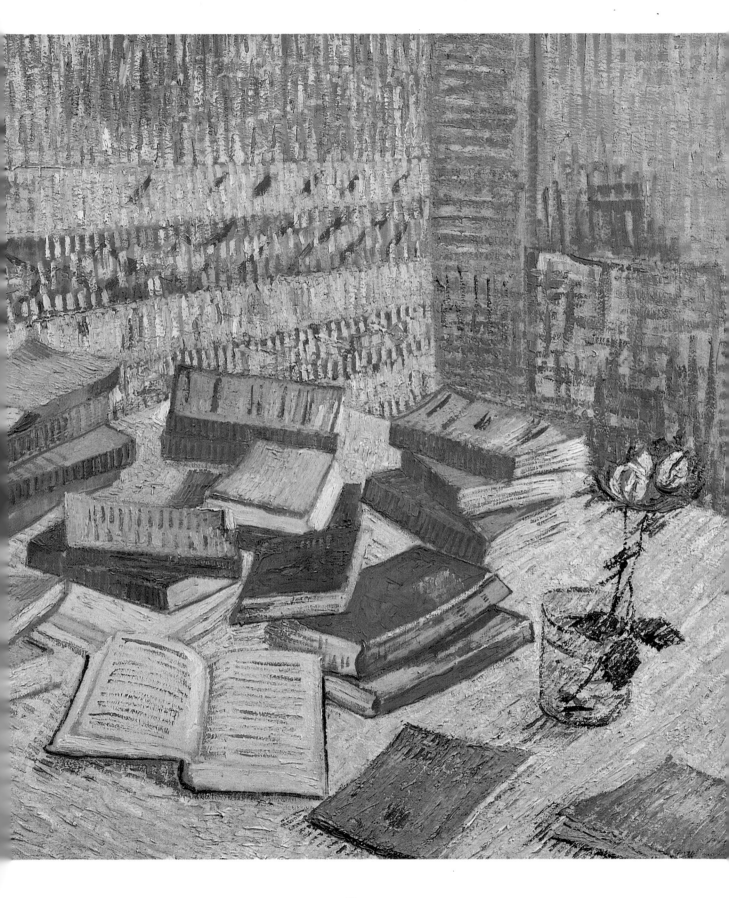

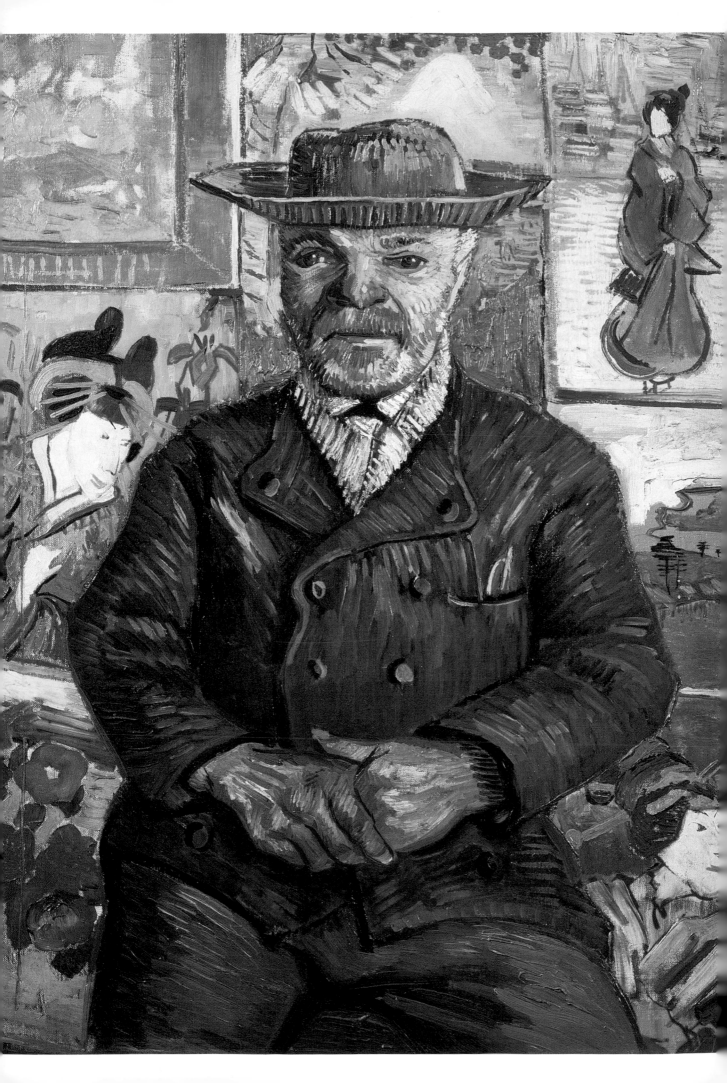

STUDY FOR PORTRAIT OF PÈRE TANGUY (1887)
Collection Stavros S. Niarchos. Courtesy of AKG

A KEY feature of Van Gogh's new life in Paris was his greatly extended social circle. His varying styles during the period were perhaps due in no small part to this sudden glut of influences, among whose number Père Tanguy ranked highly. Tanguy owned a small shop selling artist's materials, which he often exchanged for paintings, and particularly those by radical young artists. He considered Van Gogh to be just such a person, and actually once sold one of his paintings (pre-exchanged for paint) for 20 francs. The myth of Van Gogh never selling a painting in his life-time can thus be dismissed – in fact Tanguy was only one of several purchasers.

As a study for the later portrait of Tanguy, this painting is particularly detailed. However, the later work was not just a more polished version of the former. Several features were dropped and new ones added. Here, for example, we can see one of Van Gogh's own still lifes, in the top left-hand corner, which was subsequently omitted. Also left out in the final tableau was the innovation of outlining the sitter in red.

It had been suggested that the frontal pose, clasped hands and Japanese prints were all meant to give Tanguy connotations of a Japanese

Portrait of Père Tanguy **(1887)**
Courtesy of AKG. (See p. 82)

Buddhist priest. Van Gogh revered Japan as some sort of utopian paradise where art and life were in perfect synchrony. His desire to associate Tanguy with this society would therefore have been understandable. Considering the shop-keeper had never traded in Japanese prints, the inclusion of them here would seem strange if we did not interpret the whole picture as a eulogy to the East.

PORTRAIT OF PÈRE TANGUY (1887)

Musée Rodin, Paris. Courtesy of AKG

VAN GOGH painted three portraits of Tanguy, all of which deploy a much more intense palette than hitherto. The significant technical reason for his brighter canvases, as with those of every other artist around this time, was one which Tanguy himself would have been familiar with from professional experience. New developments in the manufacture of oil paints meant a whole range of ready-mixed pigments became available in easy-to-use squeezable tubes. Such an innovation was invaluable to Van Gogh.

Similarly influential to his career were Japanese prints, like those

Study for Portrait of Père Tanguy (1887)
Collection Stavros S. Niarchos.
Courtesy of AKG. *(See p. 81)*

surrounding the sitter here as a decorative backdrop. He had originally seen and begun collecting them in Antwerp in the previous months, and admired them for their stylised design and sense of nature's clear-cut beauty. Indeed the whole picture, with its deft brushwork and flat picture plains, has distinctly Japanese overtones. Above all, the emphasis is on Tanguy's working-class origins and straightforward, socialist principles. His forwards pose, simple, naïve expression, clasped hands and straw hat are all signs that here is a man of the people.

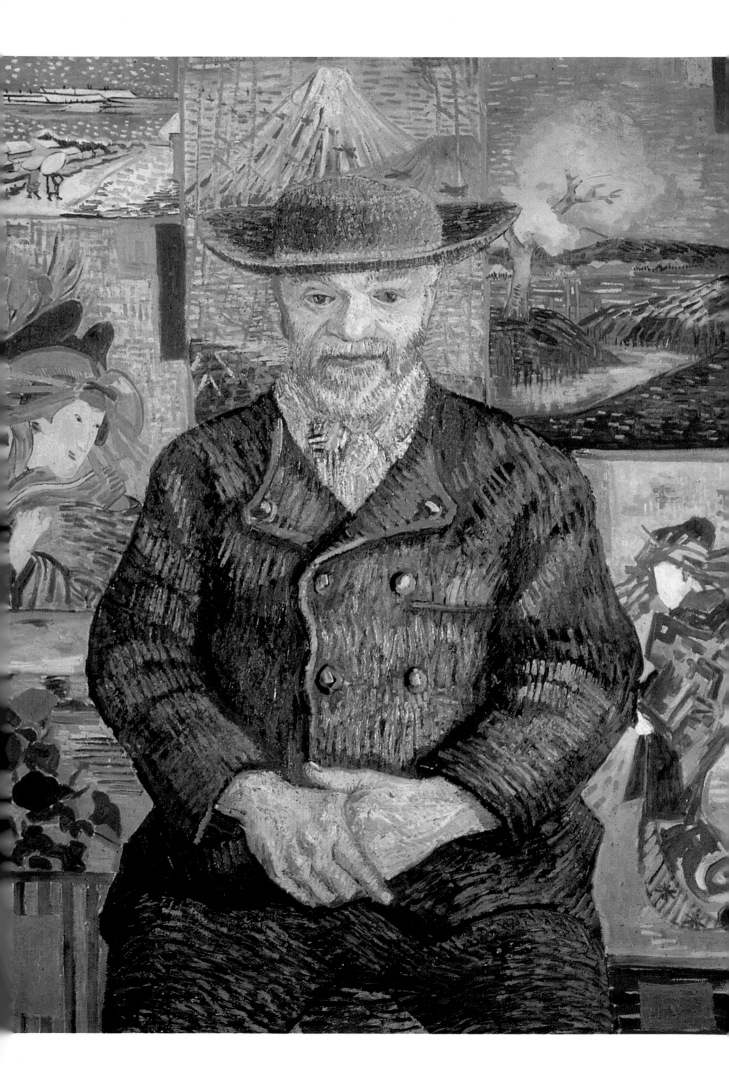

STILL LIFE WITH PEARS (1887–88)

Neue Meister, Gemäldegalerie, Dresden. Courtesy of AKG

*T*HE most striking artistic development that accompanied Van Gogh's passage from Neunen to Paris involved his use of colour. He became quite single-minded in his determination to master the full range of his palette. This bold new course obviously pleased Theo, his agent. At last, Theo must have thought, his brother's paintings would actually sell. He wrote to their mother about his protégé's new direction: 'He is far more open-minded than he used to be, and very popular'. Theo then went on to write: 'His main reason for painting still lifes is that he wants to freshen his colours for later work'. The still lifes Van Gogh painted around this time, then, such as the one here, were part of a transitionary period in his work. The final results can be seen in later canvases like *The Sunflowers* (1888) where the chromatic intensity reaches an all-time high.

Nevertheless, *Still Life with Pears* is still a painting of considerable warmth and richness. The fruit itself appears almost over-ripe – on the verge of putrefaction. It is evidence perhaps that Van Gogh had begun improvising with colour, using it expressionistically rather than as a tool of realism. The dashes of red, blue and yellow in the foreground, for example, are as much a sign of his new-found confidence with colours as they are a debt to Impressionism.

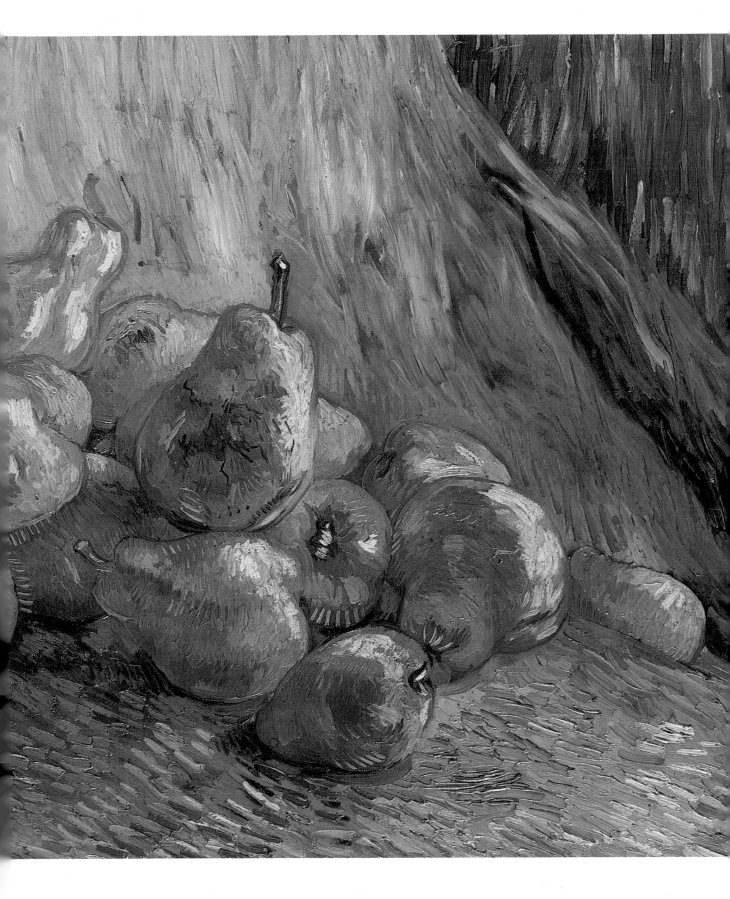

SELF-PORTRAIT BEFORE EASEL (1888)

The Van Gogh Museum, Amsterdam. Courtesy of The Bridgeman Art Library

*V*AN GOGH'S attitude towards the self-portrait has often been compared to that of his similarly illustrious compatriot, Rembrandt. Indeed, their almost obsessive urge towards self-investigation has been widely regarded as a quintessentially Dutch trait. However, whereas Rembrandt's prolific numbers of self-portraits were relatively normal for his time, Van Gogh belonged to a small, loose group of artists for whom concerns with the interior world were primary. His fellow Post-Impressionists, Paul Cézanne and Paul Gauguin, for example, also painted dozens. Whereas the Impressionists had been predominantly interested in charting social or public life, the Post-Impressionists turned inwards to ask why we are here in the first place.

Painted just prior to leaving for Arles, this is one of many self-portraits Van Gogh produced during his time in Paris. Towards the end of his stay, each successive canvas seemed to reflect an increasing depression with life in the capital. The current thinking on Van Gogh's emotional condition is that he almost certainly suffered from chronic clinical depression. Analysing this particular period of his life reveals several specific factors which surely contributed to, or sparked off, this condition. Gauguin, with whom he had struck up a close friendship less than a year previously, left Paris for Brittany. Then his lover, Agostina Segatori, who owned a café where he exchanged paintings for food, also left him. Despairing of ever starting a family, he confessed to Theo that 'the love of art makes one lose real love'. Whether Theo concurred with these pronouncements is unclear, but their quarrels over other matters during this period, particularly money, are well documented. Van Gogh's acute awareness of the financial burden he was imposing on his brother is yet another potential reason for his melancholic moods.

Staring ahead, playing the part of the artist who suffers for his art, this portrait reflects the emotions of a man whose personal relationships were in some turmoil.

Detail from *Self-Portrait* (1888)
Courtesy of AKG. (See p. 163)

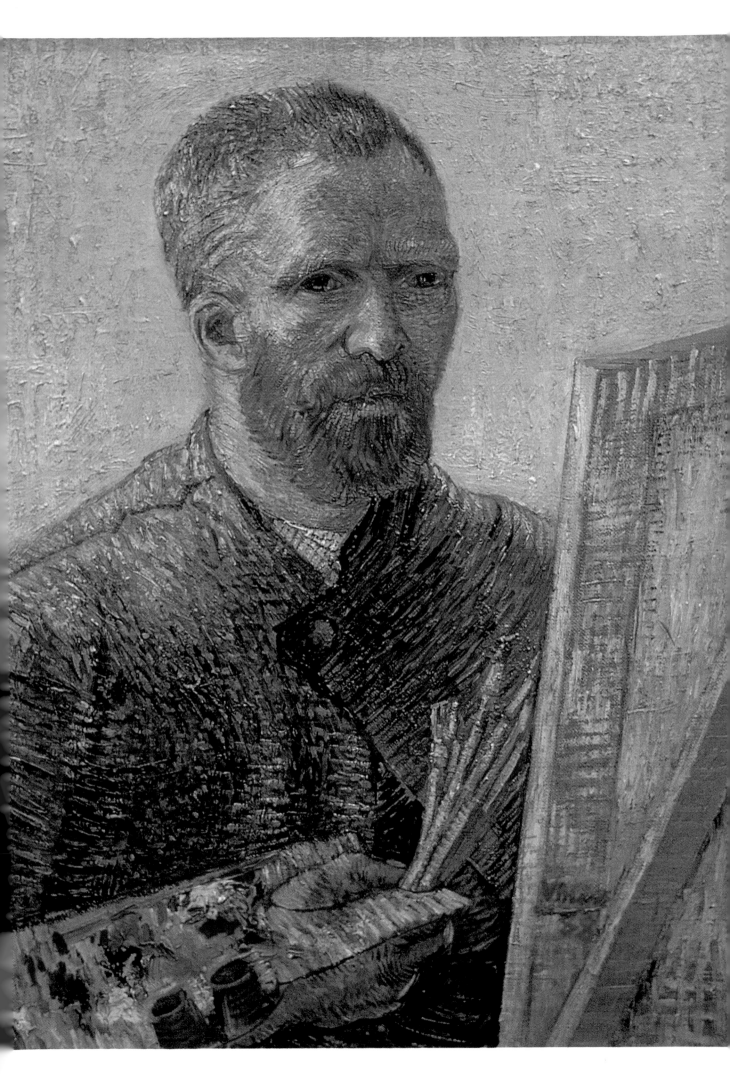

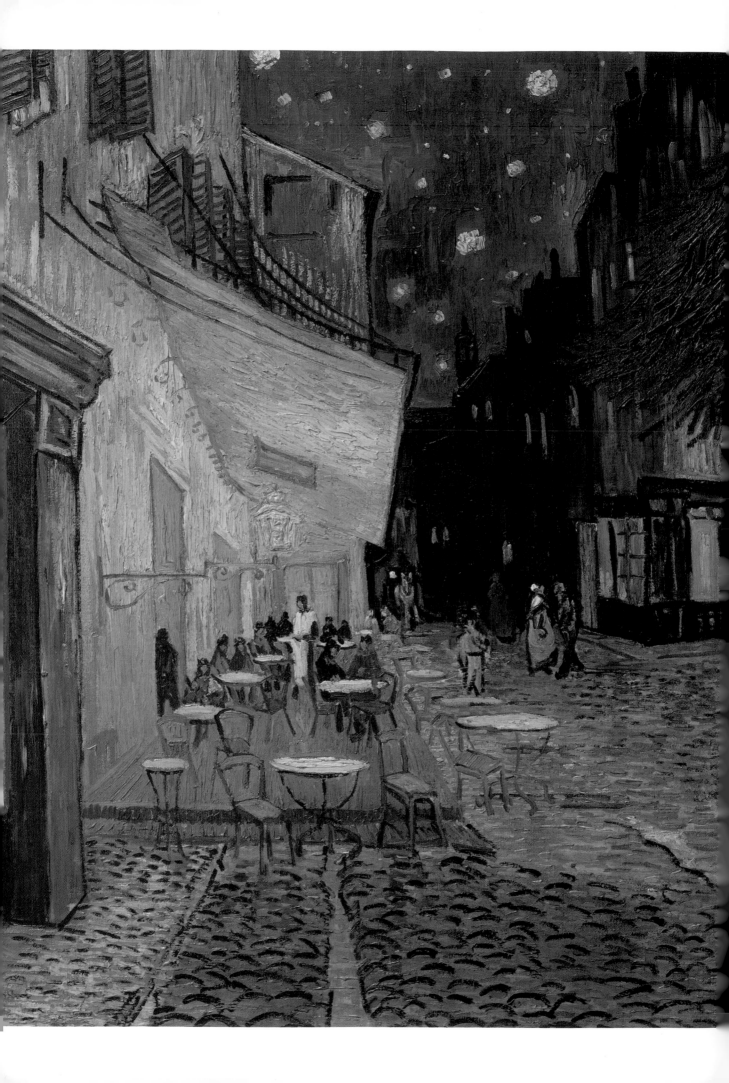

CAFÉ TERRACE ON THE PLACE DU FORUM (1888)

Rijksmuseum Kröller-Müller, Otterlo. Courtesy of AKG/Erich Lessing

*O*NE of the first scenes Van Gogh decided to paint during his stay at Arles, this is a work which heralded what was to become one of the most prolific periods in his career. In a single year, Van Gogh completed a staggering 200 canvases as well as writing some 200 letters. Considering the sheer quantity of his correspondence, it is surprising perhaps that the precise reasons for his move to Arles remain unclear. Perhaps he chose Arles for the legendary beauty of its women; the famous Arlesiennes raved about in the contemporary guidebooks and novels. Despite the warm and welcoming atmosphere that led Van Gogh to make confident pronouncements about his hopes for building an artistic community in Arles, his overall response to the place was ambivalent. He once called it 'a filthy town'.

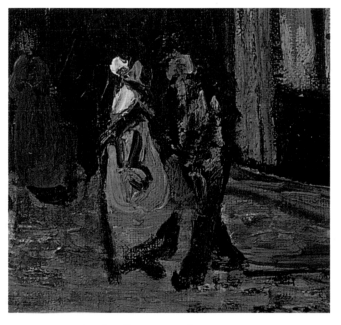

Café Terrace on the Place du Forum was presumably situated in a more salubrious arrondisement, although cafés were a favourite meeting place for prostitutes and their clients; the couple who stop to talk in the middle of the road could be far from innocent and the empty seats in the foreground may indeed be welcoming us to participate in just this type of exchange. Alternatively, what we witness is 'simply' a scene of calm and stability – still rendered with an expressionistic use of paint, but with no sign of the frenetic activity which surrounded Van Gogh's later works.

THE NIGHT CAFÉ (1888)

Collection Hahnloser, Berne. Courtesy of AKG

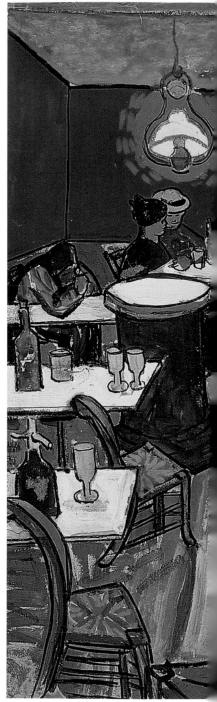

*V*AN GOGH ignored the Roman ruins for which Arles is internationally renowned, and did not even mention them in his letters to Theo. What he did feel warranted writing about – and painting – was the Provençal countryside of the 'Midi' and his beloved cafés. Compared with chic Paris, café life in Arles offered far worse company, but in many ways that was precisely the point. Considering himself to be an isolated figure operating on the margins of society, Van Gogh felt naturally attracted to cafés for their seedy, underground reputation. With alcoholics, prostitutes and the homeless numbering amongst their 'socially excluded' low-life denizens, Van Gogh, the poor struggling artist, felt quite at home.

The Night Café was just such a site of urban alienation. By choosing to frequent and represent this kind of scene, Van Gogh was curiously returning to *The Potato Eaters* (1885) territory. Certainly neither painting has the light, detached air that characterised his more Impressionist works of the interim period. Instead of using colour to define spatial forms, for example, here it is deployed entirely as a means of expression. The picture's large blocks of pure, flat colour anticipate the later German movement of Expressionism in many ways. Likewise, the steep perspective that throws us into the room makes for a strange and oppressive disorientation. The lamps that give off an almost tangible, luminous energy add to the overall sense that, as Van Gogh himself so aptly put it: 'it is the delirium tremens in full swing'.

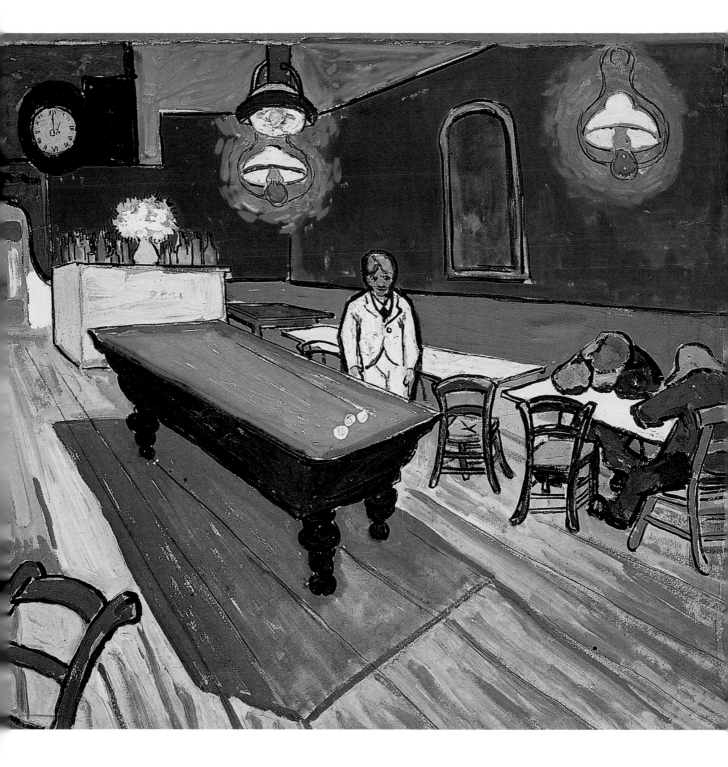

STARRY NIGHT OVER THE RHÔNE (1888)
Musée d'Orsay, Paris. Courtesy of AKG/Erich Lessing

*P*AINTED a couple of months after his arrival in the south of France, this is perhaps the lesser known of Van Gogh's two 'starry night' scenes. It is also a significantly calmer, more harmonious painting than the one completed a year later, while still retaining its creator's typically manic edge. Inspired by a walk at night, Van Gogh seems to have experienced a kind of hyper-reality when confronted by grass, water and sky in close combination. It is certainly striking how these three elements fuse into one dynamic whole. For once Van Gogh also felt confident that he had rendered nature's beauty in paint successfully. Such pleasure with his own efforts was not always evident. He once confessed to Theo that 'what often vexes me is that painting is like having a bad mistress who spends and spends and it's never enough, and I tell myself that even if a tolerable study comes out of it from time to time, it would have been much cheaper to buy it from someone else'. Whether this quote was meant as self-deprecating rhetoric or an indication of genuine self-disgust, Van Gogh's desire to paint never really waned. Although he only took up painting at a relatively late age of 28, from then on it was a vital part of his life with a distinctly therapeutic value. A canvas like this in fact epitomises the joy which painting inspired in him. Like the silhouetted couple in the foreground, it seems to revel in the romantic, celebratory nature of starlight.

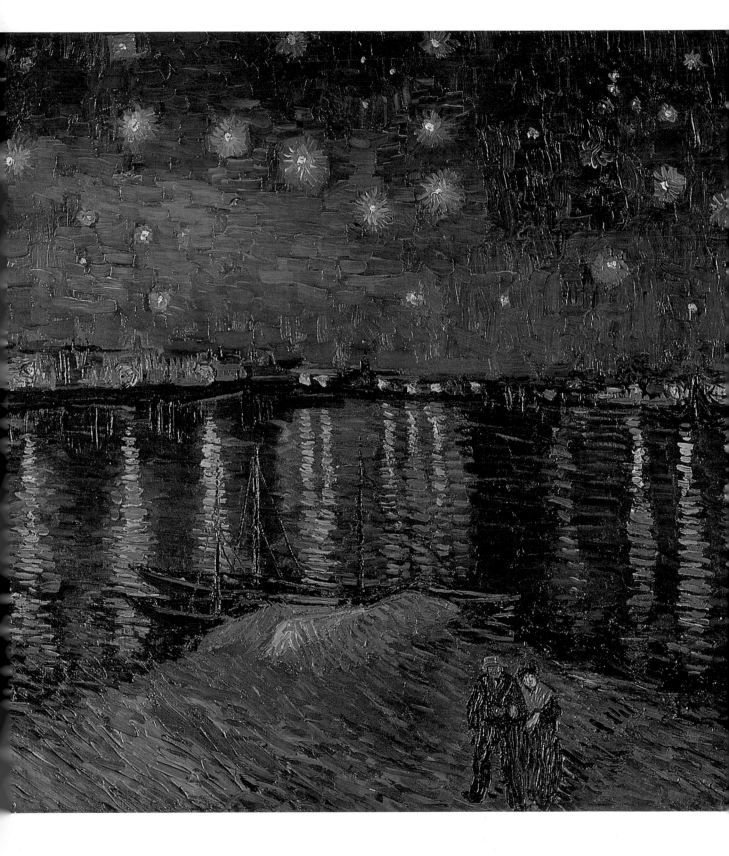

PORTRAIT OF EUGÈNE BOCH (1888)

Musée d'Orsay, Paris. Courtesy of AKG/Erich Lessing

RUMOUR has it that not only did Van Gogh attach candles to his easel whilst painting at night, but also placed them in the brim of his hat. Such stories, which fuelled speculation about his madness, may however have actually been true. He certainly took the Impressionist's edict to paint *en plein air* quite seriously, and was attracted by night scenes in Arles from first moving there.

It was in the absence of Gauguin, who had not yet arrived in Arles, that Van Gogh chose to paint another friend, the young Belgian poet, Eugène Boch. Although this particular work was not painted at night, the choice of a starry-night backdrop was certainly unusual for a portrait, and virtually unique in Van Gogh's portraits. Van Gogh believed that Boch bore a resemblance to the great Italian poet, Danté, about whom he had recently read a romantic biography. This, together with the letter that he wrote about the portrait to Theo before its execution, are significant facts. They go some way to countering the widespread myth of Van Gogh's work being entirely spontaneous and unplanned. They also reveal him as a man fixated on a fantasy world of stereotypes and sentimentalised genius. In his mind's eye, Eugéne Boch was the universal poet and the starry backdrop represented the infinity of Boch's poetic dreams.

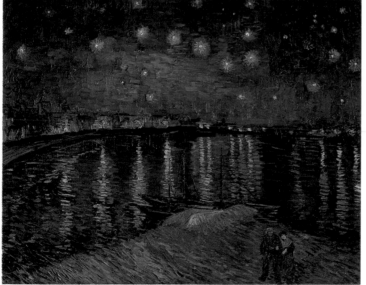

Starry Night over the Rhône (1888)
Courtesy of AKG/Erich Lessing.
(See p. 92)

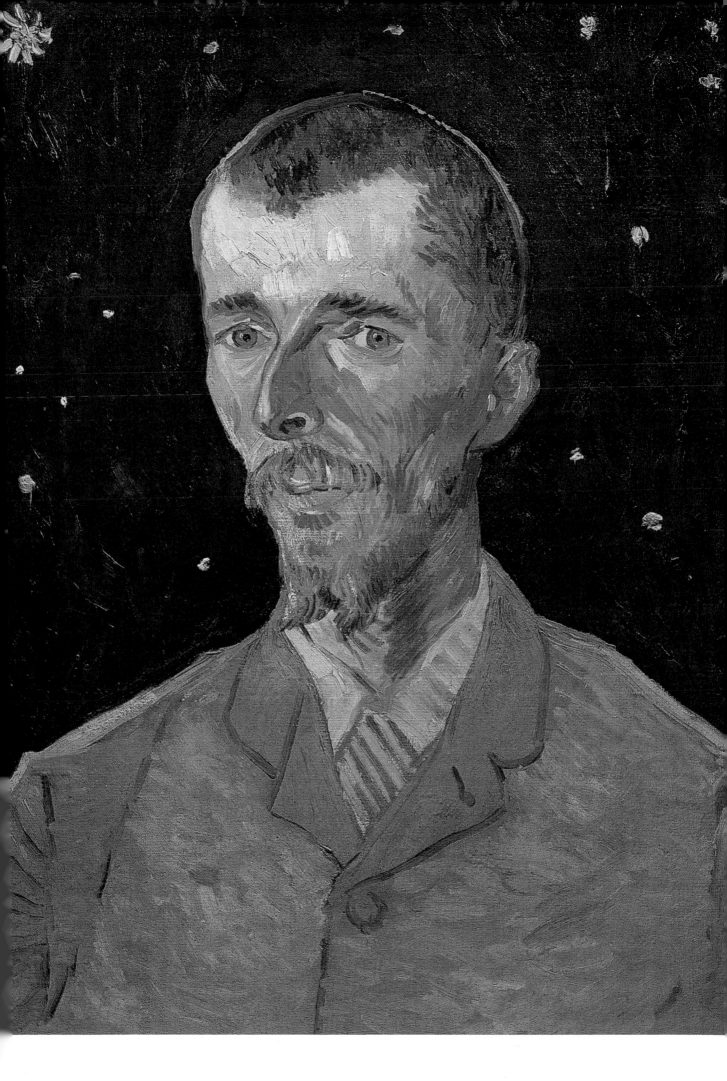

PORTRAIT OF THE FARMER PATIENCE ESCALIER (1888)
Private Collection. Courtesy of AKG

*T*HIS portrait typifies the transformation that Van Gogh's art underwent at this time. As with his earlier relocation to Antwerp, a new context in Arles again made him feel liberated and open to fresh possibilities. He wrote of his anticipation to Theo: 'I am convinced I shall set my individuality free simply by staying on here'. What has perhaps come to epitomise Van Gogh's 'individuality' is his striking use of colour and, as his quote foretold, it was only really in Arles that his painting's chromatic intensity came to the fore. Time and time again he referred to the source of this development as being Japan. 'I wish you could spend some time here,' he pleaded to Theo, 'you would feel it after a while, one's sight changes. You see things with an eye more Japanese, you feel colour differently'.

Van Gogh's desire to see his brother was certainly about more than just wanting to share artistic ideas. He had always suffered a certain loneliness, and this trend continued in his new home, where Patience Escalier was one of the few acquaintances he made. A farm-hand employed in the south of Arles, here he looks more like an odd job man or friendly gardener. In other words, what we see here

is significant. Escalier is an individual about whom we speculate spontaneously, rather than one of the social 'types' so predominant in Van Gogh's early Neunen days and epitomised in portraits such as *Woman Digging* (1885). This departure represented a critical break in Van Gogh's attitude towards humanity.

***Woman Digging* (1885)**
Courtesy of The Bridgeman Art Library.
(See p. 42)

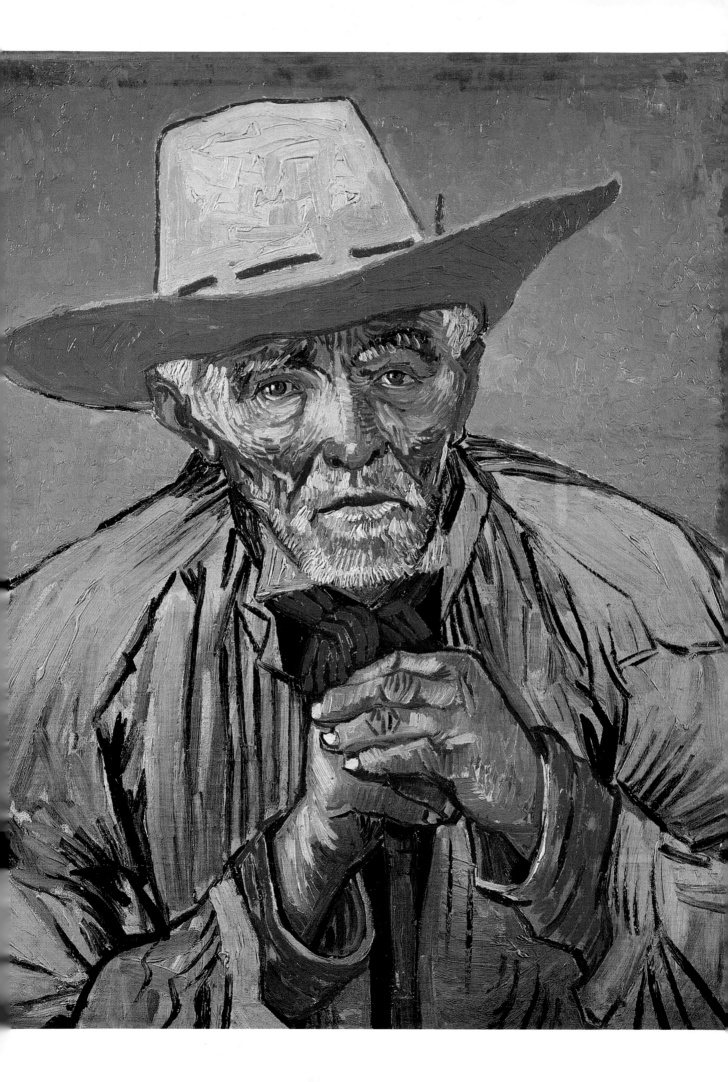

STILL LIFE WITH POTATOES (1888)

Rijksmuseum Kröller-Möller, Otterlo. Courtesy of AKG

*V*AN GOGH'S attitude towards potatoes was formed long before he decided to become an artist. Throughout his time in the Borringe district of Belgium, where he worked and lived with the poorest coal miners, trying to alleviate their hardships through religious instruction, Van Gogh came to regard the humble vegetable in largely symbolic terms. Inextricably linked with poverty, in Van Gogh's mind the potato stood for hard, honest labour. His affinity with those that engaged in such activity was further nurtured, of course, during his early painting career. A famous work that emerged from this period testifies explicitly to his metaphoric use of the motif: *The Potato Eaters* (1885) took as its central theme that of the 'the righteous poor'.

Still Life with Potatoes was painted in Arles in March 1888. Although its peasant subject obviously exerted an enduring power on the artist, its treatment marked a discernible break with the past. The strangely tilted perspective and the light, delicate feel of the painting betray Van Gogh's wider outlook at this time. Here is a work which pays tribute not only to the workers, but to more highbrow concerns: namely the art of Gauguin and the Japanese printmakers.

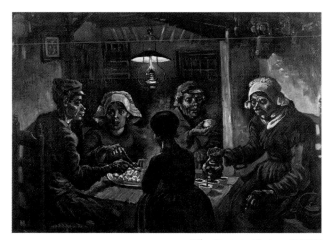

The Potato Eaters (1885)
Courtesy of AKG. (See p. 40)

THE TRINQUETALLE BRIDGE (1888)
Courtesy of Christie's Images

AS with *The Sunflowers* (1888), this picture was painted to decorate Van Gogh's house in Arles. The results pleased him. Despite initial appearances, the image is far from being a 'simple' photographic likeness of the scene it purports to depict. As usual Van Gogh has distorted the visual world to his own artistic end; the purpose of his 'alterations' was of course emotional. As he wrote to Theo: 'If you got the colour exactly right or the drawing exactly right you would not convey those emotions'. But what are 'those emotions'? The wide-angled view and intense blue tones would suggest a certain wistfulness. The rainy scene, with its isolated figures going about their everyday business, is hardly bursting with joy. However, for all its bleakness and sense of urban alienation, this is a townscape which Van Gogh loved. The modern bridge at the heart of it all is painted with as much care and affection as his landscapes or still lifes were. It is also just as dramatic. The exaggerated perspective of the stone steps leading in, and the bridge and road leading out on either side, give the picture a taut, dynamic energy.

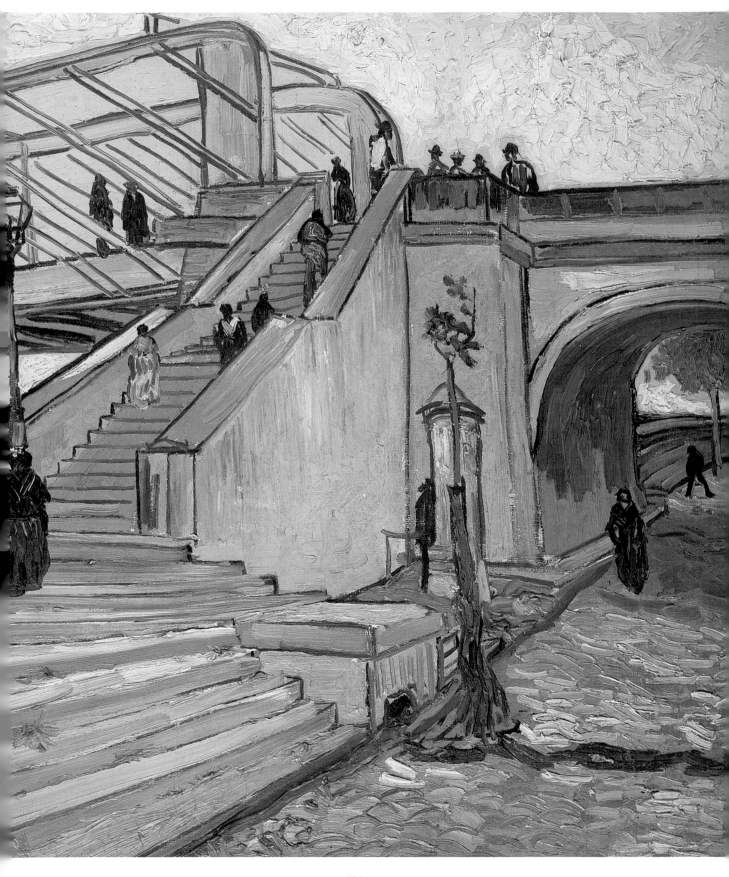

THE LANGLOIS BRIDGE (1888)
Rijksmuseum Kröller-Müller, Otterlo. Courtesy of AKG

*L*IKE his Impressionist predecessors, Van Gogh was fascinated with man's increasing impact on nature during the 19th century. Modern interventions in the natural world were at an unprecedented high when this painting was completed in 1888. Significantly, however, Van Gogh chose a scene whose central technical features – the Arles de Bouc Canal and the Langlois Bridge – had actually been built many decades earlier. Their modernity had

therefore, by the time of his depiction, been severely tempered. They had fused with their surroundings to become almost like organic outcrops. The same could perhaps be said of the riverbank washerwomen, whose busy labour is very much subsumed within the whole image. The entire scene must have appealed to Van Gogh's idea of the picturesque 'Midi', as he painted it four times and made numerous pen drawings.

Stylistically, the painting is something of a mix. Although retaining some Impressionist influences, its blocks of colour and energetic style owe more to the increasing impact of Japanese prints. The bridge itself is particularly redolent of similar structures as painted by the Japanese artist Hokusai 50 or so years earlier.

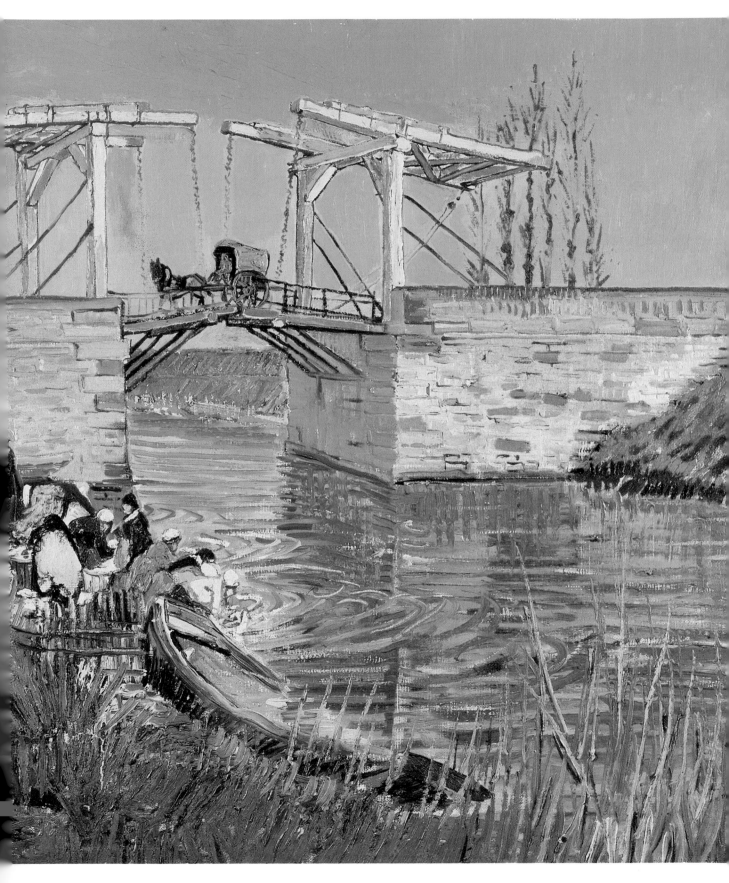

PEACH TREES IN BLOSSOM
(SOUVENIR OF MAUVE) (1888)
Rijksmuseum Kröller-Müller, Otterlo. Courtesy of Artothek

*T*HIS beautiful image was one of the few pictures Van Gogh signed, a clear indication of his satisfaction with the piece. It was painted in March as a response to the death of his cousin, the well-respected Dutch painter Anton Mauve (1838–88). Apart from the short period of time Van Gogh spent studying at the Antwerp Academy of Fine Art and Cormon's studio in Paris, Mauve had been his only teacher, and was therefore someone he came to feel a profound affection for. Van Gogh decided to paint the picture as a gift for Mauve's widow and wrote on it in the bottom left-hand corner: 'Souvenir of Mauve, Vincent and Theo'. His brother's name was subsequently deleted from the canvas, although the reason why Theo would have wished to disassociate himself from such a successful work remains unclear. The recipient was reported to have been very touched by the gift commemorating her late husband.

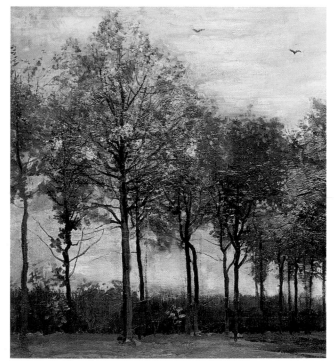

Detail from *Autumn Landscape* (1885)
Courtesy of AKG. *(See p. 44)*

However, Van Gogh's motives were not altogether altruistic; he secretly hoped the painting would be seen by Mauve's close friend, the influential art dealer, Terstoeg. As he confessed to Theo: 'It seems to me [*Souvenir of Mauve*] might really break the ice in Holland'. Nevertheless, there is also little doubt that *Peach Trees in Blossom* was sincerely meant as a heartfelt tribute. He further wrote to Theo: 'Mauve's death was a terrible blow to me. You will see that the rose-coloured peach trees were painted with a certain passion'.

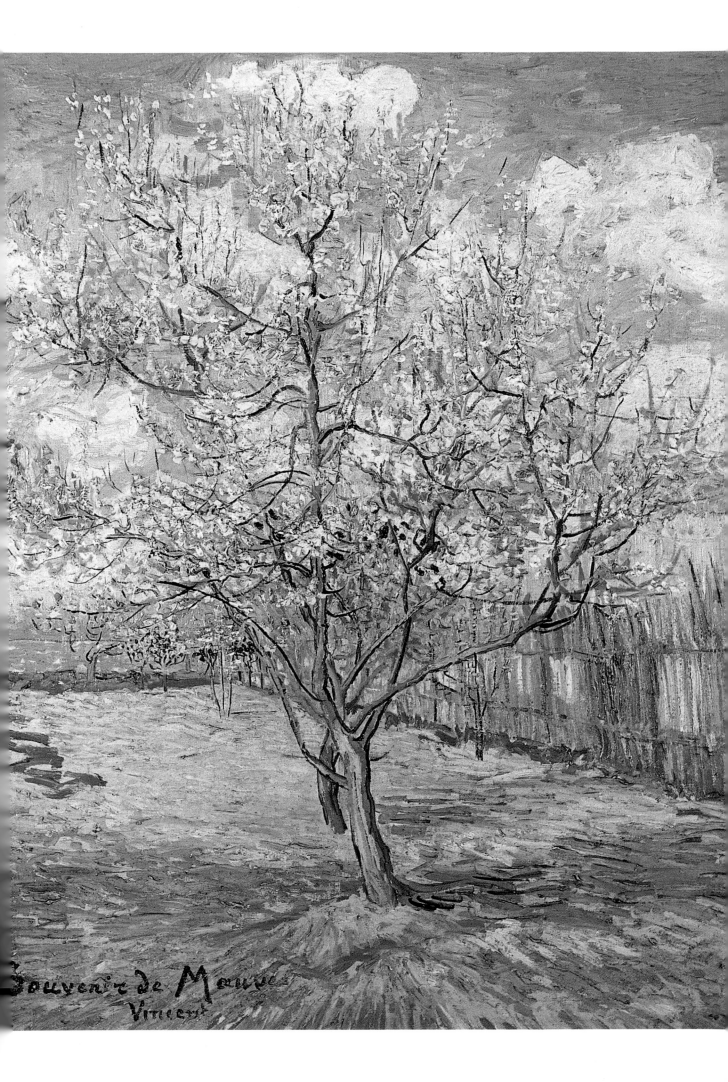

Souvenir de Mauve
Vincent

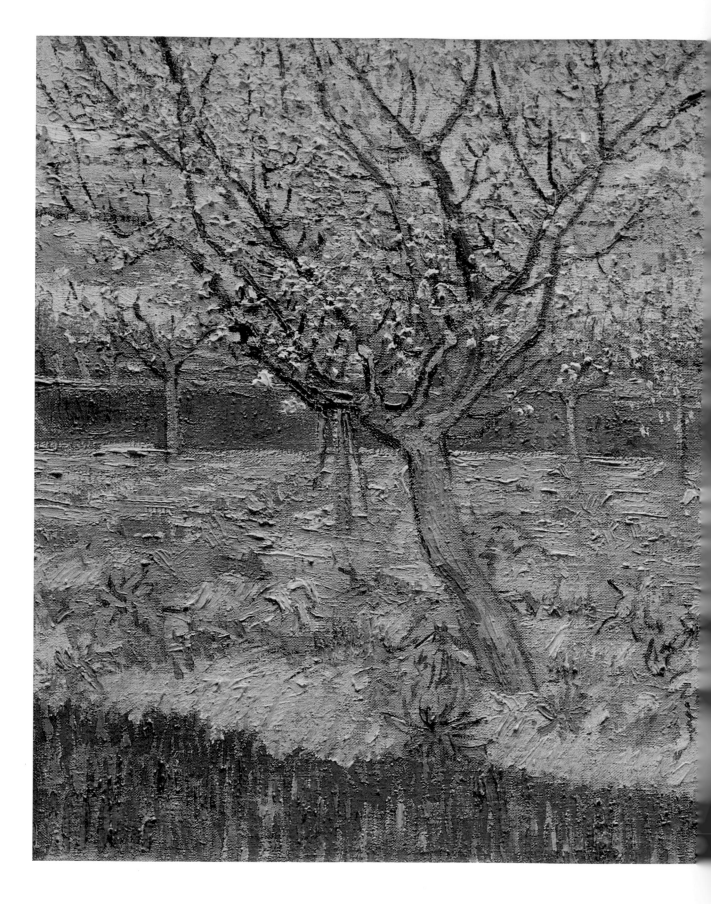

BLOSSOMING FRUIT GARDEN WITH APRICOT TREES (1888)

Private Collection, Switzerland. Courtesy of AKG

WHEN Van Gogh arrived in Provence in 1888, this is exactly the kind of scene he had imagined to find. In its 'limpidity of atmosphere' and 'gay colour effects', he compared his new surroundings to his beloved Japan. The intense colouring also reminded him of paintings by Pierre-Auguste Renoir (1841–1919) and Cézanne. His only reservations were directed at the strong Mistral wind, which regularly blew down the Rhône valley. 'But what compensations, what compensations, when there is a day without wind – what intensity of colour, what pure air, what vibrant serenity'.

This painting is one of a series of 14 orchards in bloom completed in less than a month. Painted shortly after the snows he first encountered at Arles had disappeared, it clearly reflects the rebirth of nature in a new season, as well as Van Gogh's own renewed energy. It is a typically silent and unpeopled scene, which stresses the purity of the natural phenomenon of a blossoming tree. The whole scene has a distinctly oriental feel.

Van Gogh planned to assemble his orchard paintings in groups or triptychs and send them to Theo in Paris. With this in mind, he deployed different formats and sizes of canvas. Measuring only 55 cm x 65 cm (21 in x 25 in), this was the smallest in the series.

L'ARLESIENNE (1888)

Musée d'Orsay, Paris. Courtesy of AKG/Erich Lessing

*T*RANSLATED, 'l'Arlesienne' literally means 'the woman of Arles', which might suggest that Van Gogh's motivation for choosing this subject was a desire to represent another 'type' just as he had done with *Woman Digging* (1885). However, this particular Arlesienne was well-known to him as the wife of café proprietor, Joseph Ginoux, from whom he rented a room. After financial disputes with previous landlords, Van Gogh was wary of being overcharged, but the couple's friendliness soon assuaged any lingering anxieties.

Describing his latest effort to Theo, Van Gogh had this to say: ' ... the background is pale citron, the face grey, the clothes black, black, black of raw Prussian blue. She is leaning upon a green table and seated on an armchair of orange coloured wood'. Van Gogh's preoccupation with colours was not so much a concern over the colours themselves, but rather their inter-relationships as part of a whole. The same sensibility is at work in *Irises in a Vase* (1890). His description, incidentally, could also apply to another version of the picture, which features books instead of an umbrella and gloves. The status of these objects as 'props' could have suggested itself to Van Gogh by a well-known contemporary play, also entitled *L'Arlesienne*. The heroine's beauty and vigour, visible here, were known to be characteristics of '*les Arlesiennes*' and led Van Gogh to remark of a lieutenant friend: 'he is lucky, he has as many Arlesiennes as he wants, but then he cannot paint them, and if he were a painter he would not be able to get them'.

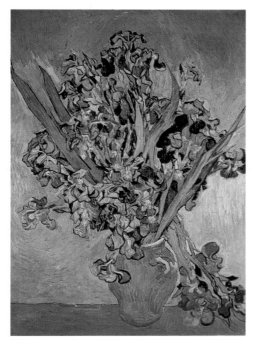

Irises in a Vase (Yellow Background) (1890)
Courtesy of Art Resource. *(See p. 219)*

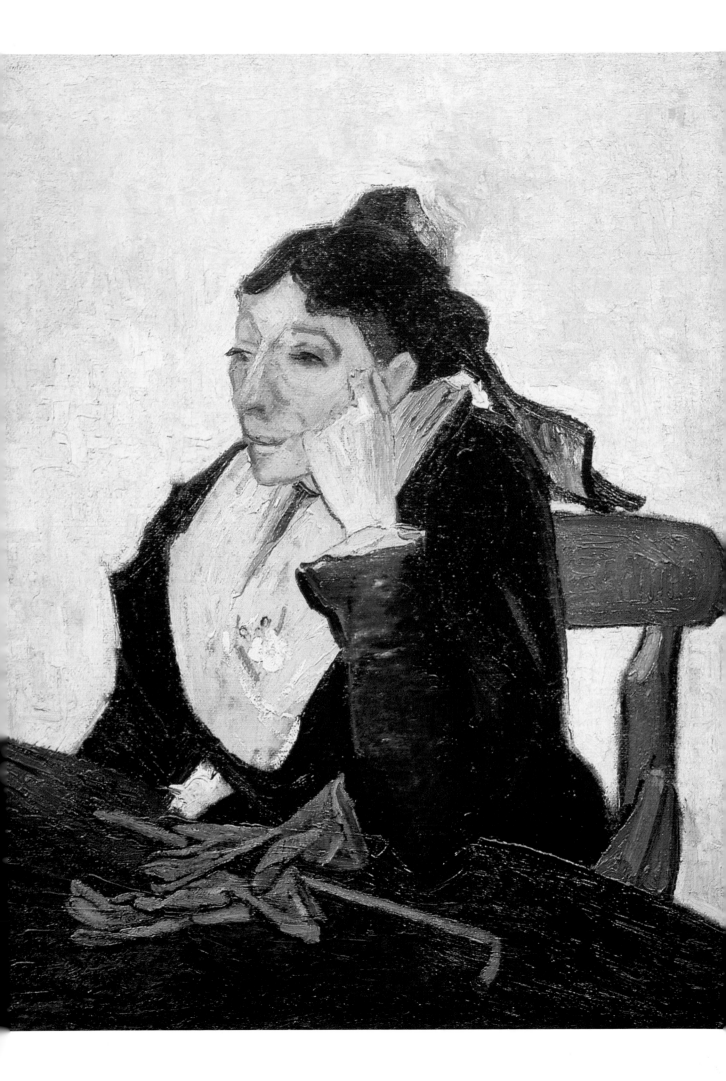

GYPSY CAMP WITH HORSE AND CART (1888)

Galerie du Jeu de Paume, Louvre, Paris. Courtesy of AKG

*T*HIS painting represents the memory of a big trip Van Gogh decided to make at the end of May 1888. Perhaps because of financial constraints, he rarely journeyed outside Arles to see the surrounding environs, but made an exception in this case. Along with thousands of others, he was drawn to Les Saintes-Maries de la Mer, 30 miles from Arles, by a religious festival held there from the 24th to the 25th of May each year. It was on these dates in AD 45 that the small seaside town had been the reputed landing site of Mary Magdalene, her sister Mary Cleopha, and Mary Salome. All three had allegedly come to convert the region to Christianity. Their cult

Souvenir of the Garden at Etten **(1888)**
Courtesy of The Bridgeman Art Library.
(See p. 147)

proved particularly popular amongst local gypsies, and it was a group of these that Van Gogh chose to paint on his return home. This approach was unusual for Van Gogh, who almost always worked from life. However, unlike other exceptions to this rule such as *Souvenir of the Garden at Etten* (1888), the image here does not represent a symbolic dream reality, but rather an actual event, as visibly recollected in the tranquillity of the studio. The subject's socially marginalised status would surely have attracted Van Gogh, whose empathy with such characters can only have been heightened by their itinerant life-styles.

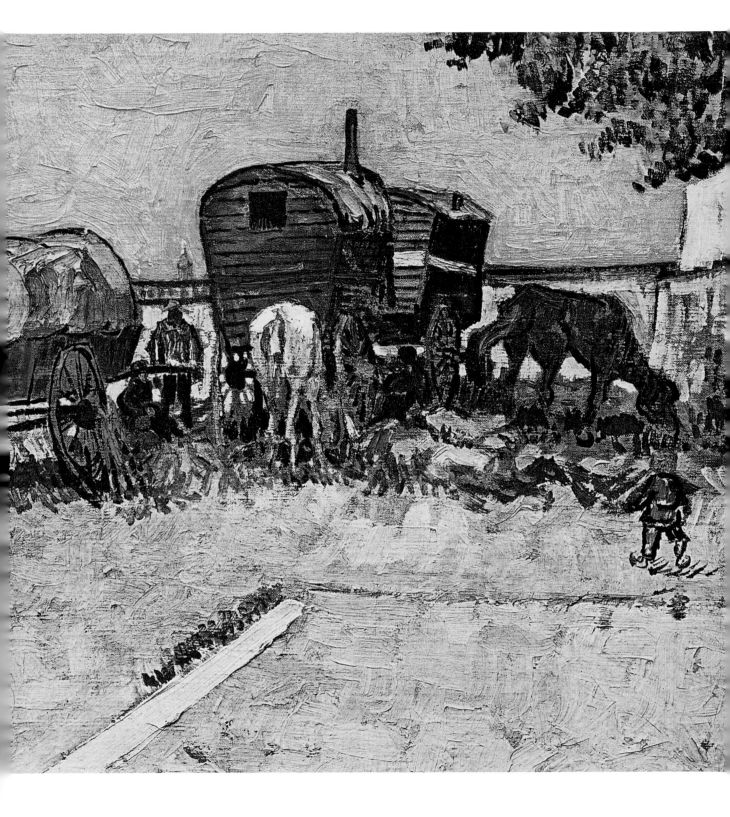

STREET IN SAINTES-MARIES (1888)
Private Collection. Courtesy of AKG

ALTHOUGH Van Gogh only spent four days in Les Saintes-Maries de la Mer, he was clearly much taken with the place, particularly its cottages. As with so many aspects of the French countryside, it reminded him of home. He wrote to Theo: 'And yet what houses ... like those on our heaths and peat bogs of Drenthe ...' The crucial difference though, was the southern light and its consequent effects on his palette. As he wrote from the seaside town: 'I'm absolutely convinced of the importance of staying in the Midi and of positively piling it on, exaggerating the colour'. Judging by the startling evidence here, this is exactly what he did. This image was based on sketches he brought back with him to Arles, and in it colour is completely liberated. It represents Van Gogh's greatest commitment yet to the principal of using colour as a means of expression. His love of complementary contrasts is indulged unashamedly: the reds and greens to the right, the blues and oranges to the left and the yellows and violet in the centre play off each other to create a vibrant effect.

The subject matter of peasant housing may have derived from Van Gogh's past but its treatment is completely different. What was once grounded in gritty realism has now become a dream of vivid brightness and colour.

Turf Huts (1883)
Courtesy of AKG. (See p. 21)

SEASCAPE (1888)

Pushkin Museum, Moscow. Courtesy of AKG

WHILE still in Holland in 1885 Van Gogh wrote 'Sand–sea–sky – I would like so much to express these at some point in my life'. At Les Saintes Maries de la Mer, he at last had the opportunity to do so. He spent only four days at the seaside town in late May, but was sufficiently enamoured to make nine drawings and three paintings of it on his return. Of the paintings, two were seascapes and this is the better of the two. In fact Van Gogh was so pleased with it that he produced three copies in August. At the time of the original, Van Gogh was aspiring to a more assured way of working; the broader strokes, called for in painting the sea, freed him from his previous precision. Added to this, the Mediterranean proved more colourful than he had expected it to be and strengthened his belief that 'colour must be exaggerated even more'. In a letter describing the scene to Theo, he outlined his further surprise that: 'The deep blue sky was flecked with clouds of a blue deeper than the fundamental blue of intense cobalt, and others of a clearer blue, like the blue whiteness of the milky way'.

Indeed, it is the blues of the waves which seem to be the painting's real subject, with the boats relegated to background add-ins. The foreground waves, which have a curious grass-like quality, are painted in a particularly thick impasto that makes them appear to splash off the canvas.

THE SOWER AT SUNSET (1888)
Rijksmuseum Kröller-Müller, Otterlo. Courtesy of AKG/Erich Lessing

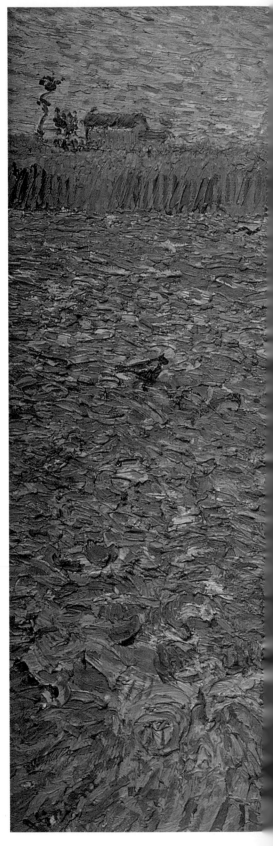

*V*AN GOGH painted several images of the sower, but this particular version was especially significant to him. He began making plans for the picture long in advance of its final execution, and described the completed work to Theo in no less than four letters. It was again inspired by Jean-François Millet's painting of the same scene, finished 30 years earlier. However, whereas Millet always deployed a dark, sombre palette, Van Gogh's use of colour showed that he had also learnt the lessons of Impressionism. Indeed, he conceived this painting as being one that would represent 'a symbolic language through colour alone'. The complementary yellows and violets speak eloquently of a new art and a new age: their resonance is thoroughly modern.

Comparing his efforts to those of his hero, Millet, perhaps it was inevitable that Van Gogh was displeased with the result. As a consequence, he made some changes to the original, among which included toning down the colours and changing the peasant's trousers from their original white to a more integrated blue. He also painted over the trees which had originally appeared to the right of the sun, and moved the sower himself further from the centre. Even these changes, though, didn't satisfy him. He wrote to Theo deriding it as a 'glorified study'.

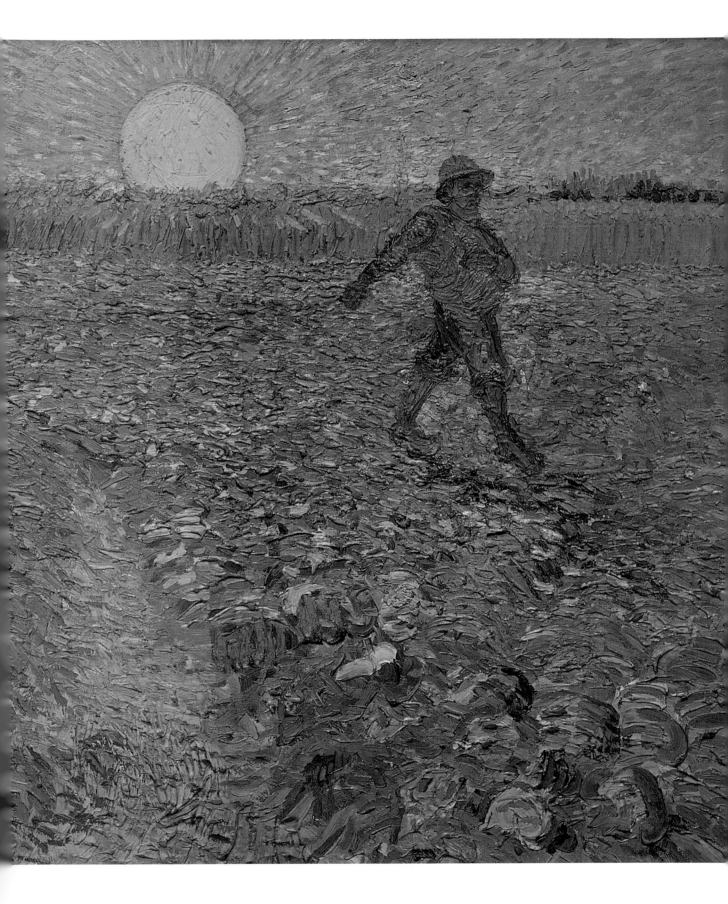

GREEN CORN STALKS (POPPY FIELD) (1888)

Israel Museum, Jerusalem. Courtesy of AKG/Erich Lessing

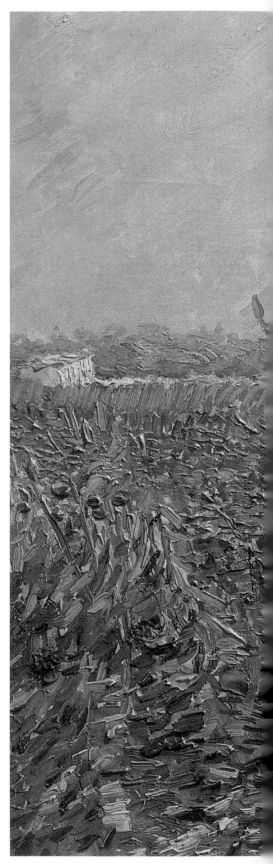

WHEREAS Claude Monet's (1840–1926) famous poppy fields are delicate and light, Van Gogh's treatment of the same subject is stronger, denser and more expressive. The Impressionist's sketchy brushwork is retained to a certain extent, but developed in a more abrupt, almost violent direction and the colours are purer and more intense. Complementary reds and greens play off each other to startling effect. Since leaving Paris, Van Gogh had gained much confidence in his artistic ability. Inspired by such artists as Monet, he resolved to integrate their working practices into his own. One such method was to reject the use of traditional preliminaries, such as sketches and oil studies, in favour of painting *en plein air* directly on to the canvas. This is not to say that his work was entirely spontaneous – calculation and premeditation were always present in the final works – but experimentation was allowed to take place right up to the last brushstroke. Sometimes paint was even applied straight from the tube. This may in fact have been the case here; the impasto technique has certainly been applied in the foreground with some gusto.

CORN FIELD (1888)

P&N de Boer Foundation, Amsterdam. Courtesy of AKG

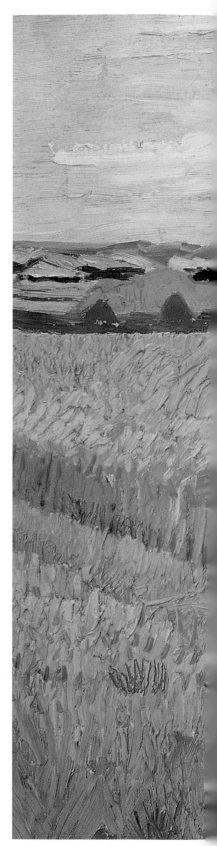

AT first sight this painting looks just like a typical Impressionist scene of rural paradise. It does not take much closer inspection, to realise that an entirely different sensibility is at work. The technique of deploying varying marks according to each element in the composition, rather than the homogenising 'all over' approach of say, Monet, was typical of Van Gogh's Provençal landscapes. The short vertical jabs used to represent grass and corn were also a common feature of this period. However, the most significant break with Impressionism was Van Gogh's attitude to colour; from being an echo, albeit enhanced, of reality, it now took on profound psychological and spiritual meanings.

The colour on which Van Gogh's search for emotional truth converged was of course yellow: it dominates this canvas as it did many others. With a limited range of values, it is a notoriously difficult colour to handle, but Van Gogh rose to the challenge magnificently – 'A sun, a light, which for want of a better word I must call pale sulphur – yellow, pale lemon, gold. How beautiful yellow is'. The gravity of great sunlight effects filled his work. The symbolism that he attached to the colour can only be called religious, but not in the sense of orthodox Christian iconography. The sun, absent yet implicit here, was a dominant force for Van Gogh. It presided over the world like an immense faraway judge. Van Gogh's colours may be rich and exquisite, but they are more than mere expressions of pleasure. They evoke an ever-present moral purpose to life: nature here reflects not only human passions but the will of God.

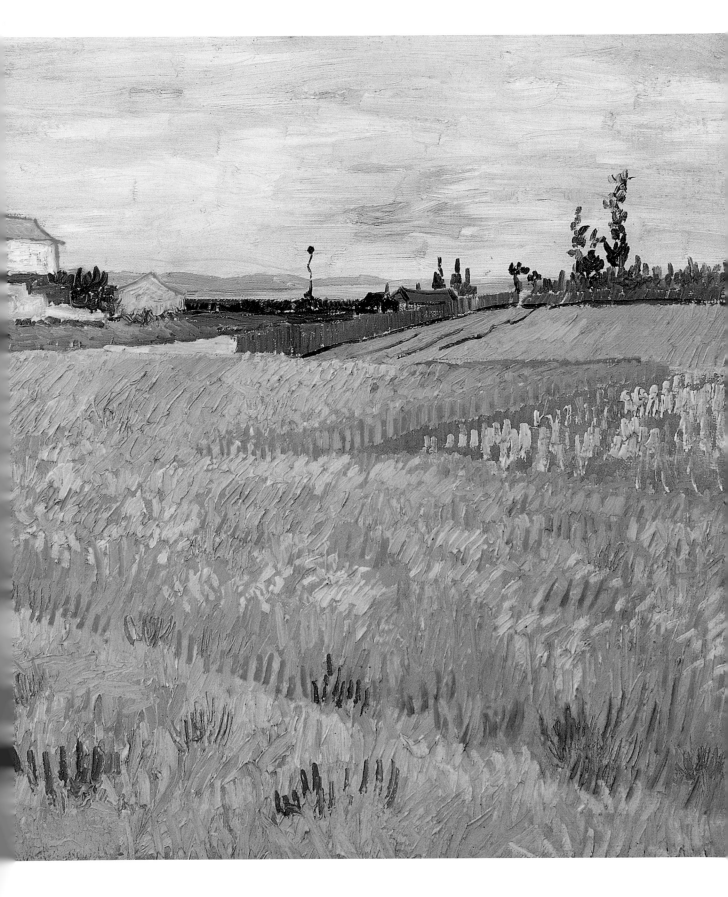

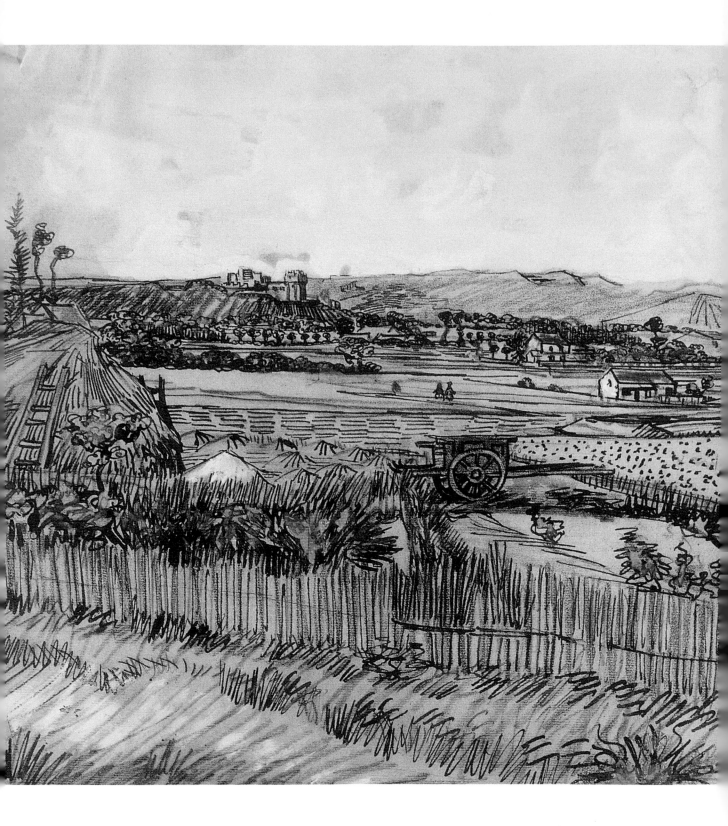

THE HARVEST (1888)

Fogg Art Museum, Cambridge, Massachusetts. Courtesy of AKG

CONTINUING the landscape theme, Van Gogh turned his attention to the harvest, which was just beginning around Arles, and spent two weeks devotedly committing this motif to canvas and paper. This is only one in a series of scenes of wonderful, delicate drawings he completed of this view made famous in the painting of the same name. The decision to draw it was not an accident, and Van Gogh wrote of his intentions to Theo a few weeks earlier: 'What I would like to do is the panorama ... [which] has such breadth and then it doesn't change into grey, it remains green to the last line – that of the last line of the hills'.

Although Van Gogh subsequently executed the view in paint, he drew the scene initially mainly because pencils were cheaper than oils. His economies were for Gauguin's benefit. He confirmed: 'I think it is right to work especially at drawing just now, and to arrange to have paints and canvases in reserve for when Gauguin comes'. Indeed, after completing this sketch, Van Gogh received the long-awaited confirmation from Theo that Gauguin had at last agreed to come to Arles (although he did not arrive until September or October). So desperate was Van Gogh that Gauguin should not change his mind, that he completed more of these drawings in order that Theo might sell them and subsidise Gauguin's train ticket. In this particular drawing, every variation of line has been employed to stunning effect in order to render justly the various textures of the Arlesienne countryside.

THE HARVEST (1888)

The Van Gogh Museum, Amsterdam. Courtesy of Topham

HAVING completed an almost identical version of this scene in his detailed drawing of *The Harvest* (1888), Van Gogh felt confident enough to finish this painting in one long sitting. He was sufficiently pleased with the end result to give it a French title – *La Moisson* – a rarity for Van Gogh, most of whose work has been titled by subsequent dealers, critics and art historians. At the time he considered the image to be such a success that he even wanted to show it at the annual Indépendants Exhibition in Paris. Comparing it with his other work up to this point, Van Gogh's praise was unusually emphatic. He wrote to Theo: 'The [...] canvas absolutely diminishes all the rest'.

Previously in Holland, Van Gogh had been unable to attempt such panoramas, partly due to a certain technical immaturity, but mainly for straightforward topographical reasons. Quite simply Holland was too flat. The Provençal countryside, compared to its Dutch equivalent, was the source of a far greater variety of cultivation and associated agricultural activities; many feature here. It is not hard to see why Van Gogh was so happy with his efforts. It is a truly stunning view, a landscape of unprecedented clarity and a rich evocation of an area in France that he came to love.

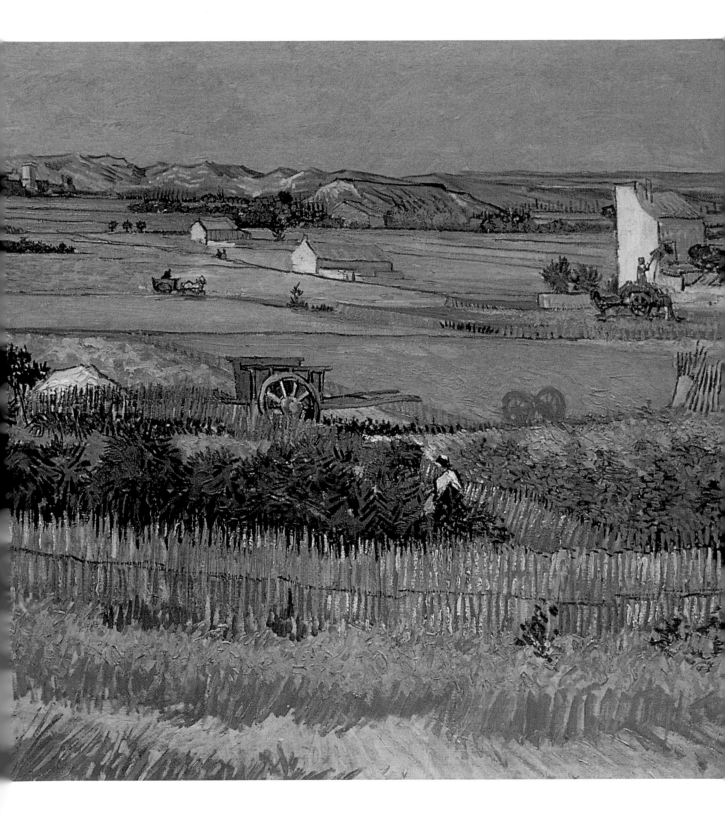

HARVEST IN PROVENCE (1888)

Jerusalem Museum, Israel. Courtesy of AKG/Erich Lessing

DURING his time in Arles, Van Gogh's long apprenticeship and period of stylistic experimentation came to an end. He had always felt naturally drawn to peasant subjects, but in the south of France his canvases became larger and his already fast pace of work increased considerably. Indeed, Van Gogh himself explained to Theo that the paint flowed as naturally from his brush as sentences from his lips. At times he felt he was incapable of distinguishing between good work and bad, and hardly felt in control of his movements. This was not, as has been suggested, because he was mad – this is hardly the work of someone who is mentally unstable – but it is more likely to have been a result of working many hours on end in wheat fields such as this under the blazing Provençal sun.

This is one of the canvases executed under such conditions. It was painted quickly and instinctively, but quite purposefully. The subject was chosen beforehand and he wrote to Theo that he had hit a 'high yellow note' in the summer of 1888. Although it would be puerile to suggest Van Gogh had an absolute 'favourite colour', yellow was the one that dominated his palette in Arles.

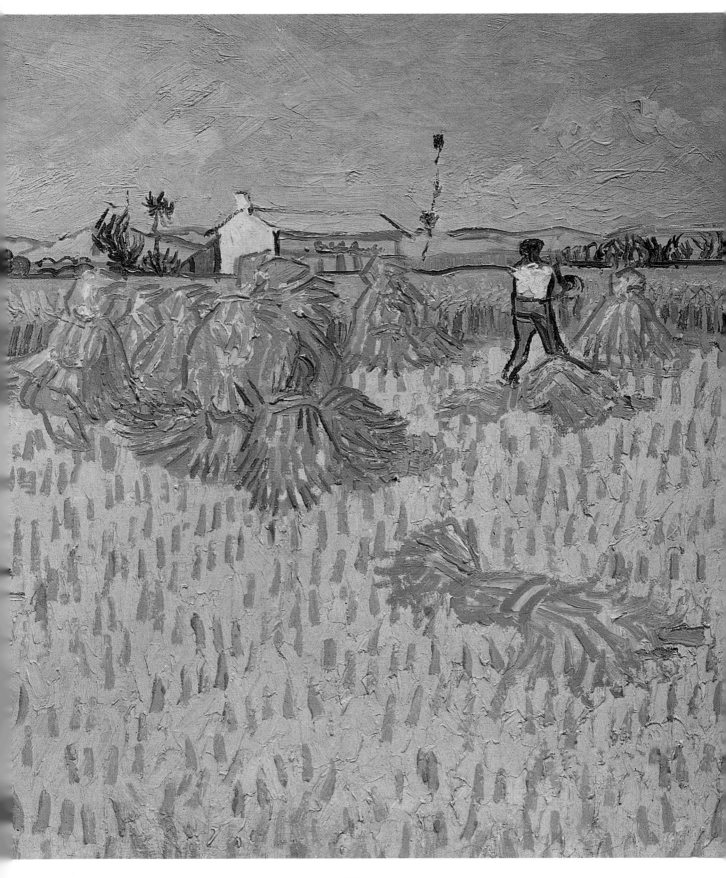

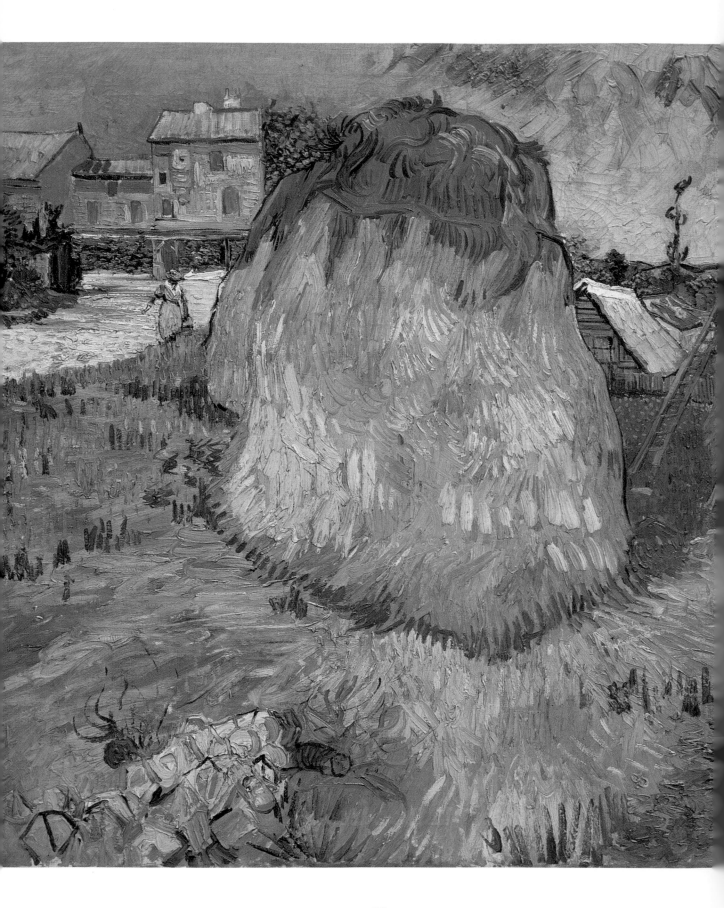

HAYSTACKS IN PROVENCE (1888)

Rijksmuseum Kröller-Müller, Otterlo. Courtesy of AKG/Erich Lessing

HAYSTACKS have been a ubiquitous feature of the French countryside since the days it was first cultivated. Their representation in art, though, was never so common as during the 19th century. Most famously, perhaps, Monet chose them as a perfect device for revealing the protean effects of light throughout any given day. Later, Symbolists like Gauguin used them to stand in for things outside physical reality: representations of the 'Idea'. Van Gogh was attracted to both these artists, and so his haystacks draw in many ways from their approaches to the subject. This image, for example, while being emphatically rooted in reality, concerns itself with more than mere verisimilitude. It also is about an idea: namely Van Gogh's belief that interacting with nature necessarily aroused strong religious feelings in the viewer. Although his father was a pastor, Van Gogh did not actually belong to any organised religion at this time in his life. Instead, he developed his own brand of pantheism (the doctrine that God is the transcendent reality, of which man, nature and the natural universe are manifestations) with a wry twist. As he once admitted to Theo: 'I feel more and more that we cannot judge of God from this world; it's just a study that didn't come off'.

Van Gogh's criteria for whether his own paintings had 'come off' also had religious parallels. To be successful, they had to soothe and console, like music, or, indeed, religion. The warm familiarity imparted by this painting does just that.

129

FLOWER GARDEN (1888)

Courtesy of Christie's Images

IN AUGUST 1888 Van Gogh wrote to his brother: 'I have just sent off three large drawings ... the little cottage garden done vertically is, I think, the best'. Indeed, Van Gogh's pleasure with *Flower Garden* was such that he signed it in the bottom left hand corner. This was a relatively rare sign of his satisfaction with any given work.

Drawn using a quill and reed pen in brown and black ink on paper, it is an image whose medium is exploited to the full. Van Gogh's efforts to economise during the summer of 1888 found him engaged in drawing more than ever before in France. As a result, he had more time to experiment with the different marks and strokes made by a pen as opposed to a brush. Here, as in *The Harvest* (1888), we can see the fruit of his various efforts; the drawing style is recognisably Van Gogh's own. In this drawing, however, Van Gogh has taken his decorative technique one step further to cover the sky with a multitude of dots. Some have interpreted those dots as an attempt to depict the heat of a Provençal summer. Others point to Van Gogh's outside influences, notably those

of Pointillism and Japanese prints. He himself considered the style to be rather severe, for reasons he explained to Theo: 'If the drawings I send you are too hard, it is because I have done [it] in such a way as to be able ... to use it as a guide for painting'. This scene of a flower garden, a genre made famous by the Impressionists, was indeed painted by Van Gogh a short while later.

Detail from *The Harvest* (1888)
Courtesy of AKG. (See p. 123)

THE TREE (1888)

Christie's, New York. Courtesy of AKG

*T*HIS canvas is unusual for having been painted during a period of relative happiness and optimism in Van Gogh's life. Earlier his uncle had died and bequeathed a large amount of money to Theo, who in turn shared it with his brother. The unexpected new funds meant that Van Gogh was now able to refurbish the Yellow House and finally invite Gauguin to stay with him there. He was determined that his dream to create a community of artists in Arles could now finally be realised.

Van Gogh admired Japan because he felt its people had reached a perfect unity of art and life; art and beauty were integral to their lives. This somewhat romantic view of the Japanese perhaps spoke more about his own artistic goals than actuality. As he said to Theo: 'I envy the Japanese the extreme clearness which everything has in their work. It is never wearisome, and never seems to be done too hurriedly'. This picture is a perfect example of the simple, unhurried style that Van Gogh aimed to achieve. By placing the tree in the middle of the composition and using a restricted palette, he evokes Japanese art, as well as the fast developing phenomenon of photography, in which cut off images were a wonderful novelty.

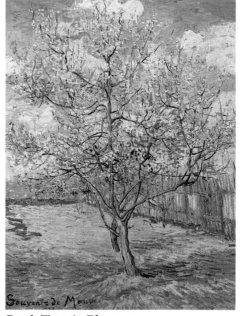

Peach Trees in Blossom (Souvenir of Mauve) (1888)
Courtesy of Artothek. (See p. 104)

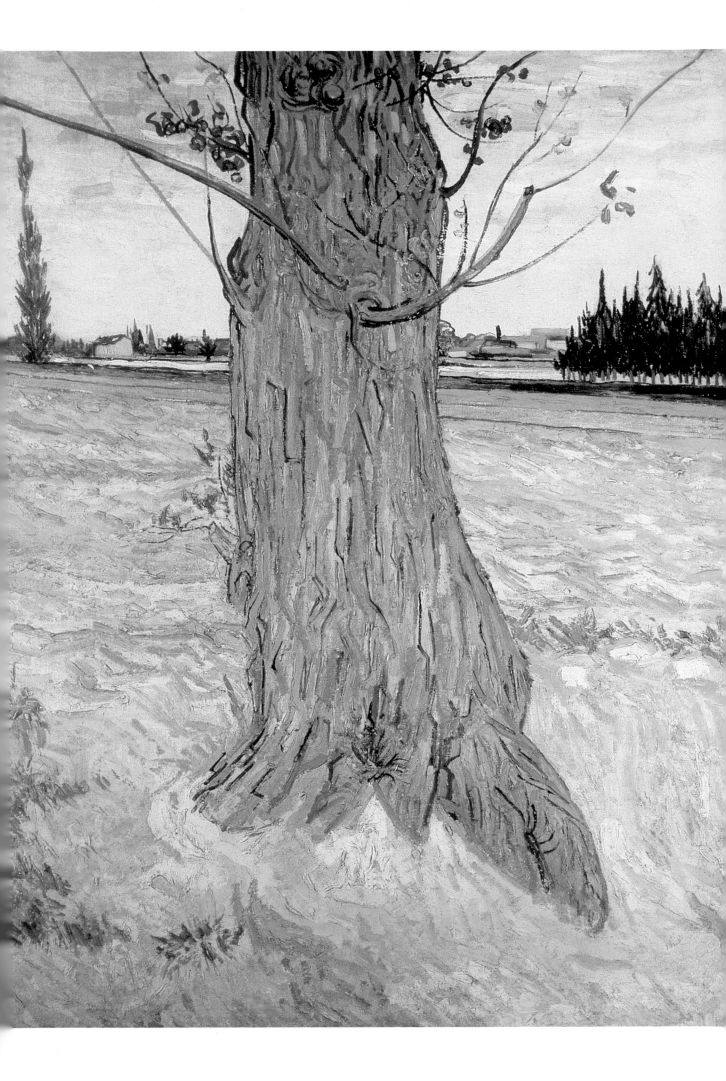

THE SOWER (1888)
Winterthur, Sammlung. Courtesy of AKG

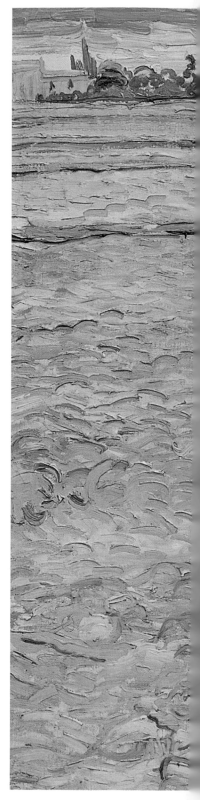

*V*AN GOGH painted a series of sowers, originally inspired by Jean-François Millet's famous picture from 1850. The theme's religious and symbolic connotations appealed to both artists, whose romantic persuasions meant they saw in their subject something profoundly mystical. Van Gogh first chose to draw a sower in the Hague six years previously, so the subsequent versions painted in France may have served to remind him of his homeland. As ever, however, they all spoke more of an imagined reality than anything else.

This is perhaps the least experimental of the 'sower' pictures – the others feature an intensity of colour, strong black outlines and a fantasy-type countryside that this one lacks. More typical is his application of the 'golden rule', whereby the figure is placed more or less in the top third of the composition – a device that attracts our eye to him as the picture's obvious focal point, and enlivens an otherwise plain landscape. The boy's stance is identical to the previous picture, but this time Van Gogh has not made any self-conscious attempt to imbue the image with the dream-like qualities that emerge after Gauguin's arrival.

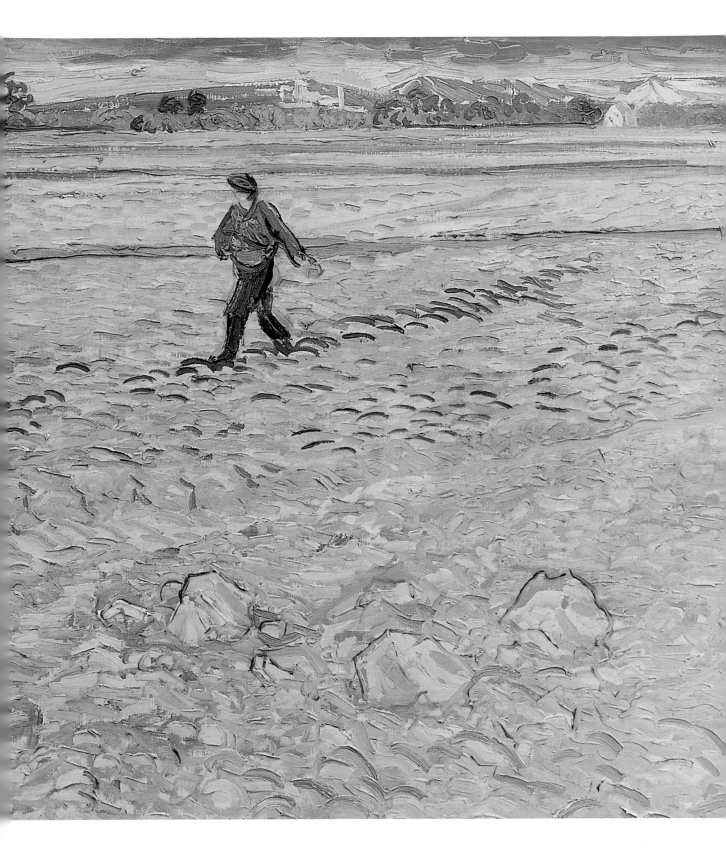

THE RED VINEYARD (1888)
Pushkin Museum, Moscow. Courtesy of AKG

*P*AINTED in the autumn of 1888, *The Red Vineyard* depicts an event that took place annually around this time of year: the grape harvest, or 'vendage'. As a northern European, unfamiliar with such rituals, Van Gogh had certain preconceptions of what they were like. It is these ideas and opinions, formed beforehand in Holland, that manifest themselves in this idyllic scene. Also significant, as always with work of this period, was the influence of the Japanese prints he had admired in the exhibition halls of Paris. Van Gogh convinced himself that southern France would closely resemble the Eastern landscapes he had seen in the capital. In actuality it more than lived up to his expectations.

These grape harvesters were people Van Gogh felt he could relate to by the fact they were working with nature and its rhythms and not against it. Accordingly the picture has a romanticised 'Japoniserie' about it. 'If we study Japanese art,' Van Gogh noted, 'we see a man who is undoubtedly wise, philosophic and intelligent, who spends his time doing what? In studying the distance between the earth and the moon? No. In studying Bismark's policy? No. He studies a single blade of grass'. Indeed, this obsessive concern with minutiae of the natural world at the expense of science and politics is significant. There is no sign here of aching backs or tired and weary faces, prematurely aged by years of exploitation and drudgery. Instead Van Gogh's harvesters are bathed in the warm and sentimental glow of late afternoon sunshine.

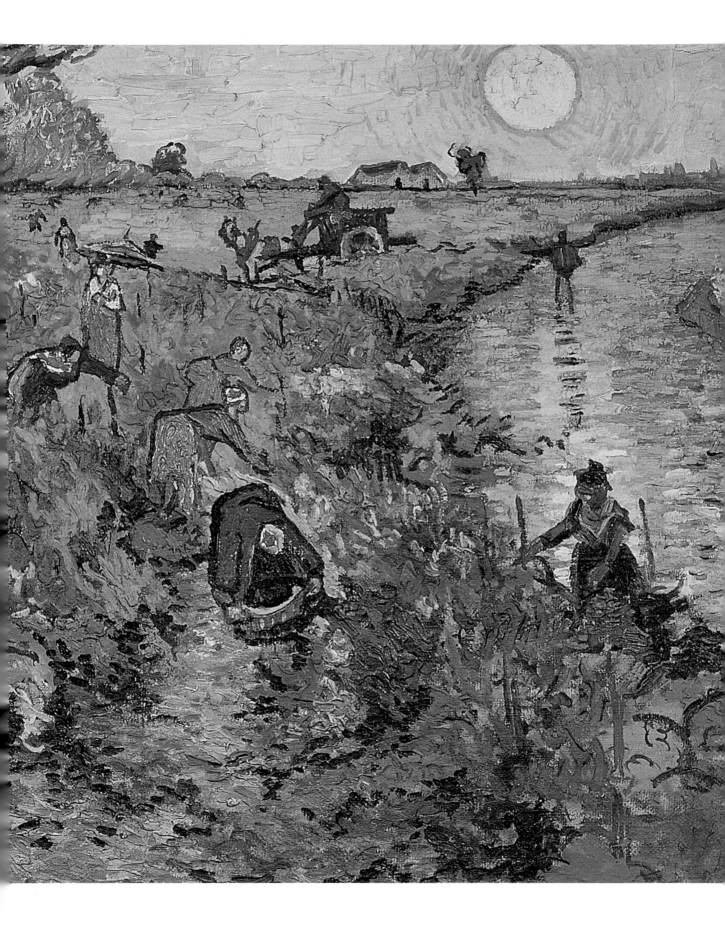

THE SUNFLOWERS (1888)

Neue Pinakothek, Munich. Courtesy of AKG

*P*AINTED after a period of relative loneliness, *The Sunflowers* expresses the radiant warmth and joy felt by a man whose melancholia had been magnificently banished. The person responsible for lightening Van Gogh's mood so radically was his fellow artist, Gauguin. Their decision to move into Van Gogh's Yellow House in Arles during the summer of 1888 saw Van Gogh embark upon a series of four sunflower paintings, of which this is the most famous. All were intended to decorate Gauguin's bedroom, but only two were eventually deemed worthy of Van Gogh's signature.

To many, *The Sunflowers* represents 'the greatest still life in the history of art' – more real even than real flowers. Their 'light on light' technique, in which multiple shades of yellow magically enhance one

another, were to Van Gogh the embodiment of happiness. The whole composition is alive, bold and furiously animated. What we are confronted with is not an 'artistic frenzy' though, but controlled vitality.

However, life does not always imitate art, and shortly after completing *The Sunflowers*, the control Van Gogh exerted in his painting was found lacking in his personal relationship with Gauguin and the two men found it increasingly difficult to agree on how their art should progress.

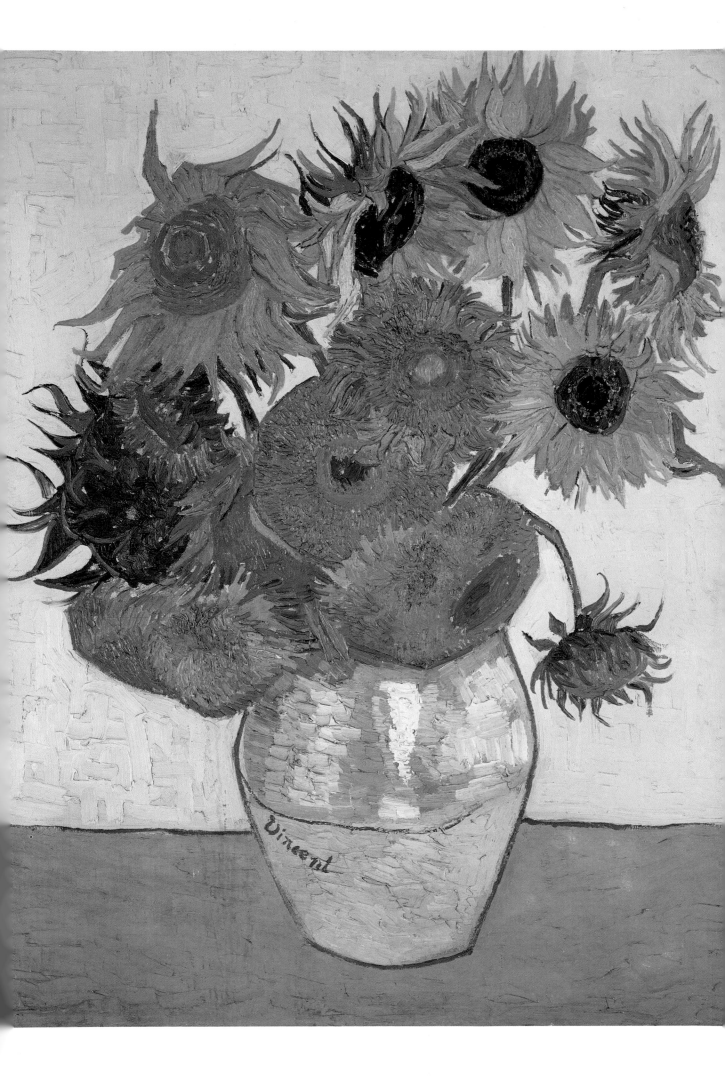

PORTRAIT OF THE ARTIST'S MOTHER (1888)
Courtesy of Christie's Images

ALTHOUGH Van Gogh kept in regular contact with his family, sending them copious letters as well as copies of his best work, he only saw them very rarely. Travel in those days was a time-consuming and costly affair, hence he only ever painted one portrait of a family member – this one of his mother – and even then did not do it from life. 'I am working on a portrait of mother,' he explained in a letter to Theo, 'because the black and white photograph annoys me so'. Van Gogh lived, then, in interesting times. At once deceptively old fashioned – trains were prohibitively expensive and cars barely existed – he also inhabited a world where another recent invention, the camera, had been democratised at a much faster rate and, by 1888, had influenced artists significantly. The Impressionist device of cutting off images, for example, was in direct imitation of the snap-shot and was deployed by Van Gogh in paintings such as *The Tree* (1888).

Here, however, Van Gogh seems to have simply used the photo as a straightforward 'aide-memoir'. The two types of image – the photograph and the painting – are remarkably similar, with one crucial exception. In the photo his mother appears stiff and matriarchal, whereas in the painting she is more animated, with relaxed and warmer features. Van Gogh may well have been representing his mother as he wished to remember her, rather than as she actually was. His

relationship with both his parents when they all lived together in Neunen was not a good one. He once wrote to Theo about them that: 'They are as reluctant to let me into the house as they would be to let in a big shaggy dog'. The camera may never lie, but paint certainly does.

The Tree **(1888)**
Courtesy of AKG. (See p. 132)

THE POET'S GARDEN (PUBLIC GARDEN WITH COUPLE AND BLUE FIR TREE) (1888)

Private Collection. Courtesy of AKG

ALONG with *The Sunflowers* (1888), Van Gogh created this image to decorate Gauguin's room. It is the third in a series of four paintings, all entitled *The Poet's Garden*, based on the public gardens near the Place Lamartine in Arles. For the first time since arriving in Arles, green dominated Van Gogh's palette. The move was quite deliberate. After completing paintings of wheat fields in July, he made this future intention quite clear to Theo: 'Perhaps I will look for green now,' he said. Various critics have described the picture as 'pleasant' and 'unpretentious', which seems about right. The composition is rather interesting, featuring the device of a triangular path that naturally draws our eye to the distant figures who are framed by trees and foliage. Broad, loose brushstrokes are used economically to portray light and shadow, but also lend the scene a relaxed, carefree air. Van Gogh referred to the couple as 'lovers', although their black clothes and faceless anonymity mean that the idyll in which they casually stroll is also tinged with a certain melancholy.

THE POET'S GARDEN (THE PUBLIC PARK AT ARLES) (1888)

Private Collection. Courtesy of AKG

THIS is another of the scenes titled *The Poet's Garden* which were intended to decorate Gauguin's room in the Yellow House. In many ways they represented an attempt by Van Gogh to stamp his own personality on the house before his friend arrived. For all his desires to live communally, he was not quite prepared or willing to give everything up. As he confessed to Theo beforehand: '[Gauguin's] coming will influence my way of painting, I believe to the good, but I am nevertheless rather attached to the way I decorate my house ... ' It was a gift, therefore, with a double edge. By placing the picture in Gauguin's room, he tried to retain a sense of his own identity, despite claiming that this was precisely what he wanted to efface by opening himself up to new influence.

The actual place depicted in this painting was rather romanticised by Van Gogh, who said 'Isn't it true there is not something curious about this garden, cannot one imagine the Renaissance poets Danté, Petrarch and Boccaccio walking amongst the bushes ...?' Van Gogh hoped his representation would prove similarly evocative to Gauguin, although in reality the park was inhabited by the typically Mediterranean old men who sat around on benches. Their presence here, along with the approaching woman dressed in dark clothing, speaks more of 19th-century France than 16th-century Tuscany.

SOUVENIR OF THE GARDEN AT ETTEN (1888)

The Hermitage, St Petersburg. Courtesy of The Bridgeman Art Library

GAUGUIN stayed with Van Gogh in Arles from October to December 1888. During that time the artist's healthy rivalry flourished, but it was probably Van Gogh who benefited most from their competitive spirit. The theories that Gaugin taught him about working from memory were applied to a number of works of this period, but never more explicitly so than here. As he explained to his sister, Willemena: 'The garden is not how it appeared in reality, but as it might look in a dream'. In many ways none of Van Gogh's paintings were realistic representations of the visible world – they were always mediated through religious, cultural or emotional experience – but with *Souvenir of the Garden at Etten,* any pretence at realism was openly denied. The inventing, manipulating and stylising of his images, which went on throughout his career, was now freely admitted. A good example of the way in which Van Gogh distorted reality, before, during and after his brief Symbolist phase, was his outlining of shapes. The effect it achieves is to flatten the enclosed objects so that they become schematic components of an abstract whole. The blue shawl, green cypresses and yellow path in the picture's foreground serve to take the viewer further into the fictionally imagined space, but visually they remain on the same surface plain.

Despite the qualified success of this technique, Van Gogh felt uncomfortable with it, and the resulting differences in artistic approaches between himself and Gauguin ultimately led to his mental breakdown.

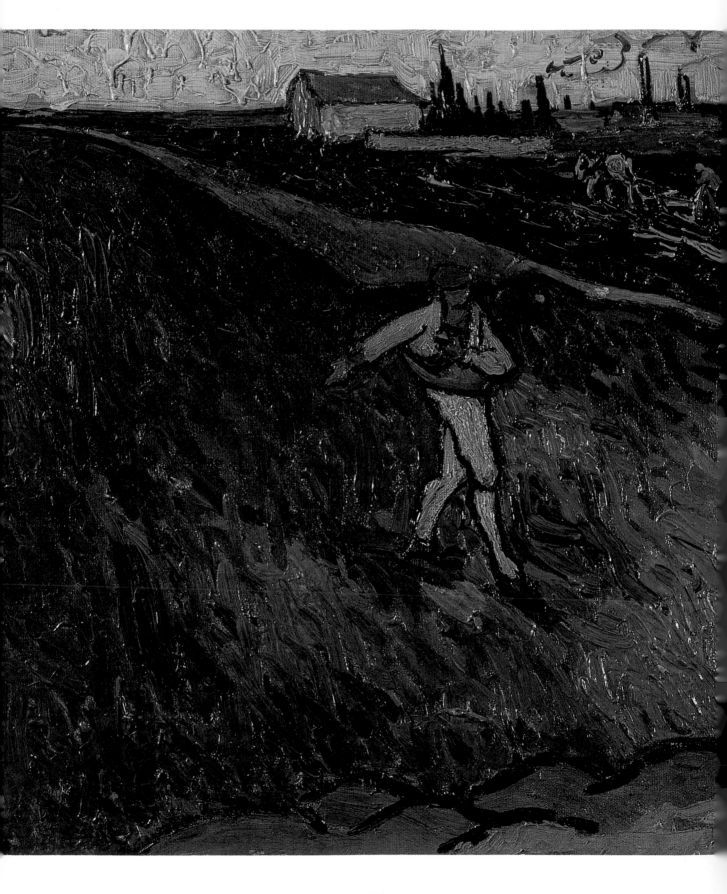

THE SOWER (1888)
Courtesy of AKG

PAINTED shortly after *Souvenir of the Garden at Etten* (1888), *The Sower* was also an image recollected from the past. We know this for a fact because it was executed in November or December – many months away from the sowing season. Van Gogh's source of inspiration – dreams – was also a further parallel with the earlier Dutch scene; he once elaborated, 'I have a terrible lucidity at moments ... when nature is so glorious in those days I am barely conscious of myself and the picture comes to me like in a dream'. Both paintings certainly have a distinctively dream like quality about them. Their solid abstract shapes, surrounded by strong black outlines, seem to represent an almost fantasy world, an effect heightened by the use of strong colour. Indeed, like many north Europeans, Van Gogh's vision of the south was a fantastic one. Involving a notion of the area being permanently colourful and vital and, above all, exotic, it spoke as much about his own origins as his new home. Even

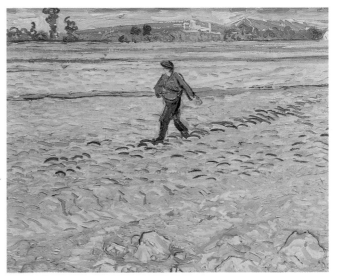

***The Sower* (1888)**
Courtesy of AKG. (See p. 134)

though he came from the countryside himself, Van Gogh invariably failed to see the grim reality of rural life for what it was. Instead, the sower always inhabits an environment that is warm and reassuring. It is significant that the one thing that rarely features in Van Gogh's landscapes is snow.

DANCE HALL AT ARLES (1888)

Musée d'Orsay, Paris. Courtesy of AKG/Erich Lessing

*I*N early 1888 Paul Gauguin and Emile Bernard had established an avant-garde community in the village of Pont-Aven in Brittany. The new style of painting that emerged from their joint venture was to have a profound influence on Van Gogh, especially when Gauguin came to Arles later that year. Although the images of Breton women that all three artists created featured the same subject popular with Salon painters, their technique was radically different. Taking their cues from Japanese prints and medieval art, the 'Cloissonists' – as the Pont-Aven group came to be known – rejected traditional composition in favour of achieving unity through colour and style alone.

Van Gogh's *Dance Hall at Arles* demonstrates this synthesis perfectly. Its simplified forms and elimination of detail were hallmarks of the new school, as was the systematic use of complementary colours. The red and green balcony in the distance, the blue and orange crowds at the back, and the yellow and violet of the foreground figures are all drawn from imagination, as mediated through colour theory. The purpose they serve is to make each colour resonate with an intensity that simply could not be achieved if they stood alone.

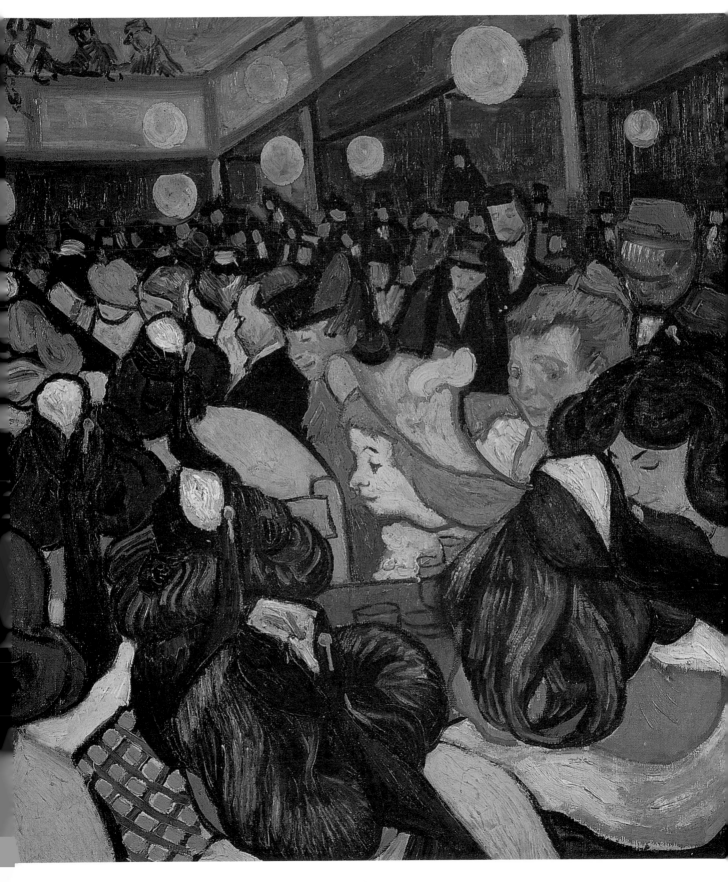

LES ALYSCAMPS (1888)

Courtesy of Christie's Images

*L*ES ALYSCAMPS was a famous ancient burial ground dating back to Roman times. All that remained of it when Van Gogh went to Arles was what is shown here: a wide avenue lined on either side by rows of poplars and ancient sarcophagi. Van Gogh painted this scene four times as part of a series featuring the different seasons. Before completing these he wrote to Theo explaining that he had already represented spring, seen in works such as *Peach Trees in Blossom (Souvenir of Mauve)* (1888) and summer, portrayed in paintings like *Haystacks in Provence* (1888), and now wanted to paint the other times of the year.

Almost symmetrical in format, Van Gogh has animated the composition by making one side distinctly darker than the other. Nevertheless, one is still struck by the central position we find ourselves in, with everything receding to a blurred green focal point of distant foliage. Even the sky forms a shape that points in that direction. As usual, however, the illusion of pictorial space is contradicted by the painting's flatness. Again the sky is significant: rather than being painted as something airy and ethereal which theoretically continues to exist behind the trees, here it appears as a triangular block of colour in its own right. The paint is layered thickly and steadily in the manner of Gaugin, whose influence was already visible in Souvenir of the Garden at Etten (1888). Gaugin's Symbolist ideas could also have affected Van Gogh's choice of subject matter in this picture – the sarcophagi are ripe with morbid symbolist potential.

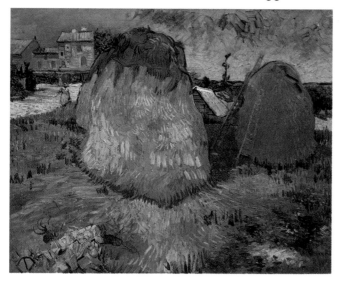

Haystacks in Provence (1888)
Courtesy of AKG/Erich Lessing.
(See p. 129)

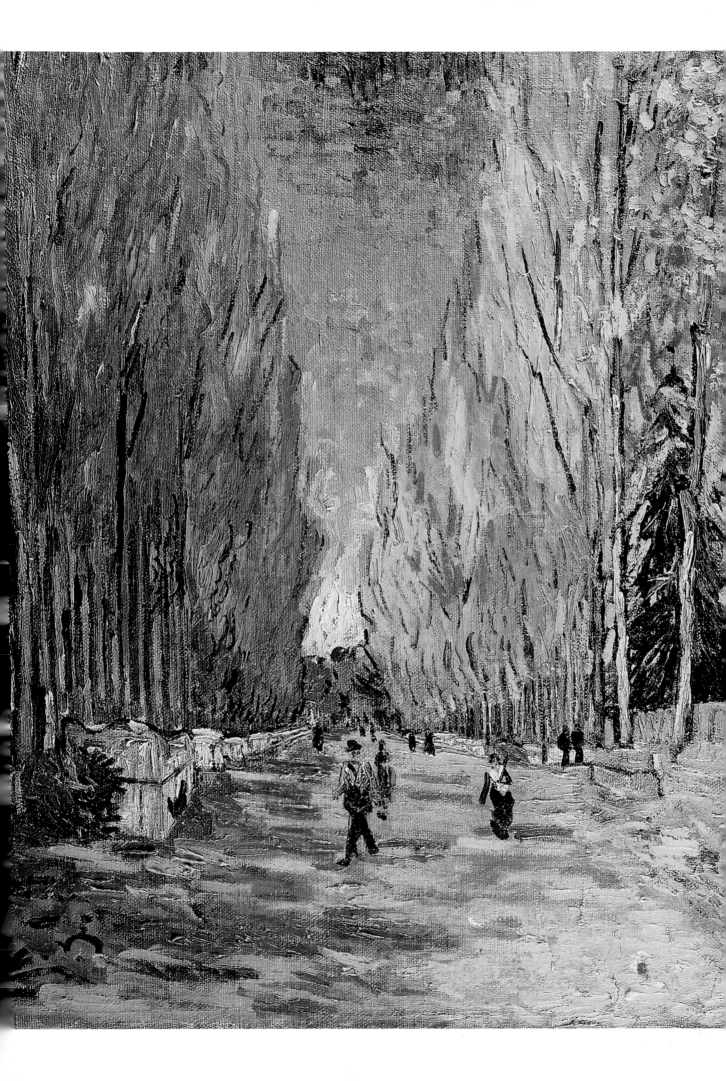

ARENA AT ARLES (1888)
The Hermitage, St Petersburg. Courtesy of AKG

*V*AN GOGH'S preoccupation with his health, and that of others, was a constant theme in his letters to Theo. 'My God!', he speculated in one, 'will we ever see a generation of artists with healthy bodies? … the ideal would be a constitution tough enough to live till eighty'. Van Gogh's own constitution of course was anything but tough; his tragic demise may have been self-inflicted, but when he died he was a far from healthy man. His prolific output was achieved very much in spite of his poor physical and mental condition.

Arena at Arles is a painting that features all the energy and vigour that Van Gogh was so obsessed with. Its ostensible theme of the bull-fight constituted a new and exciting cultural event to the Dutch artist, and one which he was immediately keen to represent. 'The arenas are a fine sight when there's sunshine and a crowd', he enthused to Theo. Indeed, it is these last two aspects of the spectacle that appear to have fascinated Van Gogh; the bull-ring itself barely appears in the top right hand corner. Unlike Picasso, painting only a few years later, the drama of 'la corrida' was to be found not in its bloody action, centre stage, but among the lively, thronging crowds.

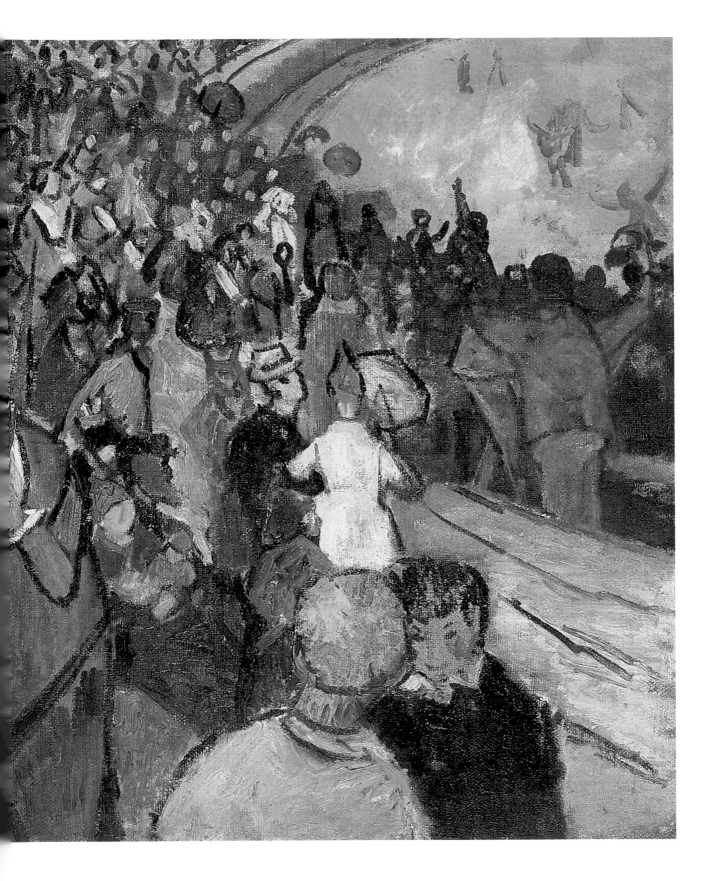

WILLOWS AT SUNSET (1888)
Rijksmuseum Kröller-Müller, Otterlo. Courtesy of AKG

DESPITE its superficial appearance of wild abandon, this is a painting whose composition and colour scheme were arranged far from spontaneously. Three distinct horizontal colour bands emerge as a stabilising overall design, which is then dominated by a splurge of complementary blues, yellows and oranges. The visual impact of the whole is quite striking and owes much to Gauguin. His notions of the painting as an autonomous object, entirely separate from its subject, was taken up by his friend with some enthusiasm but not completely embraced.

For all Van Gogh's insistence on his bold, free flowing marks being independent entities from their equivalents in the natural world, they still remain strongly rooted in reality. The three loosely rendered willow trees, for example, may emphasise their primary status as paint applied directly to canvas, but their progressively diminishing sizes contradicts this assertion of flatness with the palpable suggestion of receding perspective. It is precisely this dynamic contradiction, which also epitomised Van Gogh's and Gauguin's relationship, that lends the image such tension and energy.

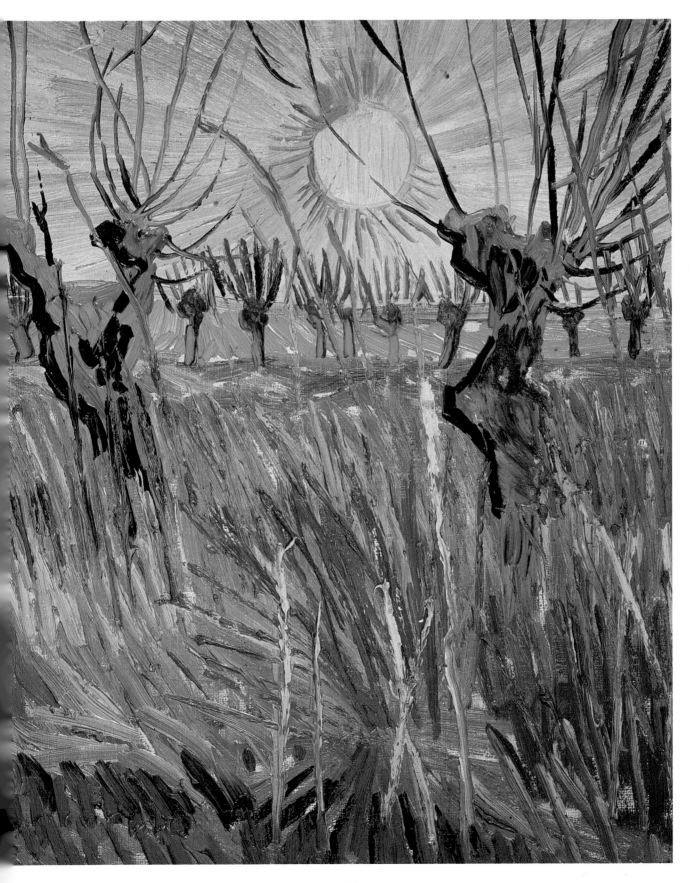

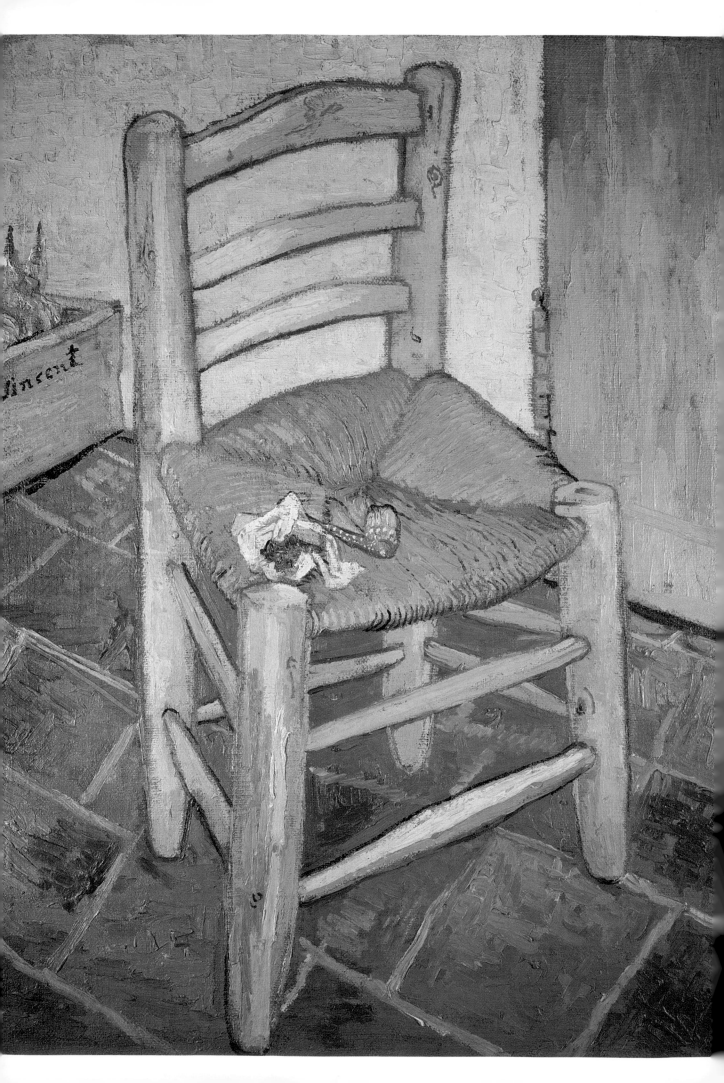

VINCENT'S CHAIR (1888)

National Gallery, London. Courtesy of AKG/Erich Lessing

EMPTY chairs had a very personal significance for Van Gogh, who appears to have associated objects strongly with people. Legend has it that the young Van Gogh cried out at the sight of an empty chair vacated earlier by his father who had been visiting him at the Hague. This image of his own empty chair resounds with a similarly plaintive call.

Gauguin's arrival in Arles a few months earlier had heralded an initial period of calm and joy in both men's lives. However, tensions soon surfaced. More at home in the city, Gauguin found Arles rather dull and ordinary. Furthermore, Van Gogh wanted more companionship than Gauguin could realistically offer and, as a consequence, he became worried that his friend would leave the Yellow House. This eventuality was made more likely by Van Gogh's notorious temperament. His violent mood swings and Gauguin's rampant egoism meant clashes became inevitable. Added to this heady brew, they also began to

disagree about art. Van Gogh expressed his fears about the possibility of Gauguin's imminent departure in two famous paintings, of which this is one. The steep perspective of this painting throws us violently into the picture, creating a disorientating dynamic. The other painting, featuring Gauguin's chair, is equally fraught with tension.

Detail from *Peasant Woman at Fireside* (1885)
Courtesy of AKG/Erich Lessing. (See p. 36)

GAUGUIN'S CHAIR (1888)

The Van Gogh Museum, Amsterdam. Courtesy of Artothek

WHAT began as a harmonious artistic collaboration between Gauguin and Van Gogh ended in acrimony and bloodshed. The experiment in shared living was paid for by Van Gogh's brother, who perhaps hoped the two men would inspire each other to great things. Ultimately, their brief union in Arles did not prove particularly successful but was more productive for future work. This canvas reveals Van Gogh's approach to painting as much more instinctive, emotional and sentimental than his companion's. Whereas Gauguin went in for synthetic compositions, largely dredged from memory and with predominantly symbolic, multi-layered meanings, Van Gogh preferred to work principally from nature and only then infuse his images with subjective content. His preference for simpler, self-contained iconic motifs is epitomised here.

Vincent's Chair (1888)
Courtesy of AKG/Erich Lessing.
(See p. 159)

A pendant piece to *Vincent's Chair* (1888), each work operates as a metaphor of their respective owners, seen of course through Van Gogh's eyes. Comparing the two is like comparing the artists themselves. *Gauguin's Chair* is everything his friend's is not: painted at night, the interior the painting depicts is significantly lit up by both gaslight and candlelight – like twin sparks of inspiration. The two books symbolise what Van Gogh believed to be the intellectual nature of Gauguin's endeavours. The floor, while equally unrealistic and distorted, is brash and gaudy next to the simple stone slabs in *Vincent's Chair*. The colours here are richer and more saturated. Both chairs are alive, like strange creatures, but this one seems more menacing, dangerous and malevolent.

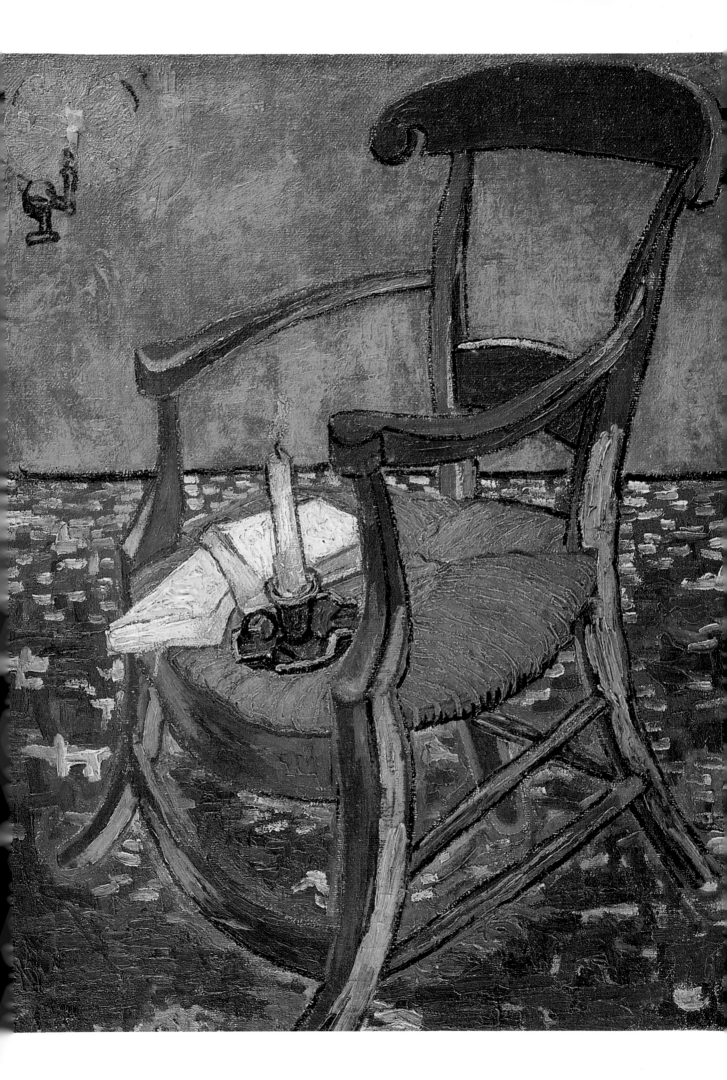

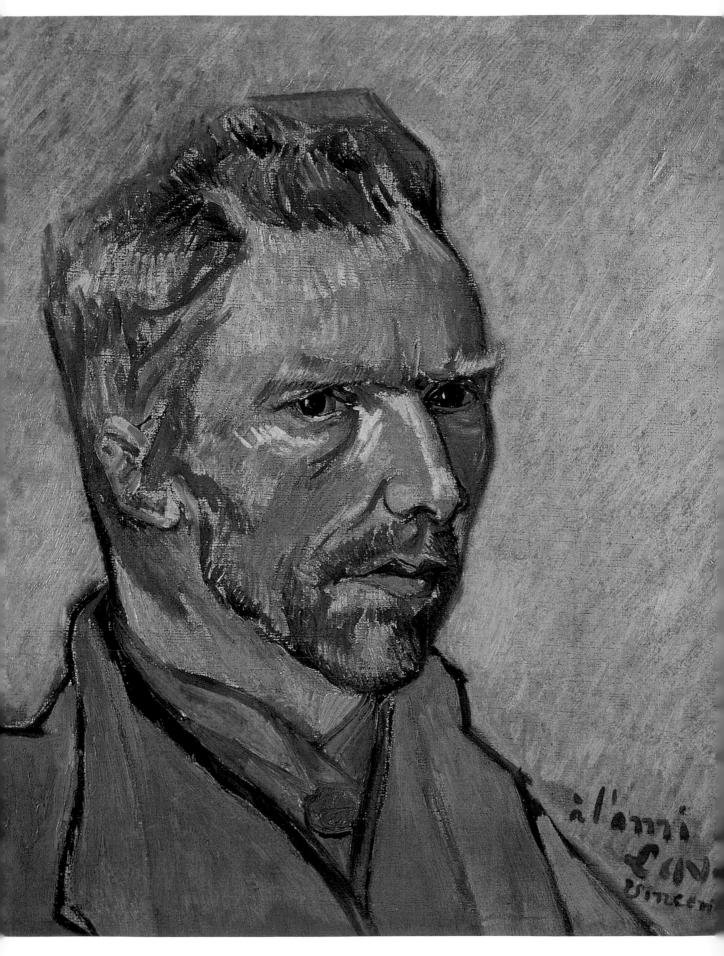

SELF-PORTRAIT (1888)

Metropolitan Museum of Art, New York. Courtesy of AKG

*V*AN Gogh's many self-portraits serve as valuable indicators of his ever-changing artistic and psychological development. With a paucity of photographs documenting his time as an artist, they also provide us with interesting, if less reliable, evidence of his physical appearance. An acquaintance of Van Gogh once described him as 'a rather weedy little man, with pinched features, red hair and beard, and light blue eyes'. The portrait featured here seems to bear this visual summary out as an accurate one, while revealing more about Van Gogh's emotional condition than his physical looks.

Painted around the time of his crisis with Gauguin, it is a disturbed and disturbing work. The sitter's glower has more than a hint of menace about it. The bright, citrus colours are concomitantly bitter; like visual equivalents of his pensive frown, they are strained and unsettling. Inviting 'tormented artist' clichés, everything seems to emphasise his oppressive sense of isolation and inner turmoil: we can imagine him turning the conflicts with Gauguin over in his mind and never resolving them. By this time, the incompatibility of the two men

was clear and Van Gogh was beginning to lose confidence in his own work. Paradoxically, it was this sense of self-doubt that spurred him on to create powerful works such as this.

Self-Portrait with Dark Felt Hat (1886)
Courtesy of AKG. *(See p. 62)*

SELF-PORTRAIT WITH BANDAGED EAR (1889)
Private Collection, Paris. Courtesy of AKG

*I*N December 1888, Van Gogh chopped off a part of his ear and presented it to a prostitute called Rachel, so the story goes. *Self-Portrait with Bandaged Ear* depicts the aftermath of these events, but provides us with few clues to their motivation. Rumours surrounding the notorious incident abound, but surprisingly all that is known for sure is that it was triggered by a conflict with Gauguin. Some have proposed that illnesses such as schizophrenia, epilepsy or even alcoholism were to blame. Certainly his neighbours considered Van

Gogh a dangerous man and, on his returning to the Yellow House from hospital just two weeks later, they signed a petition to the mayor expressing their displeasure at his reappearance.

Similar to *Self-Portrait with Bandaged Ear and Pipe* (1889), this painting, unlike the other, gives a real sense of personal catastrophe. Still in dressed in winter coat and fur hat, this self-portrait includes an easel in the background. Van Gogh seems to be relating his suffering to his art. 'Look what art did to me', he appears to be saying. Alternatively, the theory goes, the easel reaffirms his continuing commitment to his art despite his recent breakdown. The Japanese prints in the background remain an important influence for the artist who here has a vulnerable yet steady gaze. He seems to be looking but not seeing, deep in contemplation of his own anguish.

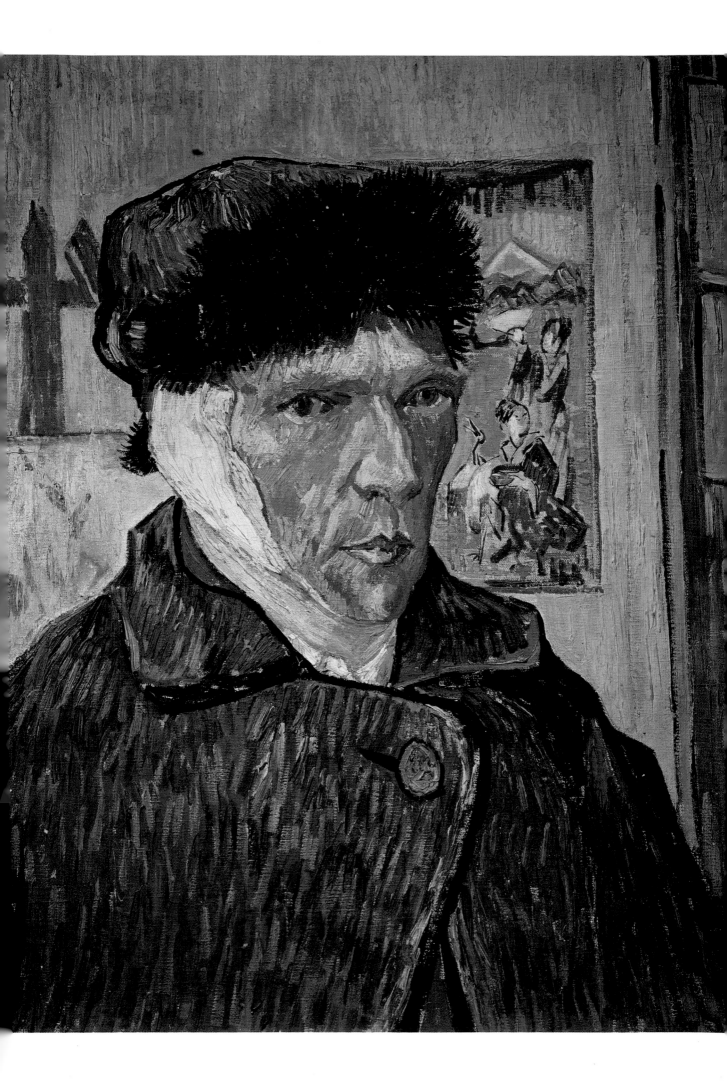

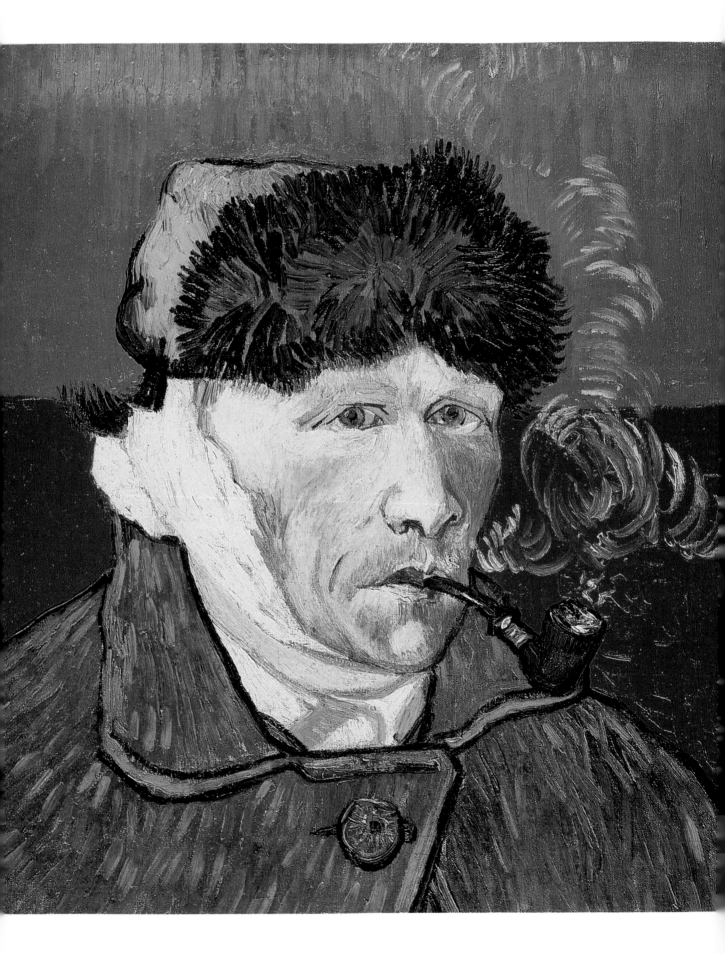

SELF-PORTRAIT WITH BANDAGED EAR AND PIPE (1889)
Private Collection, Chicago. Courtesy of AKG

*T*HIS is the second self-portrait that Van Gogh painted of himself with a bandaged ear, and arguably the better one. From a technical point of view, at least, it is quite stunning. The use of bold, complementary colours is particularly impressive. Here it involves placing two similar colours – red and orange – on top of each other behind his head, and contrasting them with, respectively, his green greatcoat below and two-toned blue hat above the dividing line. By playing down the split in the background colour – where they join the orange is much more saturated than higher up – and creating another sub-contrast between the blues of his unusual looking headgear, Van Gogh breaks up what might otherwise be too apparent a colouristic device. In theory the tactic is an obvious one, but in practice the effect is rather subtle. The two halves of the picture are further united by the wispy, smoke emitting from Van Gogh's pipe.

Interestingly, the portrait is a mirror image of its sitter. It was actually his left ear that he mutilated, but here the bandage appears on his right. Van Gogh's gaze is again steady, yet it is infinitely sad, as if contemplating his rash actions in the cold light of day.

***Self-Portrait with Bandaged Ear* (1889)**
Courtesy of AKG. (See p. 164)

ROULIN THE POSTMAN (1889)

Rijksmuseum Kröller-Müller, Otterlo. Courtesy of AKG/Erich Lessing

WITH a paucity of potential models during this period, Van Gogh increasingly turned for his subject-matter to the landscape. However, when a model was found that did appeal to him, he jumped at the chance of immortalising them in oils. Originally he met, or discovered, the postman Joseph-Etienne Roulin at the Café de la Gare in Arles, where he was renting a room. Roulin's easy-going demeanour, Republican convictions (like those of Père Tanguy) and lifestyle of heavy drinking (like the artist Monticelli in Paris) all appealed to Van Gogh. Furthermore, he also came to consider Roulin as something of a father figure, whose wisdom he compared to that of Socrates. Van Gogh painted him many times but in all his portraits, whether only of his head or featuring the whole man, his profession remains clear; Roulin may have had the mind of a philosopher, but his blue uniform with yellow buttons always showed his actual vocation to be somewhat less elevated.

This portrait was painted after Van Gogh was allowed out of hospital and may well have been executed as a token of friendship between the two men: Roulin stood loyally by when others began to regard Van Gogh as a dangerous menace. This painting differs from the other portraits of the postman mainly in its densely decorated background. Van Gogh's desire to fill the whole canvas with an overall design style can also be seen in works such as *Portrait of Dr Rey* (1889).

Portrait of Dr Rey (1889)
Courtesy of AKG. (See p. 170)

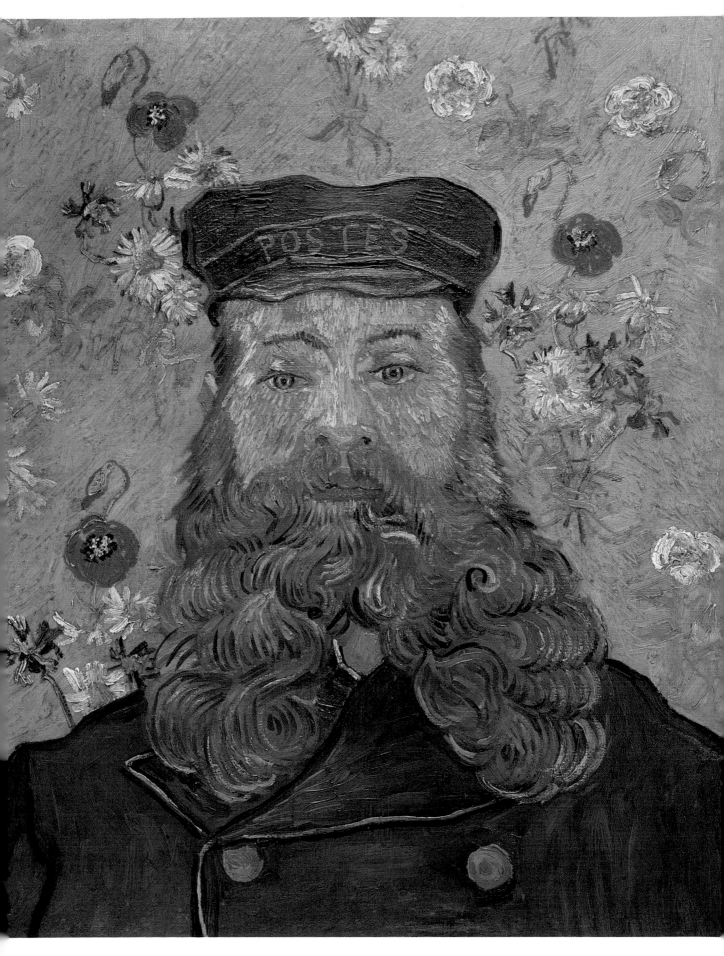

PORTRAIT OF DR REY (1889)
Pushkin Museum, Moscow. Courtesy of AKG

DR FELIX REY treated Van Gogh in hospital after his 'trifle' – in the artist's words – caused him to be admitted there in December 1888. Van Gogh's friend, Roulin the postman, persuaded Dr Rey in January 1889 that the patient was sufficiently recovered to let him leave hospital. The doctor was a sympathetic and liberal type who did just that. In a letter to Theo, he empathised with the anguish Vincent's sibling must have been enduring: 'I shall always be glad to send you tidings [of Van Gogh], for I too have a brother, I too have been separated from my family'.

This portrait, along with only a few others such as *La Berceuse* (1889), was unusual for its use of a decorative background. The polka-dotted, curlicue wallpaper that frame the sitter's head is reminiscent of Matisse's large, all-over patterned screens painted two decades later. The image is also comparable to Van Gogh's own canvases of subsequent weeks. The swirling forms that resonate throughout this picture were soon to appear in the skies and trees of his landscapes.

It was a mark of the respect and high regard Van Gogh had for Dr Rey that he presented this portrait to him as a gift. However, the picture proved too modern for the doctor's taste. The 'new' fashion for colour distortion, to convey what one felt rather than saw, proved a bewildering concept. The story goes that the confused doctor eventually used the picture to cover a hole in his chicken coop, where it was discovered years later when Van Gogh had become famous.

Detail from *La Berceuse* (1889)
Courtesy of The Bridgeman Art Library.
(See p. 196)

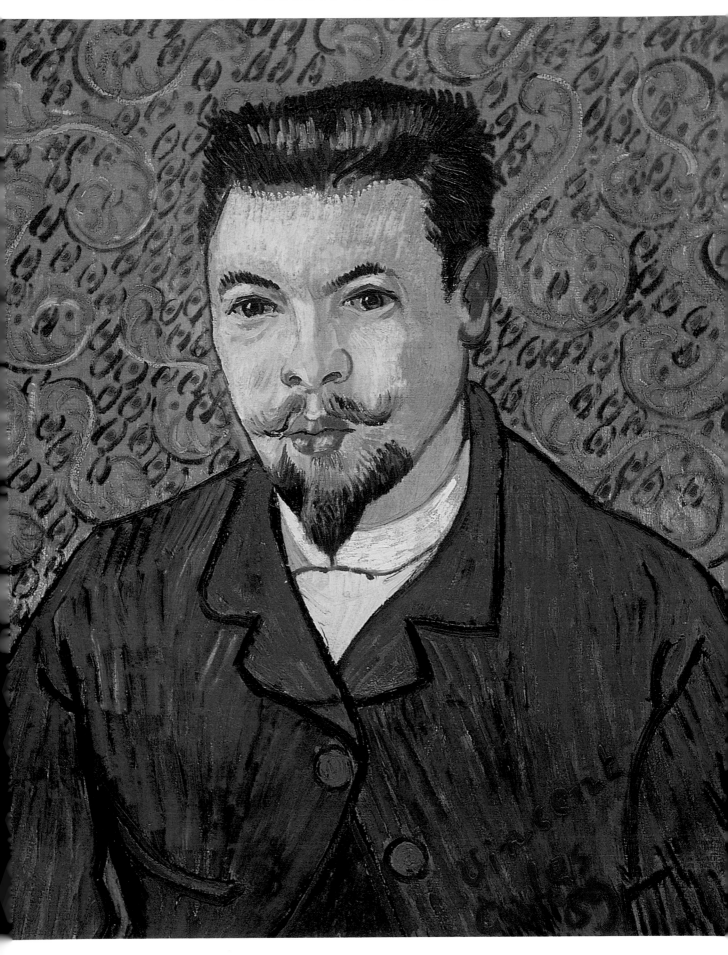

ORCHARD IN BLOSSOM WITH VIEW OF ARLES (1889)

Neue Pinakothek, Munich. Courtesy of AKG

*I*N the four months between coming out of hospital in Arles and entering the asylum at St Rémy, Van Gogh enjoyed a period of great lucidity. This painting reveals the exact extent of his powers at that time; its precise composition and technical skill are an eloquent testament to his enduring sanity. He himself wrote: 'I am not actually mentally ill. You will see that the pictures I painted in the period between any two attacks are calm and no worse than others I have done'.

For all its serenity, however, the picture does possess a strong underlying tension. Many have attributed this to Van Gogh's feelings of isolation and rejection upon finding – on his return to Arles – that its people had become suspicious and frightened of him. The shimmering distant town and its abundant fruit trees in the middle ground are seen crucially through a barrier of gnarled trunks in the foreground. Firm and resolute, like the population of Arles, they seem to frustrate his attempts at entry. Both as metaphor and compositional device, their impact is powerful. These poplars act as cage and window frame as well as beautiful objects in their own right.

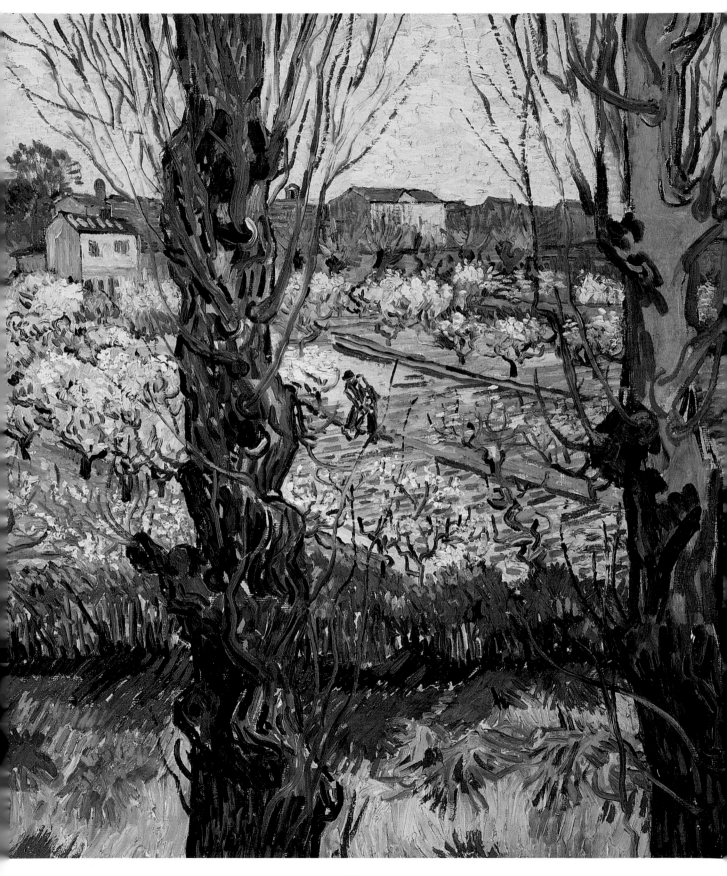

IRISES (1889)
Alan Bond Collection, Perth, Australia. Courtesy of AKG

*I*N May 1889 Van Gogh confessed of his mental breakdown to Theo: 'I am not fit to govern my affairs,' he said, voluntarily asking his brother to admit him for a rest cure at the St Paul's asylum. Van Gogh described the institution as being 'like a third class waiting room'. Hardly the place for someone who was feeling run down, suffering from hallucinations and the lingering pain of self-mutilation. In an attempt to make him feel at home, he was given an extra room as a studio. The staff also encouraged him to venture out into the decaying gardens, and it was amongst these that he discovered the irises painted here.

As with many of Van Gogh's paintings, especially those executed at this time, critics have interpreted this image more as a psychological document than as an aesthetic product. The painting certainly provides significant insights into its creator's mental state but, on a purely artistic level, it is also of much worth. It could be argued that the two forms of analysis achieve a symbiotic relationship, each feeding off the other. Compositionally, for example, the close-up view, in which a multitude of flowers dominate a skyless picture surface, render meaning to the psychoanalyst and art historian alike. To the former it might speak of enclosure and suffocation, to the latter of a strong overall design sense. The contrast between the painting's colours and Van Gogh's method of using them produce a paradox: blue is traditionally associated with peace and calm, but here these moods contrast with bold brushwork and wild, flourishing activity.

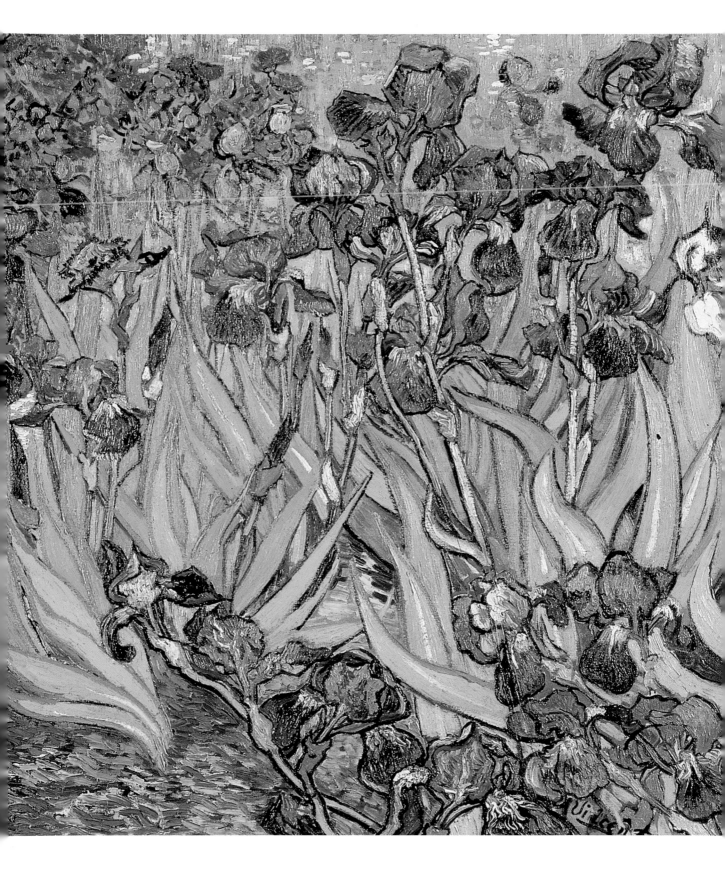

ST PAUL'S ASYLUM (1889)

Musée d'Orsay, Paris. Courtesy of AKG/Erich Lessing

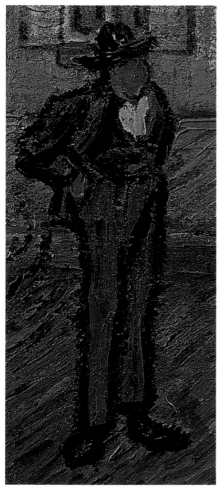

THIS particular picture is one of a series of images depicting the asylum Van Gogh stayed in from 1889 to 1890. Situated in a peaceful country setting, St Paul-de-Mausole was a large building with separate wings for its male and female patients. A few years before Van Gogh's visit, the establishment's reputation for 'modern' treatments, good food and plentiful amenities had brought it a fair measure of success. However, by 1889 the institution had seen better days. A steady decline in patient numbers meant insufficient funds had been supplied for its adequate upkeep. Nevertheless, Van Gogh's stay was purely voluntary and he even managed to find a positive side to his illness. As he wrote to Monsieur and Madam Ginoux (his ex-landlords, the owners of the Café de la Gare) ' ... my disease has done me good – it would be ungrateful not to acknowledge it'.

Having said this, St Rémy was a depressing place in which to live and work. Its rundown and shabby condition were hardly conducive to recovering from a life-threatening illness. This painting gives us a reasonable impression of the building's neglected architecture, which is further exaggerated by contrasting it with the dominant foreground pine tree. Flowing like a curtain or huge flame over the whole scene, its overhanging leaves operate as a classic Baroque device with which to frame the stage. Together with the equally fluid and dynamic trunk, they draw us into the middle ground where a heavily outlined man stands, literally faceless. Compared to everything around him, he is entirely static: the strangely still, calm centre of the picture.

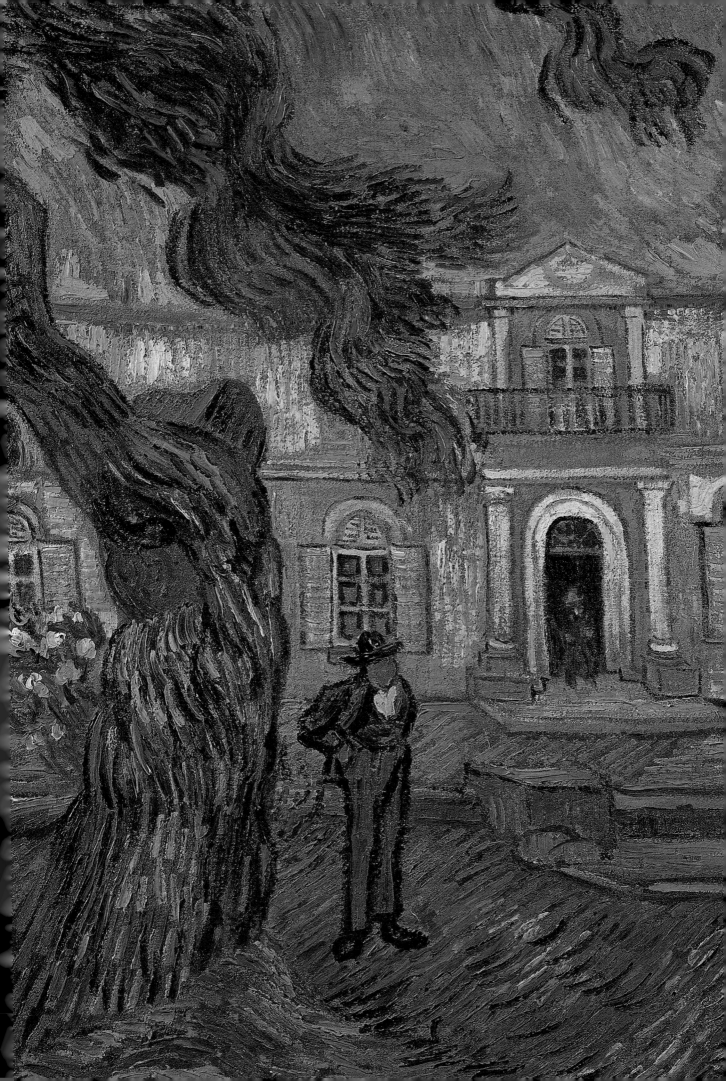

LILAC BUSH (1889)

The Hermitage, St Petersburg. Courtesy of AKG

*A*FTER entering the asylum at St Rémy of his own volition, it was not long before Van Gogh was seeking new subject-matter to paint. His first tentative forays into the adjoining garden soon suggested a whole range of possibilities. As well as the famous irises, he also discovered these lovely lilacs in the rambling but still beautiful grounds.

Despite frequent mental lapses during this period, Van Gogh's creative faculties remained largely intact for most of the time. Painting helped occupy his mind and prevented him from falling into depressive moods. The harder he worked, the healthier and more lucid he felt.

The way in which this painting has been delicately and painstakingly rendered is rather unusual for such a late work. Its method is Impressionistic, with dabs of paint scattered evenly across the canvas. The bucolic scene itself is in accordance with Van Gogh's ideas about creating an unsophisticated art, free of pretension. It would, he believed, give pleasure and consolation to all – from the wealthy art dealer in Paris to the humble Provençal peasant. Nature, then, was to be the great levelling theme.

LES LAURIERS-ROSES (THE GARDEN OF THE HOSPITAL OF ST RÉMY) (1889)
Courtesy of Christie's Images

TOGETHER with *Irises* (1889) and *Lilac Bush* (1889), paintings such as this form a series of evocative images of the asylum garden. Like Van Gogh's better-known canvases, it also features an all-over design. But that is where the similarities end.

Les Lauriers-Roses is one of 14 startling watercolours, all of which resemble each other stylistically. It depicts a scene of riotous colour that has been applied with quick, sketchy brushstrokes and no preliminary drawing. The blues which dominate the canvas are here transparent, there opaque, emphasising the painting's abstract, almost contemporary feel. The effect could only have been achieved with watercolours. Van Gogh's attitude towards the medium was ambivalent; he once commented: '[Oil painting] is somewhat more manly than doing watercolours and there is more poetry in it ... I would just as soon be, for example, a waiter in a hotel as some kind of manufacturer of watercolours'. Elsewhere he made reference to the challenge that watercolours represented: 'It is difficult to get life and movement into them,' he said, looking down upon artists who jumped straight in without first honing their skills as draughtsmen.

***Irises* (1889)**
Courtesy of AKG. (See p. 174)

Despite its rapid execution, this picture is certainly not lacking in technical proficiency. Van Gogh once quoted James Abbot Mcneill Whistler's (1834–1903) famous riposte to those who accused his work of looking rushed and inconsequential: 'Yes, I did that in two hours, but I worked for years to be able to do something like that in two hours'.

GARDEN AT ST PAUL'S HOSPITAL (1889)
Museum Folkwang, Essen. Courtesy of AKG/Erich Lessing

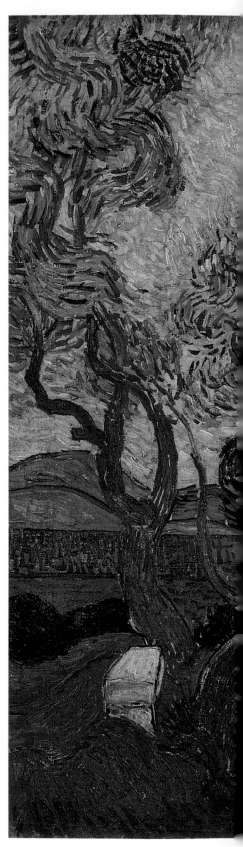

*V*AN GOGH was extremely satisfied with this portrayal of the asylum garden, probably as much for sentimental reasons as its excellent technical and expressive qualities. Although helamented his fragile physical and mental state, he never desired – at least until Theo's son Vincent was born – to be anywhere else. He fully realised he was incapable of looking after himself because the 'attacks' could strike at any time. Although he was, at times, critical of the treatment he received in the asylum, which he said amounted to 'absolutely nothing', at least he was under surveillance. His suicide may well have come sooner without the warden's watchful gaze.

This painting is an eloquent illustration of Van Gogh's belief that it was the artist's duty to remain faithful to nature and to reality. He places huge emphasis on the trunk and and the gnarled tree which he refers to as, 'that sombre giant – like a proud man defeated'. Like *The Olive Grove* (1889), it was partly painted as a response to the Biblical scenes painted by Gauguin and Émile Bernard (1868–1941). Steadfast in his belief that such images had no place in the artist's *oeuvre*, he wrote to Bernard in a rather peremptory manner: 'I ask you again, roaring my loudest, and calling you all kinds of names with the full power of my lungs – to be so kind as to come back to your own self again a little'. It was perhaps ironic that Van Gogh was to paint *The Angel* (1889) after the style of Rembrandt a few months later.

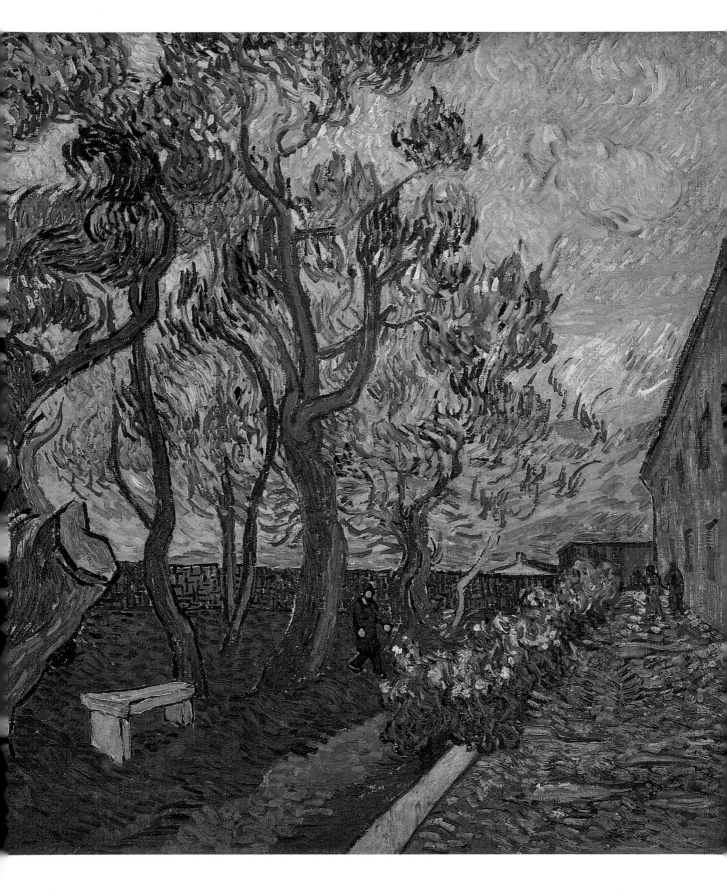

WHEAT FIELD WITH MOUNTAINOUS BACKGROUND (1889)

Ny Carlsberg Glyptothek, Copenhagen. Courtesy of AKG/Erich Lessing

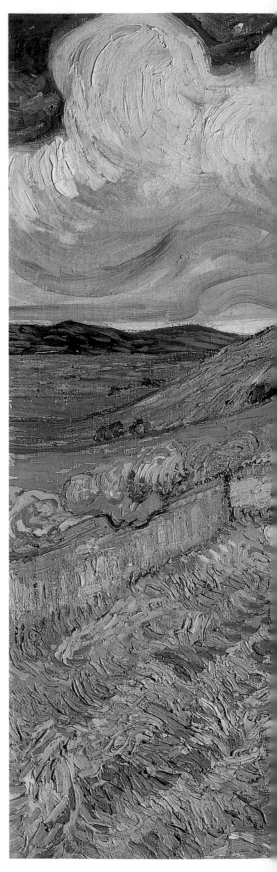

AFTER an initial two or three months spent solely in the asylum and its grounds, Van Gogh was allowed out into the surrounding countryside. Here he re-discovered familiar and well-loved themes and motifs, such as those seen in this painting. At first, Van Gogh didn't venture far from St Paul's and indeed this view of a wheat field within a wall is one that he had meditated upon time and time again from behind the protective bars of his bedroom window. He commented that it was, '[the scene] above which I see the morning sun rise in all its glory'. Van Gogh was fascinated by wheat fields and painted them at different times of year, from ploughing and sowing to the summer's harvesting. All this he recorded on canvas with the earnest dedication and personal interest of a true peasant painter.

In the preliminary sketches of this landscape, the wall dominates the composition, almost entirely blotting out the rest of the view, but in this version the scene is considerably broader. The wheat field in the foreground remains the largest element of the composition but the hills, mountains and clouds do have a significant role to play. Various loose horizontal bands constitute what Van Gogh referred to as 'a landscape of the utmost simplicity'.

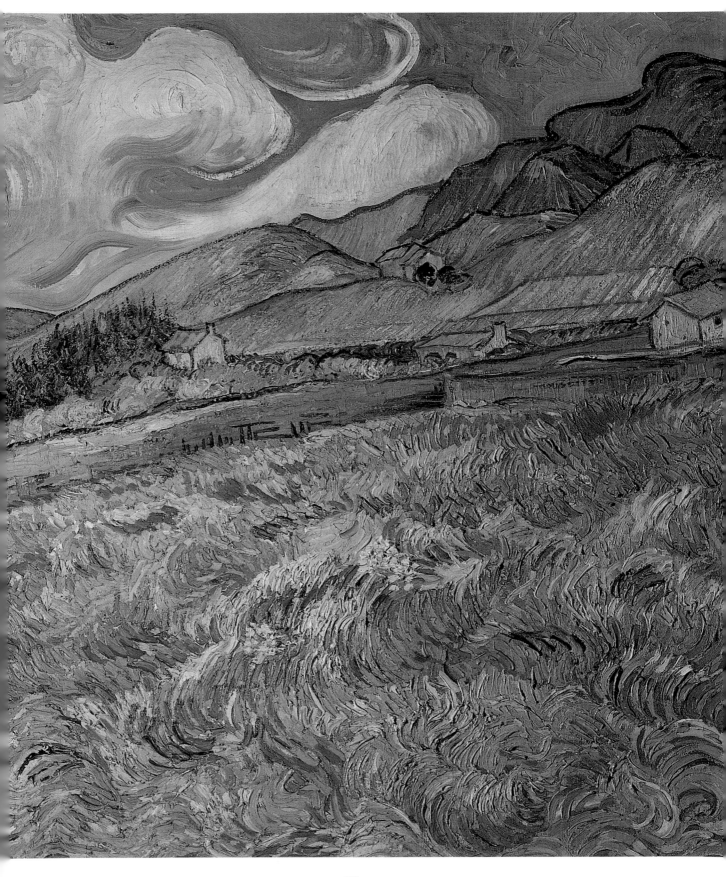

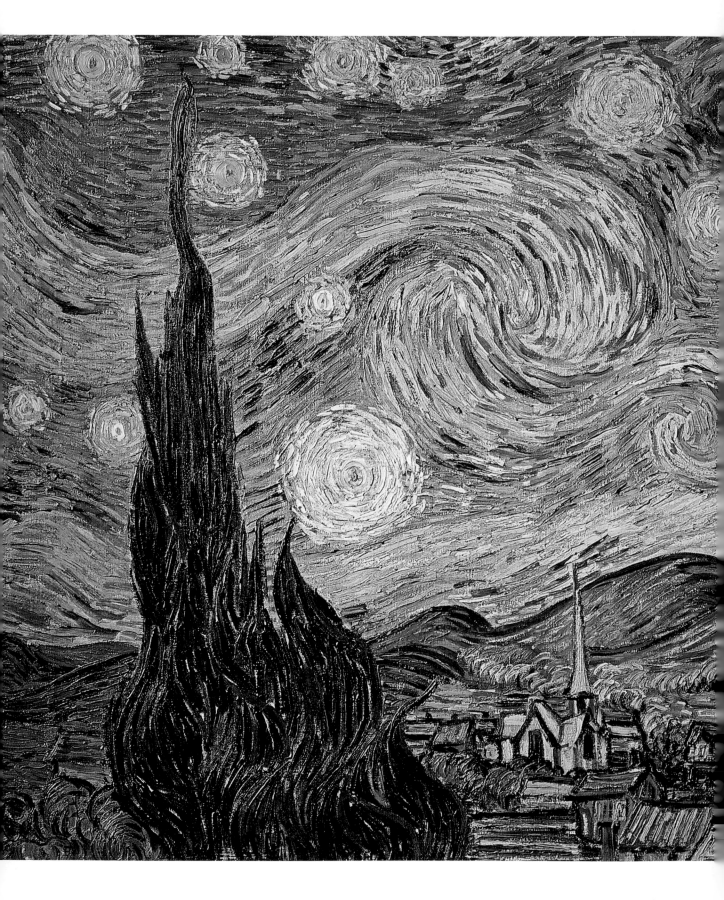

STARRY NIGHT (1889)

Museum of Modern Art, New York. Courtesy of AKG

ANOTHER of the many asylum pictures, *Starry Night* surely ranks among Van Gogh's most famous works. Much of this recognition must go down to Don McLean's eponymous ballad, in which Vincent's mythic status as the archetypal tragic and misunderstood genius reached one of its more sickly apotheoses. No-one would have been more surprised by this sentimentalising rhetoric than Van Gogh himself, who considered the image to be one of his less successful renditions of nature. In his opinion, it was just not realistic enough.

Nevertheless, it is precisely this aspect of the work that has appealed to critics and crooners alike. What these admirers almost unanimously pick up on is its visionary quality. The painting may not be a naturalistic representation of the Provençal countryside, but it does evoke another previous reality. The small cluster of houses and the silhouetted cypress tree look just like a nestling Dutch village, with its typical church spire. The sky, reminiscent of Rembrandt's etching *The Annunciation to the Shepherds* (1634) is a further throwback to Van Gogh's strict Protestant past. In some ways it also points the way towards abstraction, and certainly Expressionism. Its rhythmically swirling forms and bold patterns are also similar to those that appeared under Gauguin's influence in Arles, although surprisingly neither Gauguin nor Bernard recognised this painting as bearing their imprint, seeing it 'merely' as a scene of a village at night.

FIELD OF WHEAT WITH CYPRESSES (1889)

National Gallery, London. Courtesy of AKG/Erich Lessing

W HEN Van Gogh was well enough to venture into the countryside in late May, this magnificent painting, completed a little later, was one of the results. Throughout June, he created a series of famously powerful landscapes, each bursting with a violent energy that many have attributed to his madness. However, for all the potential signs of a tormented mind that such works display, they were all painted during periods of remission. The swirling, heavily stylised forms, now instantly associated with Van Gogh, did not suddenly appear from nowhere – they mark a progressive development in his work rather than a radical break. The earlier Cloissonist influence of Gauguin and Bernard is finally assimilated.

In the history of art, cypresses are traditionally a motif signifying death. Dark and sombre, they normally belong in the cemetery. Despite a certain sinister air, which some have linked to Van Gogh's suicidal tendencies, the trees here are alive and vibrant. In fact the whole scene is vigorously animated, with each part shading into others. Nothing is stable; everything that is solid melts into air.

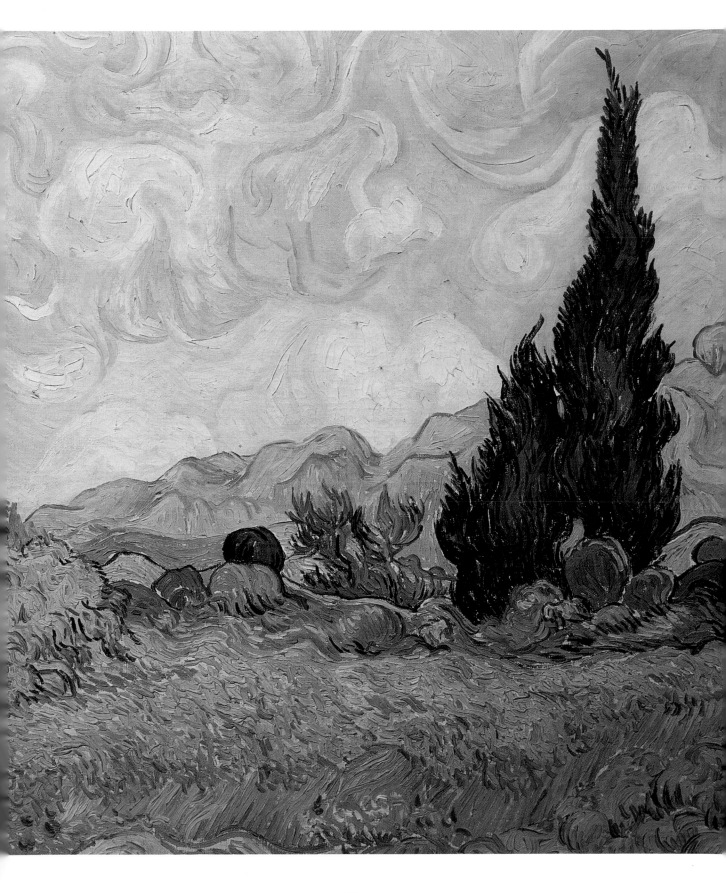

OLIVE GARDENERS (1889)
Private Collection, Lausanne. Courtesy of AKG

*P*AINTED during the same period as *Wheat Field with Cypresses* (1889), this picture features another typically Provençal tree. Olive groves were especially abundant around St Rémy and Van Gogh was regularly exposed to them at this time. His familiarity with their every detail was revealed in a letter to Theo: 'They are silver, then more blue, then greenish, bronze, becoming whiter against the ground, which is yellow, purplish pink or a kind of orange up to dull red ochre. But very difficult ... ' The kind of close scrutiny that Van Gogh put nature under 'bears fruit' here.

Produced as a secular reply to paintings by Gauguin and Bernard of *Christ in the Garden of Gethsemane, Olive Gardeners* clearly expresses Van Gogh's dislike of his fellow artist's expressive abstraction and mysticism. He argued that the painting should be based around observed reality. This did not obviate distortion, but simply suggested the importance of certain artistic foundations. The colours he uses here, for example, are various, but – for all their possible exaggeration – they were not imagined by the artist from nowhere. They were seen at first hand with his eyes and only then modified, or enhanced, by his mind.

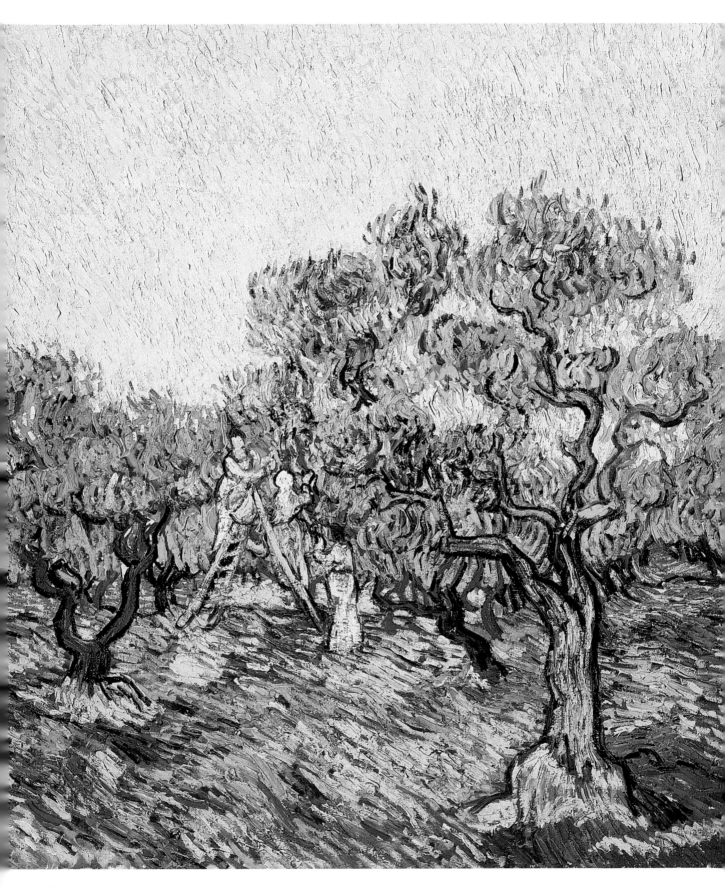

GREEN WHEAT FIELD WITH CYPRESSES (1889)

Narodni Gallery, Prague. Courtesy of AKG

*T*HE olive tree series over, Van Gogh turned his attention and energy back to the abundant cypress trees in the vicinity of St Rémy. The most famous of these paintings is *Starry Night* (1889), whose tortuous brush strokes heralded another of Van Gogh's agonising attacks of mental illness. The calmer scene depicted here was executed after the inner torment had subsided, and the result is altogether less intense.

In describing the scene to his sister, Van Gogh proudly wrote, 'I have just finished a landscape of a ripening corn field boxed in by brambles and green bushes. At the far end of the field a little pink house with a tall and dark cypress standing out against the distant hills of purplish blue, and against the sky of myosotis blue streaked with pink, its pure tones contrasting with the yellowy ears, already heavy in tones as warm as a crust of bread'. Unfortunately the pinks have now almost completely faded to white, and the yellows have lost much of their heat. The effect is thus rather flat.

This painting developed a month later into a tableau more redolent of the mature Van Gogh – *Yellow Wheat Field with Cypresses* (1889), in which the cypress became the focal point and the style more coherent.

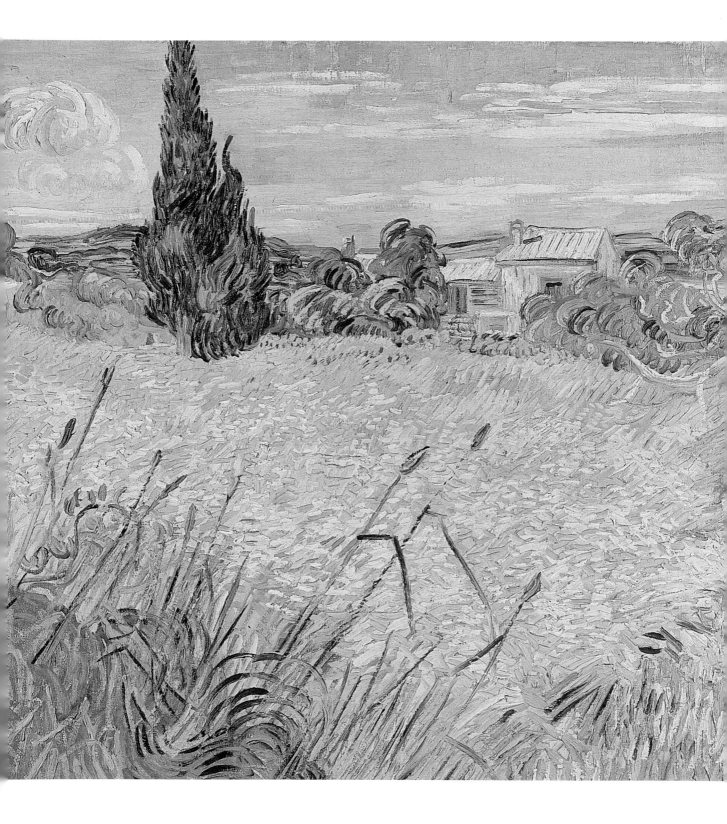

THE POPPY FIELD (1889)

Kunsthalle, Bremen. Courtesy of AKG

V AN GOGH'S intense rivalry with Gauguin
and Bernard was undiminished in spite of
his current state of artistic isolation in the
asylum of St Rémy. There is evidence of it here, as
there was in other works such as *L'Arlesienne* (1888)
painted while Van Gogh was still in Arles. Upon
hearing of the two men's intentions to organise a
modernist answer to the rigidly traditional World
Exhibition, Van Gogh was obviously keen to
contribute. In painting *The Poppy Field,* Van Gogh
adopted a significantly more stylised technique than
was usual for his landscapes, in the hope his work
would be acceptable to his two friends. Van Gogh
suggested he was using, 'a more spontaneous drawing
style' with 'strongly felt lines', a characteristic typical
of stylised art. Each element of the painting boasts a
change in the style of brushwork, and, as a result,
Van Gogh failed to achieve the harmony he sought.
He himself described it to Theo as, 'one of the
studies which lacks coherence', and according to Van
Gogh, it was this essential cohesion that was
necessary for a painting to achieve true greatness.

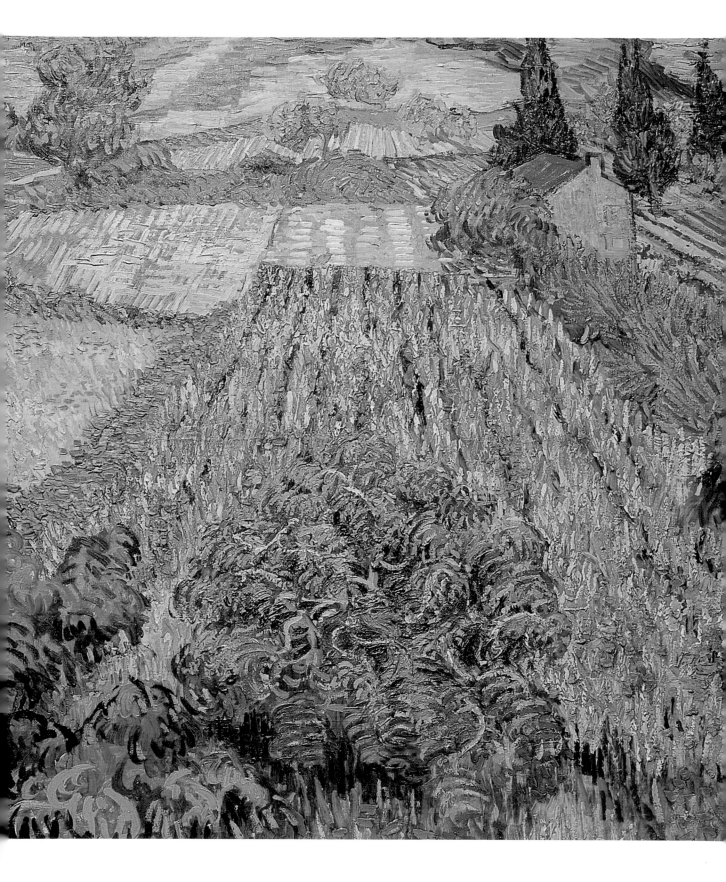

LA BERCEUSE (1889)

Private Collection. Courtesy of The Bridgeman Art Library

*V*AN GOGH painted Madame Roulin, the wife of his friend the postman, Joseph Roulin, five times. He began the first portrait in December 1888, when Gauguin also asked her to sit for him. This version was completed whilst in St Rémy, by which date Van Gogh had built up a great respect for the whole Roulin family. He got to know them during his stay in Arles and painted them all. He particularly liked Madame Roulin whom he considered the archetypal woman and mother. As if to reinforce this image, he paints her here holding a cord attached to an unseen cradle (the title actually translates as *The Hand that Rocks the Cradle*). The figure's large breasts and ample figure further emphasise her 'feminine' and 'maternal' qualities.

During his 'attacks', Van Gogh sometimes thought he saw the room where he was born in Holland. These hallucinations comforted him and he deliberately tried to recreate their effect in his depictions of Madame Roulin as the quintessential mother figure. His very real feelings of tenderness towards her – and her husband – were largely the result of their loyalty towards him whilst he was at St Paul's asylum. At a time when others had been eager for the artist to leave the town, they had visited his sickbed and remained supportive friends. Their enduring kindness led him to suggest that, with this portrait, he had 'sung a lullaby in colour'. However, from a purely technical point of view, he was less enthusiastic, to the point of self-deprecation: 'The coloured prints in the cheap shops,' he complained, 'are of infinitely better quality'. His first description is, perhaps, nearer the truth.

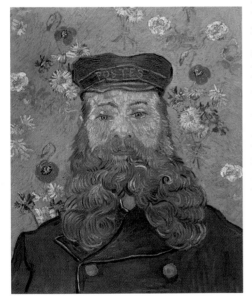

Roulin the Postman (1889)
Courtesy of AKG/Erich Lessing. (See p. 168)

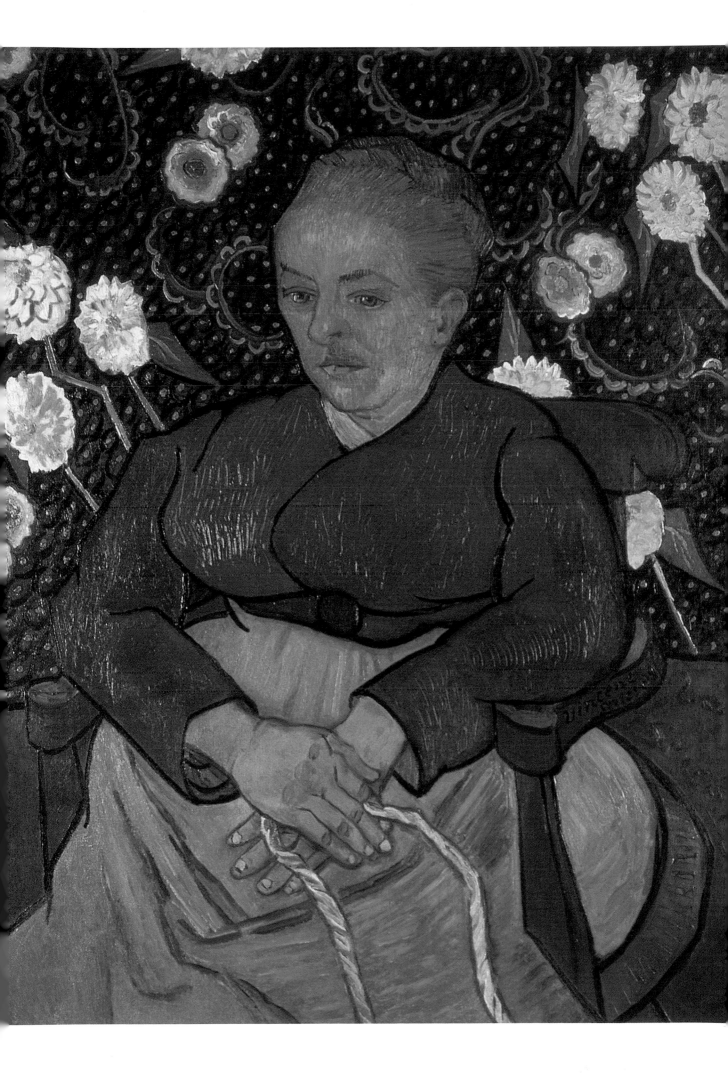

THE ANGEL (1889)

Private Collection. Courtesy of AKG

IN 1889 Van Gogh attempted unsuccessfully to commit suicide by swallowing paint. This event was possibly triggered by the news that Theo's wife, Jo, was pregnant. Some have speculated that Van Gogh felt himself to be an inadequate failure because he, the elder brother, was neither married nor a father. Others have suggested that this lack of self-worth further manifested itself in his constant decision to copy from 'the greats', rather than make entirely original works of his own. *The Angel* is one such 'copy', although a more accurate word might be 'transcription'. It was a practice Van Gogh first engaged in while at the Antwerp Academy of Fine Art, and one which he henceforth considered an invaluable way of learning from others – in this case Rembrandt. He found it relaxing and creative in equal measure, although his interpretation of Biblical scenes was rare. In reaction to Gauguin's and Bernard's representations of the scriptures, he even said: '[Their] *Christs in the Garden of Gethsemane*, with nothing really observed, have got on my nerves. Of course, with me there is no question of my doing anything from the Bible'. Despite this assertion, Van Gogh also transcribed *The Raising of Lazarus* (1889) and *The Good Samaritan* (1889). His choice of subjects was limited but significant. All represent hope, renewal and redemption: values that must have seemed particularly pertinent after his recent survival in the face of his suicide attempt.

VASE WITH TWELVE SUNFLOWERS (1889)

Yasuda Fire and Marine Insurance Company, Tokyo. Courtesy of Christie's Images

THIS is one of three copies Van Gogh made of the famous sunflowers whilst in the asylum of St Rémy. He referred to them all as being 'absolutely equal and identical'. In reproducing his own work in this way, Van Gogh was openly flouting the accepted notion of the supremacy of the 'one-off' and 'never-to-be-repeated' original. In fact, Van Gogh often repainted earlier works in order that he might retain a copy of the canvases he gave away to friends.

The Sunflowers (1888)
Courtesy of AKG. (See p. 138)

Vase with Twelve Sunflowers is another example of the 'light on light' technique so magically employed a year earlier in *The Sunflowers* (1888). Various tints of the same colour are used together, layer upon layer, to stunning effect. As with the original Sunflowers series, the vase, background wall and table surfaces are essentially smooth and almost even in tone, in distinct contrast with the sunflowers themselves. The vibrant heads are bought into sharp relief by the longer brushstrokes of the leaves and stems. Variously described by critics as 'an ode to Provence' and 'the best still lifes in the history of art', these sunflowers reminded Van Gogh of the happy days he spent in the Yellow House at Arles, full of anticipation for the coming of Gauguin. Confined in an asylum for the mentally disturbed, memories of those joyful days in Arles were surely what helped to prevent the fog of depression enveloping him completely.

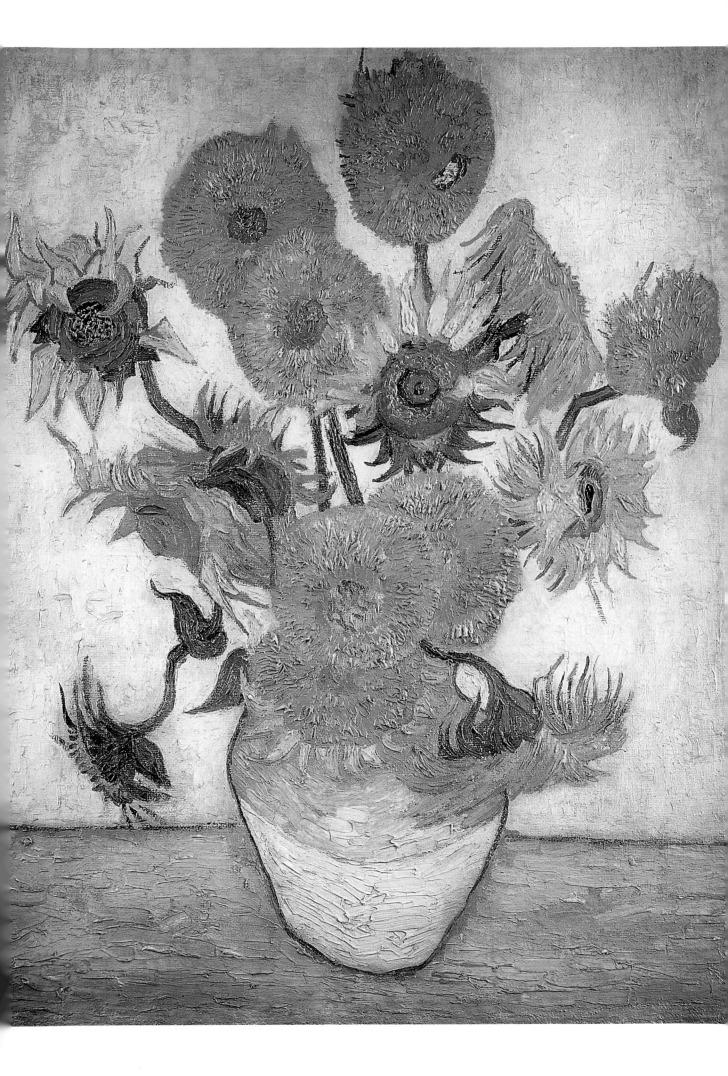

BEDROOM AT ARLES (1889)

Musée d'Orsay, Paris. Courtesy of AKG/Erich Lessing

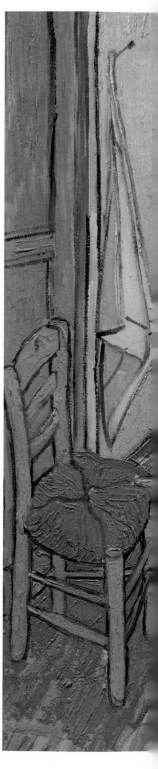

*V*AN GOGH painted two versions of this intimate picture, one either side of Gauguin's unsatisfactory visit in 1888. Excited by the prospect of his friend's arrival, he said about his first effort that 'I am conceited enough to want to make a certain impression on Gauguin by my painting. I have finished as far as possible the things I have undertaken, pushed by the great desire to show him something new, and not to undergo his influence before I have shown him indisputably my own originality'. Ironically perhaps, considering this last point, this second painting was a copy of the first. It could be that Van Gogh was trying to re-live happier times, or at least the initial calm period before his friend's turbulent departure. 'To look at the picture,' he explained, 'ought to rest the brain, or rather the imagination'. Paradoxically the room's very contents – from its

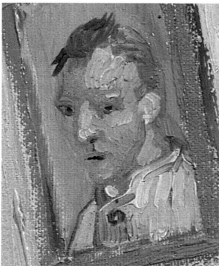

wicker furniture to his own paintings hanging on the wall – serve to remind us more keenly of what is not there; namely, its inhabitant. Van Gogh described the room as 'an interior without anything'. In fact he believed that the inanimate objects left behind in a person's room adopted their owner's personality, as did the empty room itself.

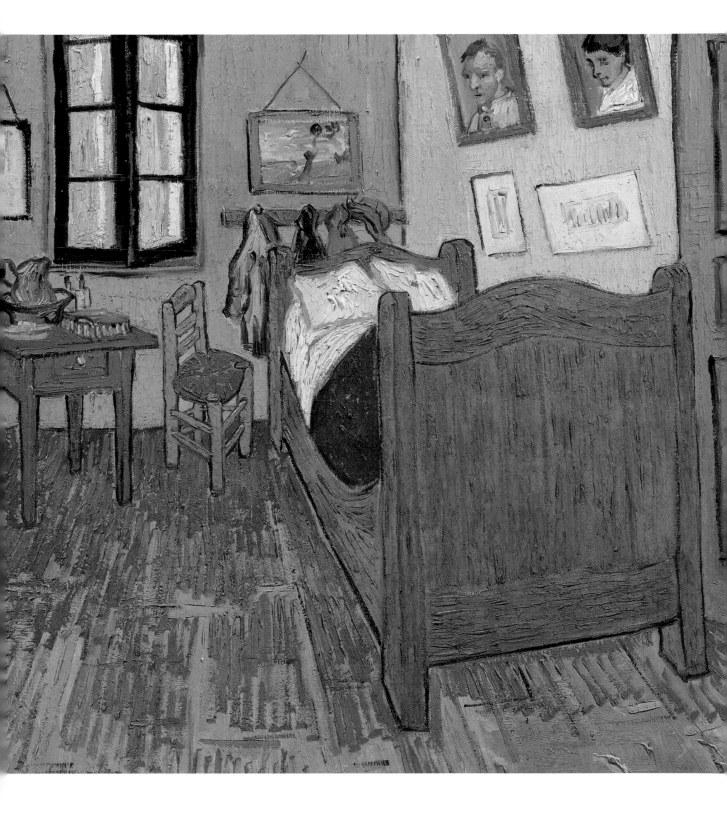

PORTRAIT OF SUPERINTENDENT TRABUC IN
ST PAUL'S ASYLUM (1889)

Kuntsmuseum Solothurn, Switzerland. Courtesy of The Bridgeman Art Library

AT the time of painting this portrait, Van Gogh wrote to Theo outlining his fears about a potentially imminent 'attack'. As if to compensate for this future period of inactivity, and in a desperate attempt at staving off the relapse, Van Gogh redoubled his commitment to art. He told his brother: 'I am working like one actually possessed, more than ever I am in a dumb fury of work'. For all the 'wildness' of Van Gogh's words, the paintings he produced in his 'manic condition' are surprisingly restrained. This is not to say that they lack drama or tension, but that these qualities appear always to be kept in check, simmering beneath the surface and constantly threatening to break loose.

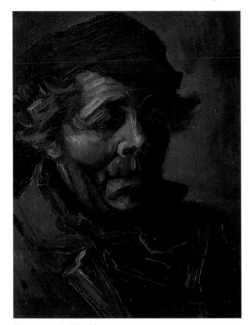

Peasant's Head
(Study for *The Potato Eaters*) (1885)
Courtesy of Christie's Images. (See p. 39)

Van Gogh painted the superintendent partly because he was there and partly because he had 'an interesting face'. He detected in Trabuc's gaze the look of a man who had 'seen a tremendous amount of suffering'. Furthermore, he admired his military manner. Trabuc's rather gaunt face and stern expression certainly convey an impression of authoritarianism, but also of a certain sadness and affection. Indeed, Van Gogh wrote to Theo that the superintendent had 'a sort of contemplative calm in his face' that is effectively portrayed here. For all the head's naturalism, the patterned jacket is decidedly stylised; they form a striking juxtaposition. In some ways, however, the two are rendered in surprisingly similar ways. Both elements of the canvas feature wavy lines that follow the sinuous contours of the surfaces they describe; the clothing is more obvious because of the contrasts in colour involved. It is an image of pure, pent-up energy.

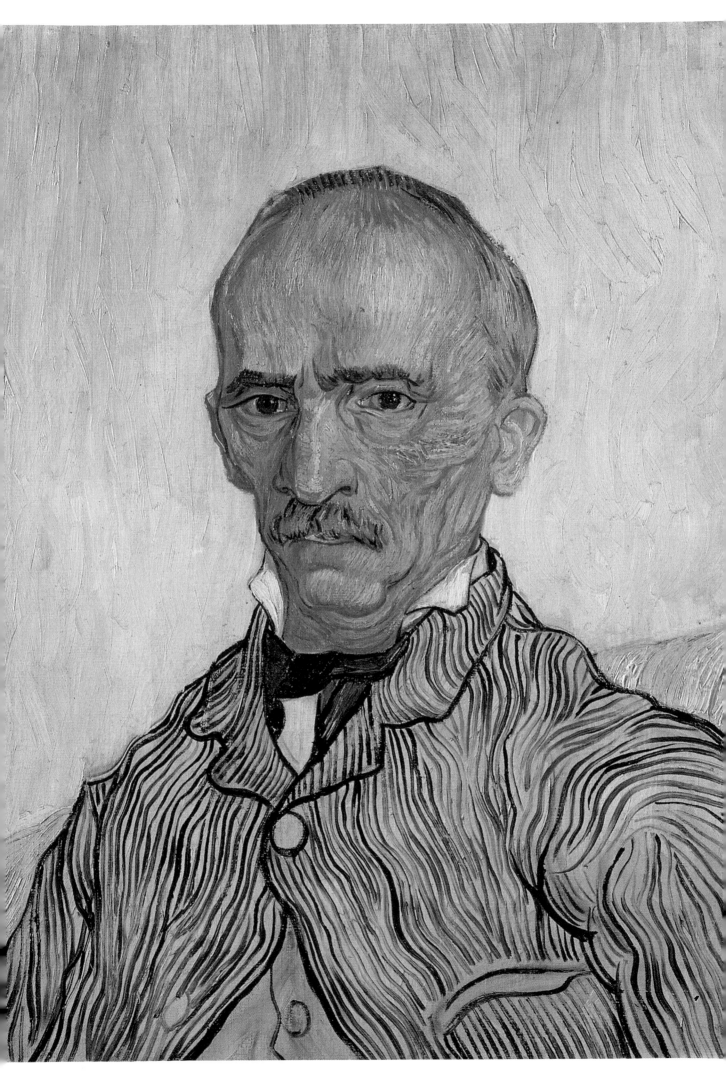

PORTRAIT OF MADAME TRABUC (1889)

Courtesy of AKG

*D*URING his year long stay in St Rémy, Van Gogh only painted six portraits, half of which were of himself. The remainder all had connections with the asylum: one was of a patient, another of the superintendent and, finally, one of his superintendent's wife, Madame Trabuc. Trabuc and his wife lived near the asylum and Van Gogh saw them regularly.

Van Gogh had a tendency to emphasise his sitter's prominent features, and this portrait was no exception. With her large exaggerated nose and eyes and unusual expression, this image is on the borderline of being a caricature. As with his depiction of the peasants in *The Potato Eaters* (1885), Van Gogh pulls back at the last minute, however, to maintain the sitter's dignity.

The artist often made copies of his favourite works at later dates and it is possible that this is one such 'reproduction'. This particular painting, original or not, disappeared during the Second World War and was believed to have been destroyed by the Germans – presumably as a typical example of 'degenerate art'. However, having been lost from public view for 50 years, it then re-emerged in 1995 at a St Petersburg exhibition, held for art taken as war booty by the Russians.

Detail from *The Potato Eaters* (1885)
Courtesy of AKG. (See p. 40)

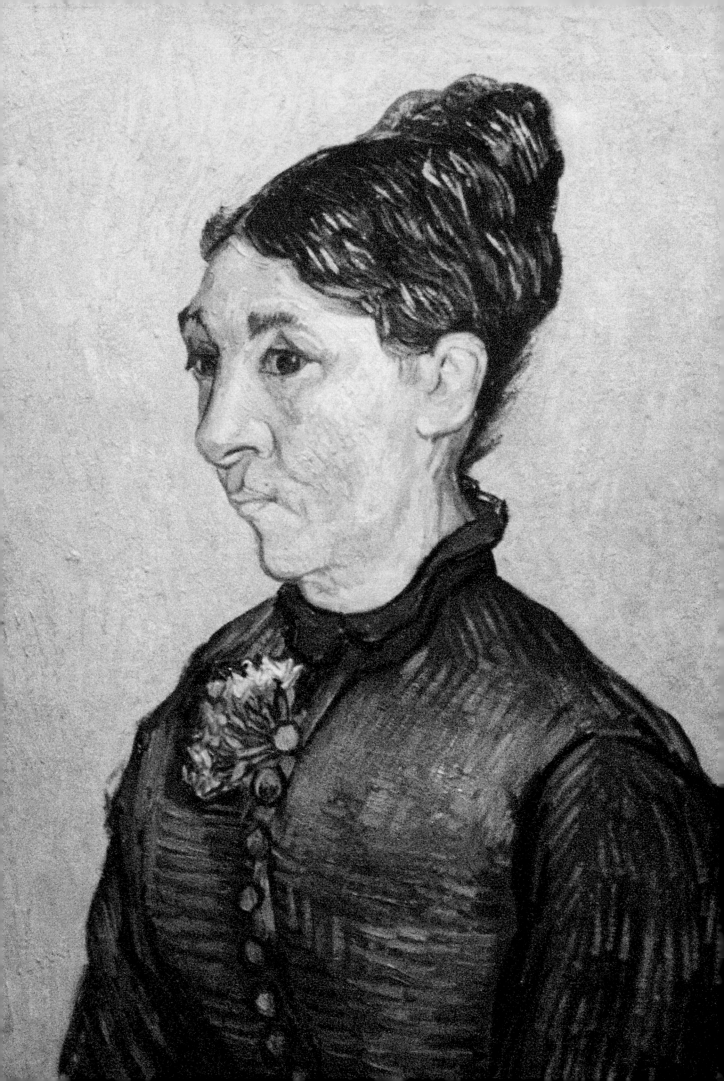

SELF-PORTRAIT (1889)

Musée d'Orsay, Paris. Courtesy of AKG/Erich Lessing

ONE of Van Gogh's best-known works, this portrait was created shortly after the artist's suicide attempt (by swallowing paints) in St Rémy. When his painting materials were eventually restored to him by his attendants, Van Gogh painted three self-portraits in quick succession. Curiously, considering the intense results, he claimed to have chosen the genre as a respite from working outdoors. To avoid the excessive excitement and stimulation he would have felt venturing outside the asylum itself, Van Gogh chose instead to turn inwards and paint the landscape of his soul.

In some ways this portrait does not appear to be the work of a man whose inner torment had recently led him to attempt suicide. His furrowed brow may betray a certain dissatisfaction or disturbance, but the face that stares out at us so intently is also confident and surly. If the

Green Wheat Field with Cypresses (1889)
Courtesy of AKG. (See p. 192)

sitter feels at all depressed or angst-ridden, he is keeping these troubled emotions fairly well hidden. In fact this is the painting's very strength. The artist himself presents us with only a glimpse of his psychological turmoil; the terrible depression that his strained facial expression attempts to hide, nevertheless comes pouring out around him. The stylised background swirls and organic flowing lines of his jacket are left to do most of the expressive work. They are reminiscent of other canvases painted around this time, such as *Green Wheat Field with Cypresses* (1889), which feature restless movement as a metaphor for the psyche in constant flux. Van Gogh's frown is ultimately directed beyond the viewer. His eyes seem focused on different things; the object of his gaze remains unclear. He seems to be scrutinising himself and not liking what he sees.

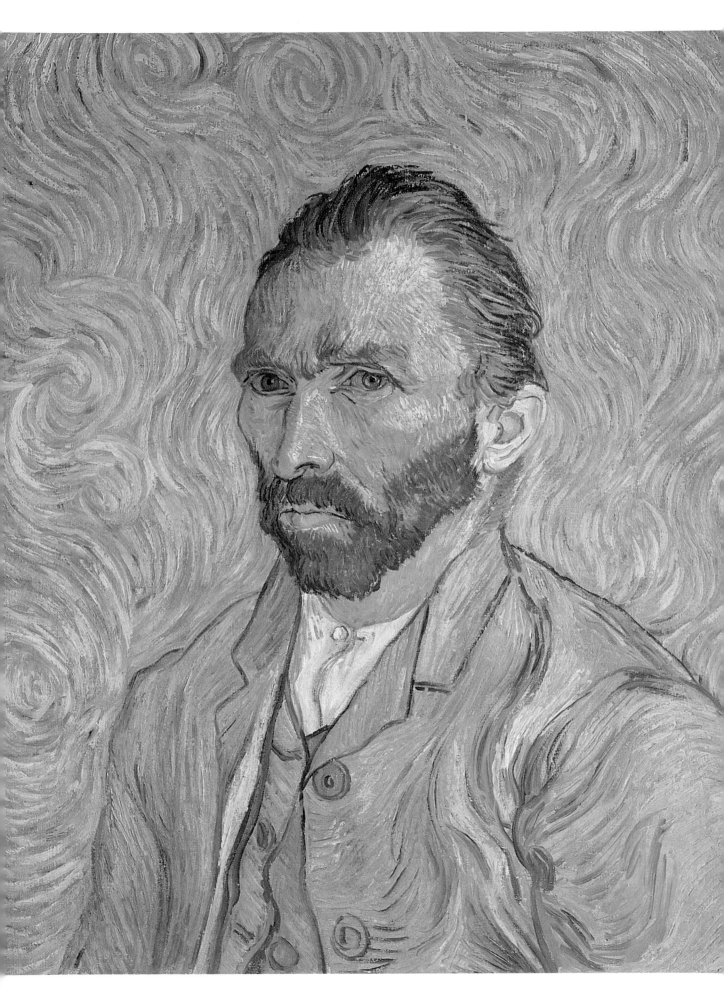

LA SIESTE (1889–90)

Musée d'Orsay, Paris. Courtesy of AKG/Erich Lessing

*T*HAT many of Van Gogh's paintings made during his final days at St Rémy were copies, and not originals, did not seem to worry him at all. Writing to Theo he commented: 'Many péople do not copy, many others do, I started on it accidentally and I find that it teaches me things ... '. Van Gogh was never afraid to acknowledge his debt to past masters and one of his favourites was the great peasant painter, Jean-François Millet.

In his youth in Holland, Van Gogh had admired Millet's rustic scenes of farm labourers, peasants and the economically disadvantaged. However, such themes had all but been abandoned in Arles, and it is significant that Van Gogh chose to return to these subjects at this point in his life. It was possibly a longing for the north and 'escape' from the asylum that prompted Van Gogh to paint works so associated with his past. *La Sieste* is arguably the most famous of all Van Gogh's copies. There is no trace in this painting of the agonising depression he was feeling at the time – the whole idyllic scene is bathed in warm yellows and complementary blues. These colours imbue the picture with a relaxed sense of calm, an effect heightened in this instance by the strong and vital brushwork.

THE PRISON EXERCISE YARD (1890)

Pushkin Museum, Moscow. Courtesy of AKG

*L*IKE *The Angel* (1889), this is another example of the 'creative copying' Van Gogh practiced during his final months in St Paul's asylum. This is a painting after Gustave Doré's (1832–83) painting which bears the same name. Van Gogh certainly admired Doré's brand of social realism, but probably more to the point, he simply did not want to 'lose sight of the figure' as he put it. As has been mentioned earlier, Van Gogh thought of himself as being primarily a portrait artist, and was frustrated by the lack of opportunities the asylum offered for this type of activity.

Again, like *The Angel*, *The Prison Exercise Yard* was not in any way a straight copy of the original, and the colours at least were purely Van Gogh's own. This did not of course perturb him, and he remarked to Theo of the painting: 'The vague consonance of colours are at least right in feeling'. Van Gogh's interpretation of the picture was more alive than Doré's version, partly because of the use of enriched colour, but also because, inevitably, the picture's strong sense of sadness and confinement are depicted with an understanding and an intimacy that can only come from experience. Van Gogh was confined within the asylum, but more particularly, he was trapped within himself, at the mercy of the psychological attacks which could strike at any time and for no apparent reason. Like the patients in the asylum, the prisoners appear here together, yet alone – each is struggling with his own problems and experiences.

The Angel (1889)
Courtesy of AKG. (See p. 199)

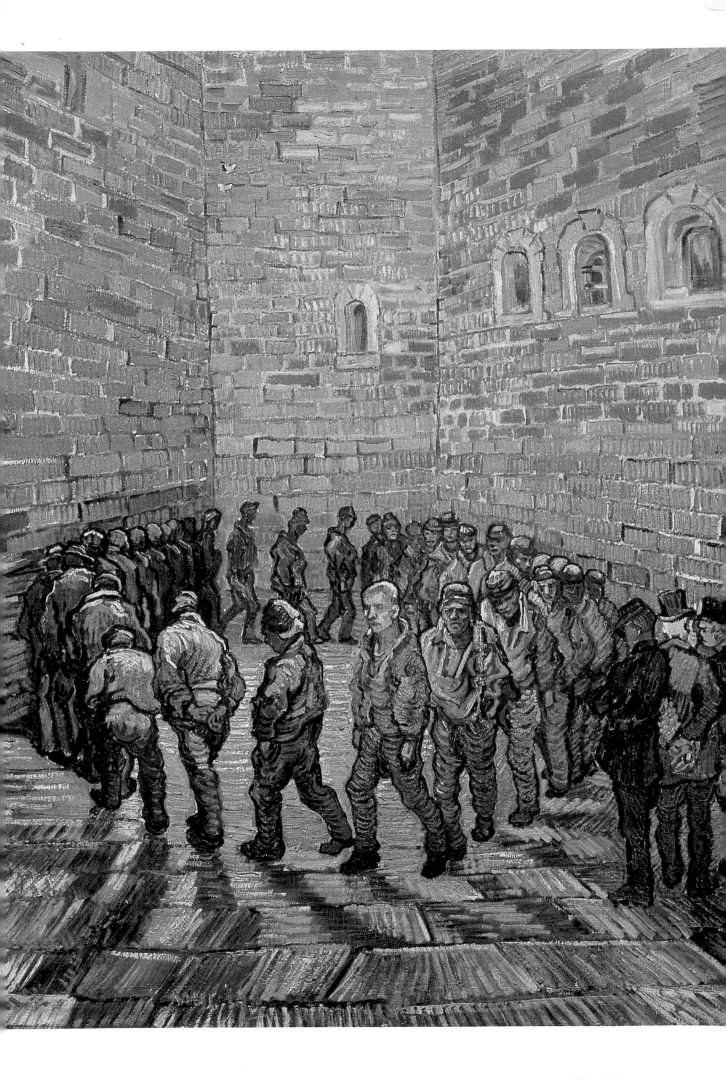

MEADOW IN THE GARDEN AT ST PAUL'S HOSPITAL (1890)

National Gallery, London. Courtesy of AKG

PAINTED as part of a series of close-up studies of bushes and plants, this image picks up on the same techniques used in those more famous pictures. The most striking similarity is Van Gogh's elimination of sky; he covers the canvas instead with an even, overall design. There is no focus on anything in particular, and neither are there are any strong contrasting colours. It just seems to be a close-up view of grass with a few butterflies, yet Van Gogh has made much with his superficially dull subject. What might have been plain and uneventful is instead vigorous and alive.

The artist had considerable admiration for American poet Walt Whitman. A particular favourite was his collection *Leaves of Grass.* Whitman believed that wisdom lay in being close to nature, and that one had to study the smaller elements in creation to see what was truly great. Van Gogh took this creed quite seriously. What appears here, therefore, to be a representation of a 'mere meadow' is actually the result of rigorous intellectual study. Having lost his faith in organised religion (he was once a devout Protestant), Van Gogh began at this time to worship nature. It provided him with an outlet for his emotional need – the need to revere something – which never went away.

MOURNING OLD MAN (1890)

Rijksmuseum Kröller-Müller, Otterlo. Courtesy of AKG

*T*HIS is a reworking of the drawing Van Gogh made in the Hague in 1882, which was rather grandiloquently titled *From Here To Eternity's Gate*. In this version though, the man looks less like a peasant collapsed in his chair (as the original obviously was), and much more like an asylum patient, dressed in a sort of regulation hospital blue. The misery or anguish the bent man is clearly exuding would also have been a familiar sight to Van Gogh as he painted quietly in the asylum's hallways and gardens. Indeed, Van Gogh commented that the strange shrieks and cries he heard at night, and one particularly powerful encounter with an old man who was unable to enunciate clearly, 'put my own attacks into perspective'.

This painting then, although ostensibly 'simply' a copy of an earlier peasant painting, is rendered with an intimacy and a sympathy

borne of long, lonely days spent interned. Van Gogh only managed to paint one actual fellow sufferer whilst in the asylum, and this was done, not from any quasi-psychological or scientific motive, but simply because there was no-one else willing or interesting enough around. This copy was probably made for similar reasons. As usual with Van Gogh's figure paintings, its anguish says more about his inner state than that of his sitters.

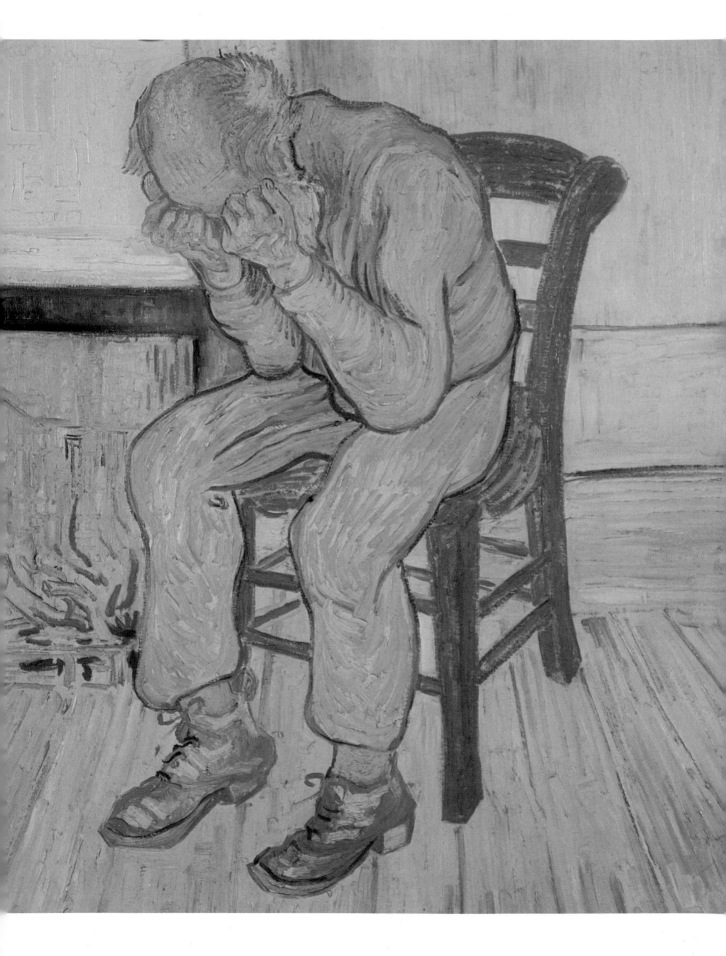

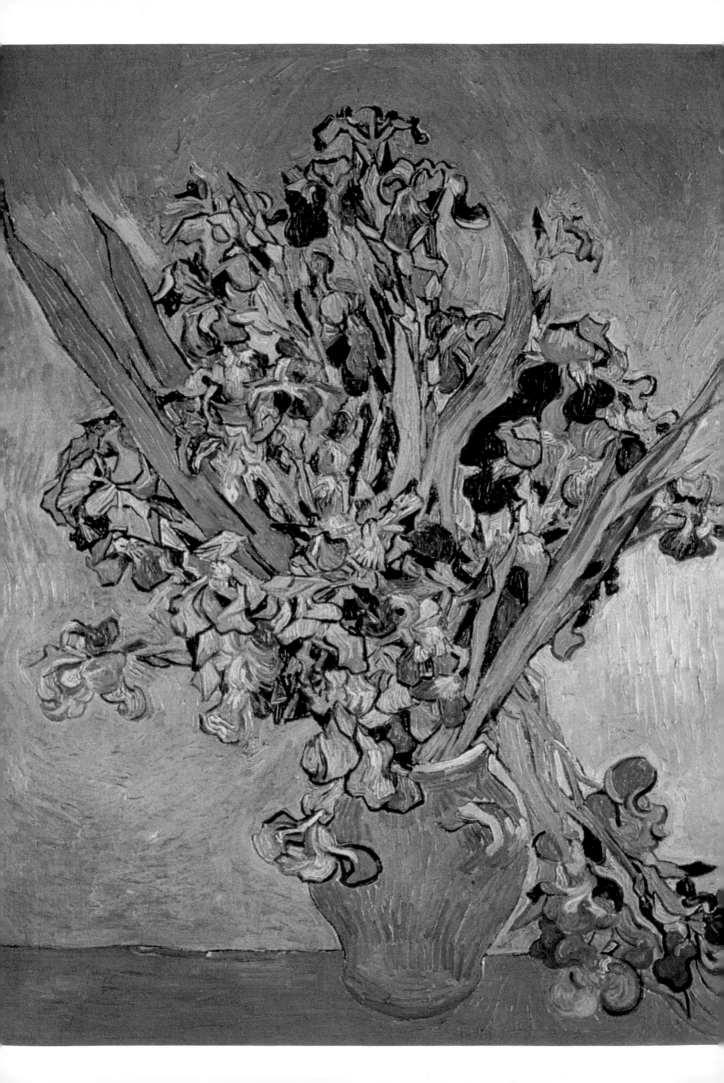

IRISES IN A VASE (YELLOW BACKGROUND) (1890)

The Van Gogh Museum, Amsterdam. Courtesy of Art Resource

*A*SEVERE bout of illness incapacitated Van Gogh from February to April, but in the brief period between his recovery and subsequent departure from St Rémy in mid-May, his output was prolific. *Irises in a Vase* was painted just a few days before he left the asylum, and represents the same flowers he had 'discovered' there on his arrival a year earlier. That canvas – *Irises* (1889) – had proved such a success at the Salon des Indépéndants exhibition in 1889 that he may have been hoping to re-ignite similar interest with the flowers shown here.

This canvas may depict the same motif – one which the artist was to turn to several times again – but its treatment in the later picture is quite different. Whereas the 1889 version was clamorous and suffocating, this one bears all the signs of a more stable mind at work. He wrote optimistically to Theo: 'Things are getting better at the moment, the

horrible crisis has passed like a thunderstorm ... I have a painting in hand ... a purple bouquet!' This joyous bloom does indeed seem to reflect Van Gogh's hopes for a brighter future in Auvers, where he was to travel via Paris, when he left the asylum. Its striking combination of purples and yellows reveals his thorough understanding of colour theory at this stage. The picture's vibrancy, he explained, is 'an effect achieved by tremendously divergent complementary colours, this very divergency heightening each colour'. The broken stem was possibly added later, as in *Still Life with Carnations* (1890), to enliven the composition still further – it has a slightly different painting technique.

***Still Life with Carnations* (1890)**
Courtesy of Christie's Images. (See p. 244)

ROAD WITH CYPRESS AND STAR (1890)

Rijksmuseum Kröller-Müller, Otterlo. Courtesy of AKG

*V*AN GOGH spent almost a year in St Rémy. During that time he developed what have subsequently come to be regarded as some of his most iconic motifs. The cypress, star and moon, featured here, were three such recurring themes. They are quintessentially Van Gogh. *Road with Cypress and Star* was painted during the last weeks of his stay in St Rémy and, as such, clearly represents the resolution of many previous struggles. He described it to Gauguin thus: 'A cypress with a star, a last attempt – a night sky with a moon that gives off no light, no more than a thin crescent rising out of the dark shadows of the earth, an exaggeratedly bright star ... '. His somewhat verbose description ends with the comment 'very romantic, if you like, but also very Provençal, I think'.

The image is certainly a romanticised vision of the Provençal countryside that Van Gogh found so awe-inspiring. Probably painted from the imagination, it is also an ode to his friend Gauguin, whose stylised forms and flattened pictorial space are strong influences. Particularly striking, over and above the painting's dramatic composition, is the violently rhythmic brushwork. Virtually every stroke seems to emphasise the vibrantly swirling effect of the whole. The religious connotations are crude but unavoidable. Four symbolic figures, two in a horse and cart, two walking on a pilgrimage. Between them, and above the flowing path, looms an imposing cypress: none other than the shadow of death.

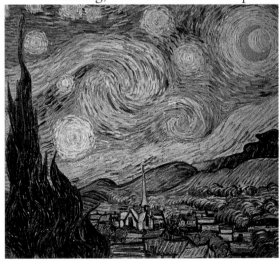

Starry Night (1889)
Courtesy of AKG. (See p. 187)

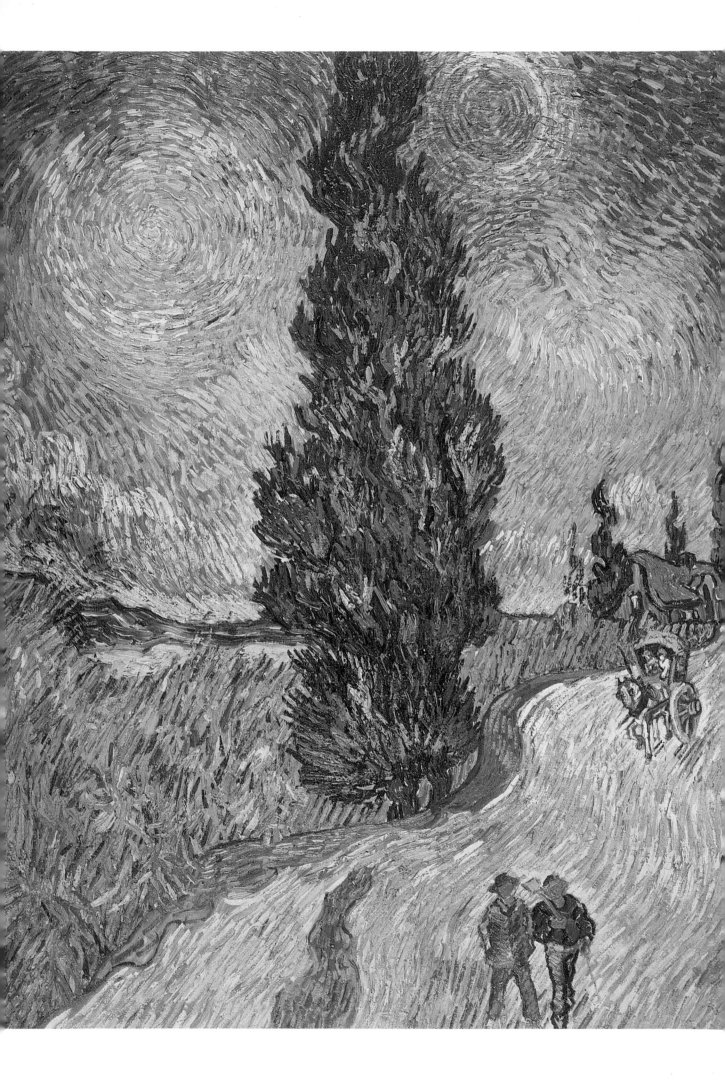

BRANCHES WITH ALMOND BLOSSOM (1890)

The Van Gogh Museum, Amsterdam. Courtesy of Topham

*T*OWARDS the end of Van Gogh's stay in St Rémy, his brother's wife, Joanna, gave birth to a son who they named after him. Van Gogh referred to the happy event as 'the thing I have so much desired for such a long time' and painted *Branches with Almond Blossom* as a gift for his new nephew. However, his joy at this time was tempered by the fast-dawning realisation that he would probably never become a father himself. Admitting himself to the asylum at St Rémy seemingly ended his chances of marriage, once and for all. Up until that point Theo, for one, had not given up anticipating. He wrote to Joanna about the matter: 'I hope that he will find sometime, a wife who will love him so much that she will share his life'. This of course never happened, and Van Gogh was instead left to revel in his brother's happiness.

After the barren winter months, an almond tree represented a symbol of renewal that the artist felt was entirely appropriate as a gift for a newborn baby. Also fitting was the way in which it was painted. Again the delicate stylisation of Japanese prints is much in evidence; a sign of Van Gogh's allegiance to the avant-garde, here it also conveys a wonderful sense of the combined fragility and energy of infants. It is a joyous, hopeful scene. The colourful branches strain upwards and are not confined within the canvas's perimeters. The painting is an image of abounding optimism for the child's future and the continuation of a family tree.

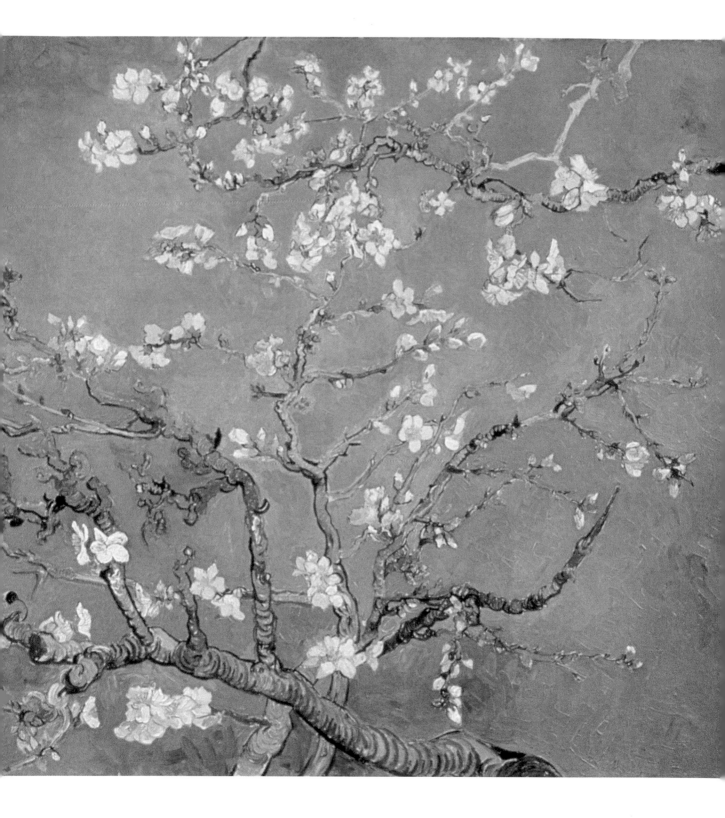

CHURCH AT AUVERS (1890)

Musée d'Orsay, Paris. Courtesy of AKG

AFTER a year in the asylum at St Rémy, Van Gogh began to feel that prolonging his stay there would be futile. He, and the authorities at the asylum, were forced to conclude that if his condition were ever to significantly improve, Van Gogh would have to get away from the south of France with its intense heat and painful memories. Thus, upon hearing the joyful news of Theo's new son, he decided to move to Auvers. He chose this village as much for its proximity to his family in Paris as for its reputation amongst contemporary artists for being picturesque and also highly paintable.

After sending his canvases on ahead of him, Van Gogh left the south of France, never to return. This painting is one of many he completed of Auvers and its environs and, as usual, he was clearly more interested in the colouristic effects he could achieve than in the church's historic significance. The entire painting is alive with emotion; even the building, with its rounded, softly undulating lines, is organic. The whole effect is disorientating and confusing, the church seems to be heaving and folding under a great pressure. In choosing to paint a church, Van Gogh is taking up a religious theme he had abandoned after his father, a Dutch pastor, died some years earlier.

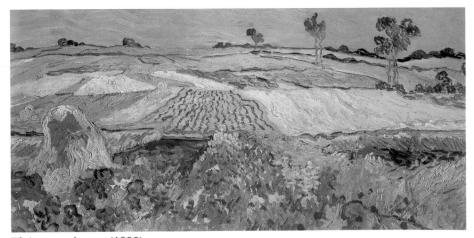

Plain near Auvers (1890)
Courtesy of AKG. *(See p. 236)*

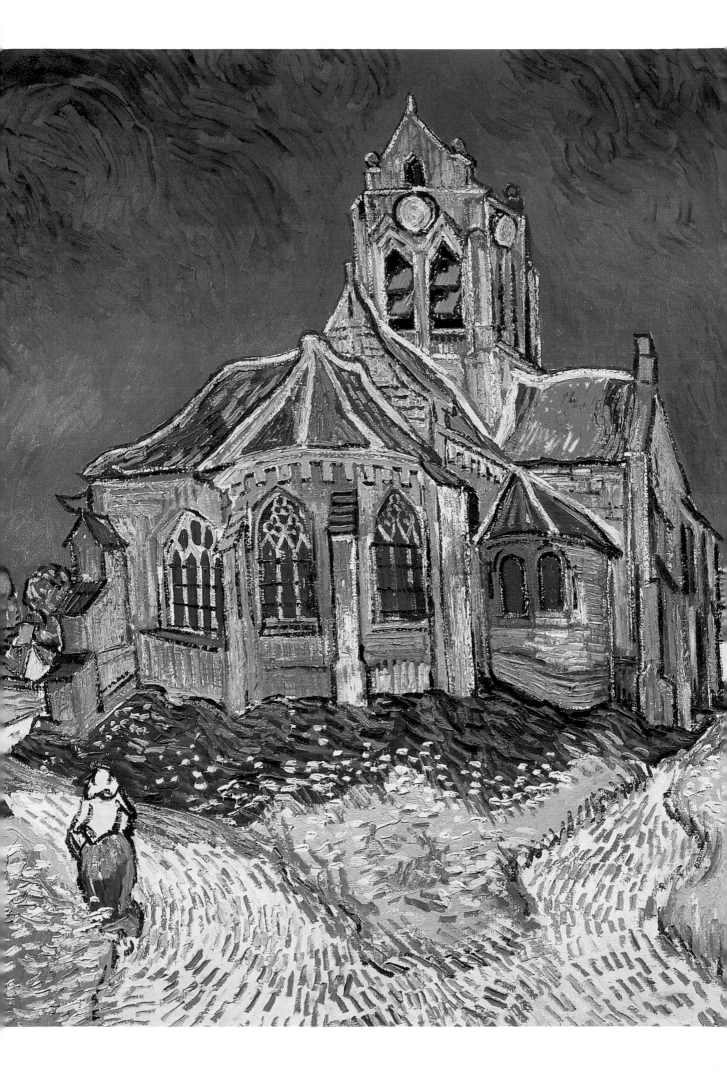

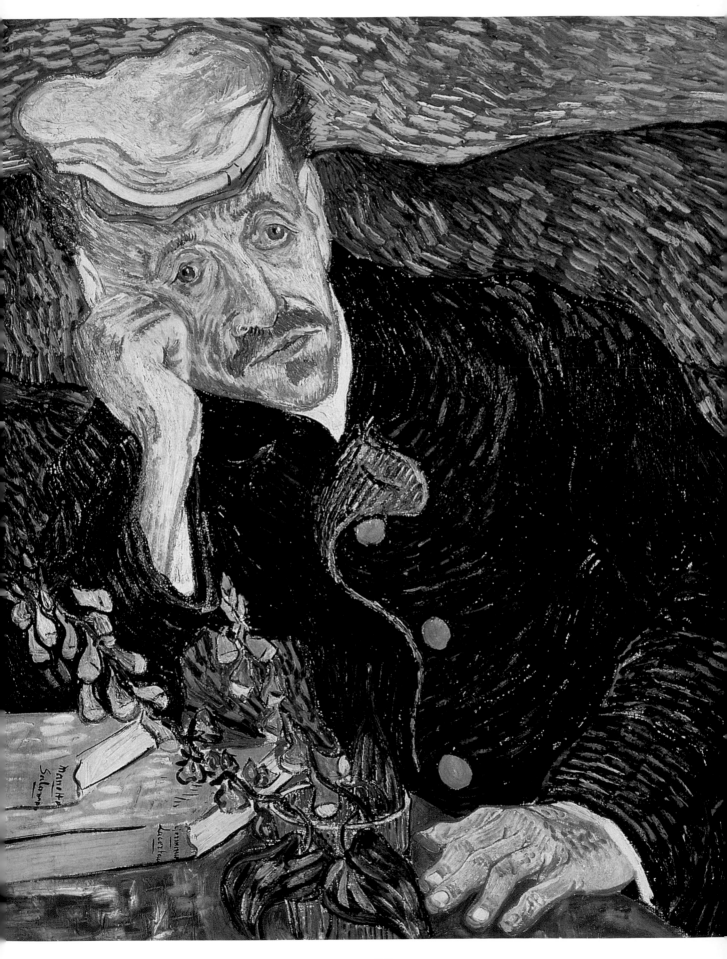

PORTRAIT OF DR GACHET (1890)
Courtesy of AKG/Christie's

WITH so many barren months behind him, Van Gogh relished the ample opportunities Auvers afforded him of returning to his first love: portraits. Dr Gachet, seen here, was the rather eccentric homeopathic doctor responsible for Van Gogh's medical care and supervision. The doctor also dabbled in painting himself and was a fervent admirer of Van Gogh. This obviously helped to get the two men's relationship off to a good start, and it was further consolidated by what Van Gogh called Gachet's 'nervous troubles ... from which he certainly seems to be suffering at least as seriously as I'. Van Gogh obviously felt he had found, in Dr Gachet, a kindred spirit.

L'Arlesienne (1888)
Courtesy of AKG/Erich Lessing.
(See p. 108)

Dr Gachet persuaded Van Gogh (who needed little encouragement) to paint this portrait after he had seen *L'Arlesienne* (1888), which he particularly liked. Indeed, a number of similarities can be seen between *L'Arlesienne* and the two portraits the artist painted of Dr Gachet. Both subjects are warm yet melancholy in attitude, and both fall prey to decorative stylisation. Dr Gachet sports a white sailor's hat. His status as a homeopathic doctor is highlighted by the variety of foxgloves, which have beneficial properties, on the table in front of him. Van Gogh's rather bleak words to Gauguin about wanting 'to portray the sorrowful expression of our age' show us that he was emphasising expression rather than attempting a perfect likeness.

DR GACHET'S GARDEN (1890)

Musée d'Orsay, Paris. Courtesy of AKG/Erich Lessing

VAN GOGH'S affection for Dr Gachet grew the more he saw of him. Furthermore, the artist felt their friendship had a beneficial effect on his art, as he explained to Theo: 'I feel that I can produce not too bad a painting every time I go to his house'. During this period Van Gogh had supper with the family nearly every week. He undoubtedly appreciated this regular invitation, but had his reservations about the quantities of food consumed chez Gachet. 'It is rather a burden for me to dine there,' he told his brother, 'for the good

soul takes the trouble to have four-or-five course dinners, which is as dreadful for him as it is for me – for he certainly hasn't a strong digestion'. However, excessive meals apart, Van Gogh was happy in Gachet's company, and particularly pleased when the doctor invited Theo, Jo and their baby Vincent to spend the day with them.

Van Gogh took particular pleasure in showing 'little Vincent' the doctor's garden, with its multitude of plants and animals. This picture gives a good impression of the somewhat ramshackle condition in which it was kept – a quality of wild freedom that attracted him to the site as a source of artistic inspiration. The close-up focus gives this particular study a strange energy; an ostensibly domestic scene borders on jungle chaos. Only the rooftops peeping through in the distance remind us that humanity has not been abandoned to nature completely.

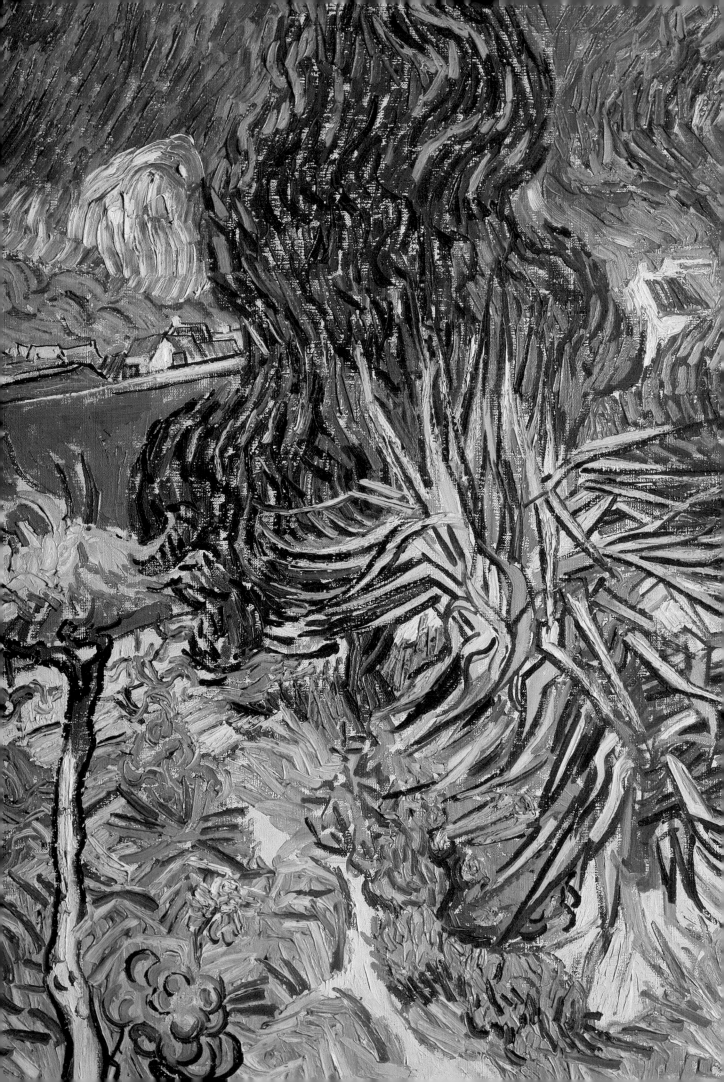

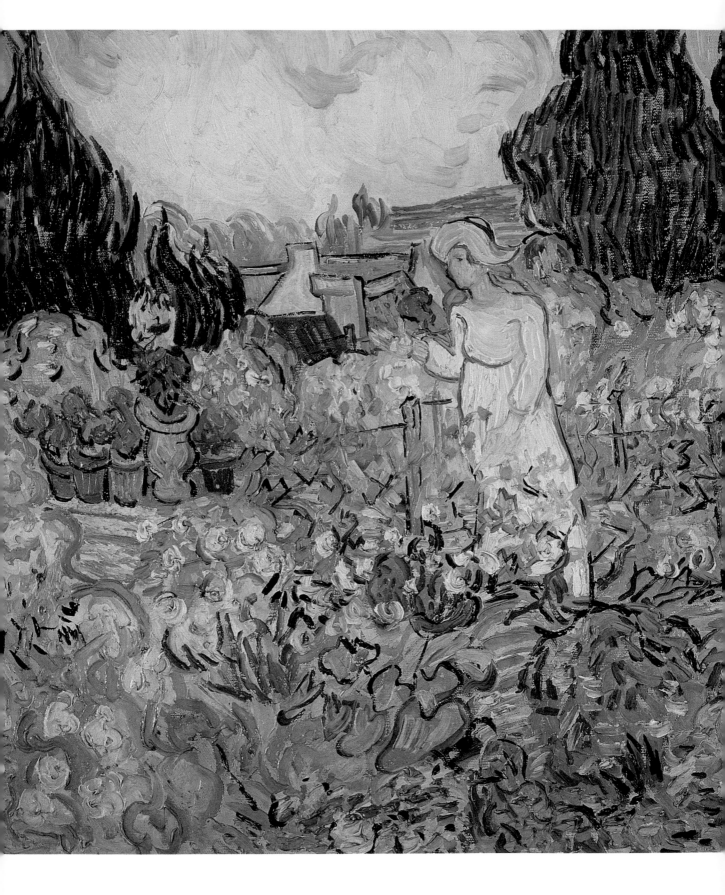

MARGUERITE GACHET IN HER GARDEN (1890)
Musée d'Orsay, Paris. Courtesy of AKG/Erich Lessing

THIS painting of Dr Gachet's daughter was presented to him as a token of Van Gogh's thanks for his kindness and friendship. Marguerite, who had just turned 20, is standing in her garden which is bursting with flowers in full bloom. The sexual parallels are obvious; here is a young woman surrounded by Mother Nature and very much part of it. The entire scene forms an homogenous whole by being painted in an all-over decorative style. Colour is deployed only modestly, mainly restricted to greens and whites. Van Gogh has represented the garden as a rural idyll in which Marguerite Gachet blends in with her surroundings, rather than making her own distinctively human mark. She is made to fit in with the abundant environment rather than it fitting in around her. Nevertheless, she does remain the picture's focal point, a status reinforced by her position just off-centre. She is literally a faceless centre, though like the patient in *St Paul's Asylum* (1889), who stands outside the asylum, she has no eyes, nose or mouth. Along with the background cypresses, like flames sprouting from the countryside, she is not unique but stands in as a 'type'.

THATCHED HOUSES IN CORDEVILLE (1890)

Musée d'Orsay, Paris. Courtesy of AKG/Erich Lessing

APART from the village church, Auvers and its surrounding hamlets – of which Cordeville was one – boasted no particular tourist attractions. Its appeal to visitors was that of the 'rustic, unspoilt' countryside. Van Gogh's response to the area was no different, and his choice of subjects from this period reflects that fact. However, his comment that Cordeville possessed a 'solemn beauty' is perhaps at odds with this painting's representation of the place. Certainly the hamlet seems more alive than Van Gogh's description might suggest. Every element in the composition appears to be fusing with another, as if moved by an invisible force. The moss-covered roofs are becoming as one with nature, consumed by the flame-like trees that crackle and flicker against them. Their curvilinear forms are mirrored by the ceaseless tumult of the clouds, whose thick impasto strokes are in turn echoed by the billowing white hedge, behind which peep a couple of cottage windows like hidden eyes.

Although Van Gogh described Auvers and its environs as being 'full of colour', here he has deliberately avoided the colour contrasts he was so fond of. The painting – a gift for Dr Gachet – possesses a marked coherence of style and colour. It is an image of man's habitat almost overcome by the fecundity of God's gifts. The jungle of greens and blues that dominate the scene are a startling tribute to nature's awesome and awful might.

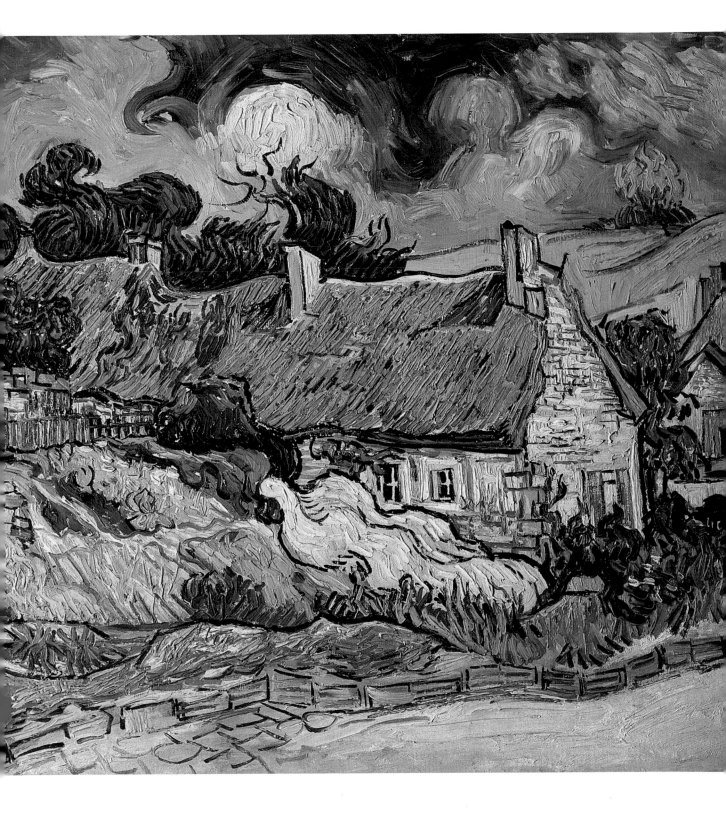

236

PLAIN NEAR AUVERS (1890)

Neue Galerie in der Stallburg, Vienna.
Courtesy of AKG

A CHANGE of scene seemed to inspire Van Gogh, who took up painting with renewed energy and vigour. During the 70 days he spent in Auvers he finished over 80 paintings. Most were, like this one, views of the countryside near the town. The great variety of patterned brushstrokes give us a glimpse of the inner sadness he was feeling at this time. Devoid of humans, it is a very lonely landscape. Nevertheless it is a painting full of life; the clouds, as usual, are especially animated, although so too is nearly everything else. He expressed his delight in the countryside at Auvers in a letter to Theo on first arriving. In it he described the land as being 'lush' with 'lovely greenery in abundance and well kept'. This last point is interesting. For all his frenetic brushwork, nearly all this series of works reveal a clear sense of control and order.

During this period Van Gogh was happy at being nearer Paris, and hence his brother, but still suffered from intense bouts of loneliness. He kept trying to persuade Theo to bring 'the little one' (his son Vincent) to Auvers for 'les grandes vacances'. 'How I do wish that you,

Jo and the little one would take a rest in the country instead of the customary journey to Holland', he wrote. Despite these pleas, Theo returned to Holland anyway, to see their mother, and Vincent's sense of isolation increased. Painting was a significant source of consolation and comfort during this period, but could never be a substitute for actual company.

PLAIN OF AUVERS (1890)
Neue Pinakothek, Munich. Courtesy of AKG/Erich Lessing

WITH its loose, sketchy brushwork and pleasantly casual quality, this painting is highly redolent of Monet. The foreground poppies are another keen reminder of the Impressionist master, whose landscape views were carefully chosen for being at once 'meaningless' and picturesque. Van Gogh may well have been after a similar combination in his own landscapes of this period. Here the gently undulating fields that merge in the far distance with a bluey-green sky could have been taken from anywhere, but they are also deeply evocative of the Dutch scenery he knew so well from his youth. The landscape near Auvers may have reminded Van Gogh of his homeland but his representation of it did not extend beyond topographical resemblances. In terms of atmosphere and style, his paintings of Holland and France were worlds apart. This is the French countryside as he had always imagined it: light, airy and free. The economy with which he depicts the whole scene – from short, stabbing marks in the bottom third of the picture, to larger squiggles for the furrows and tree trunks, to the flowing strokes of the sky – are all a far cry from the stolid heaviness of his Dutch views.

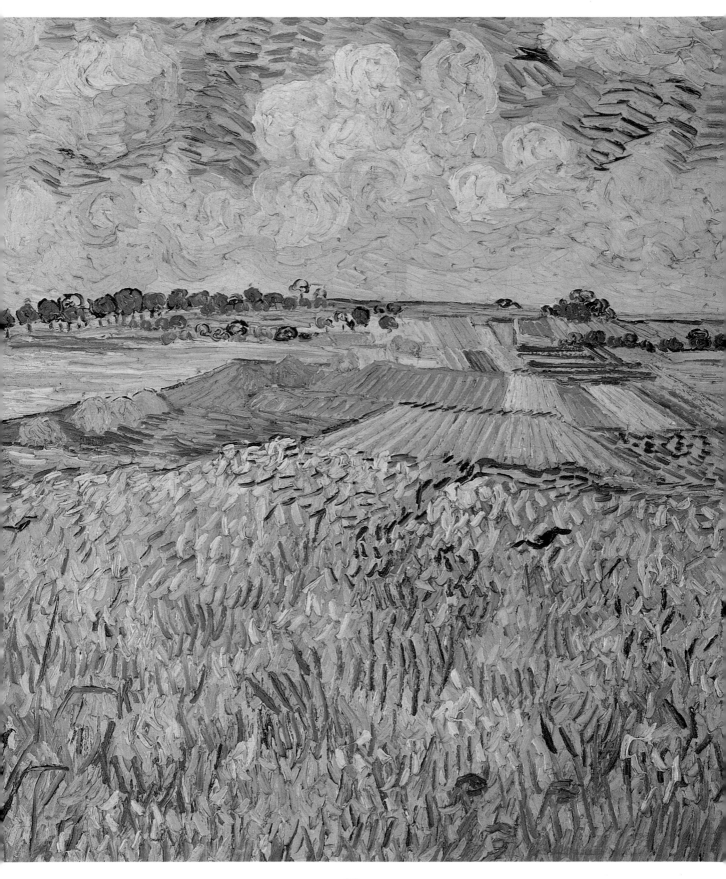

PLAIN OF AUVERS

TWO LITTLE GIRLS (1890)

Musée d'Orsay, Paris. Courtesy of AKG/Erich Lessing

*I*T has been suggested that owing to the multitude of styles Van Gogh experimented with during this period in Auvers, he was on the brink of another artistic breakthrough. His premature death means, of course, that we shall never know whether this was the case or not, but the picture we see here certainly provides another example of his stylistic variety at this time. The technique of heavy outlines and blocks of colour, with the figures dominating the canvas, was inspired by Emile Bernard's peasant paintings from Brittany. In fact the whole painting is more reminiscent of Bernard's Symbolism than Van Gogh's distinctive style. As with *The Poppy Field* (1889), it is an experiment which did not really come off.

Van Gogh was never entirely comfortable when painting children, and he invariably made them look like small adults. These young faces are wise beyond their years – they stare out of the canvas with knowing, almost weary expressions. The frenetic use of the curved line which usually serves a dramatic purpose, as in *Church at Auvers* (1890), here merely implodes. Similarly, the various shades of blue fail to create the 'light on light' effect so successfully managed in *The Sunflowers* (1888), when he employed a thousand yellow hues to such wonderful effect.

The Poppy Field (1889)
Courtesy of AKG. (See p. 194)

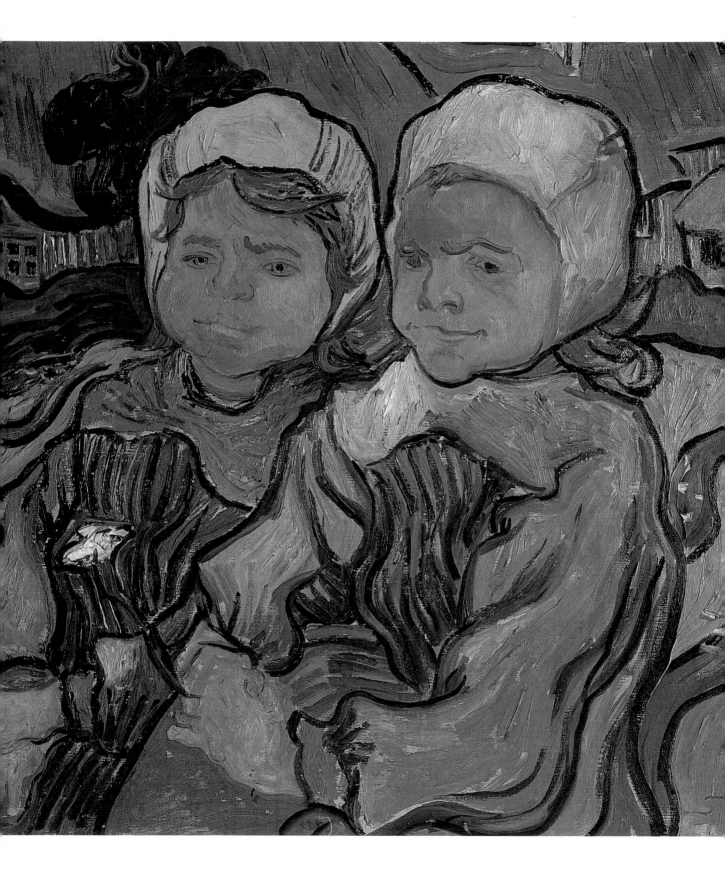

CHILD WITH AN ORANGE (1890)

Sammlung Villa Flora, Winterthur. Courtesy of AKG

*V*AN GOGH'S fondness for children is well documented. In letters to Theo around this time he often mentioned his brother's young son and bemoaned the fact that they couldn't all see each other more regularly. Van Gogh's own lack of offspring was a source of increasing regret to him, and possibly goes some way to explaining why he started painting youngsters during this period. What the resulting canvases have in common, however, is their unchildlike quality. The girl featured here is a good example of the way in which Van Gogh painted children as if they were miniature adults. Perhaps the effect was deliberate and his aim was to convey the apparent uncanny knowingness of the young, particularly infants. The little madam in this portrait, for instance, holds an orange in her hands as if it were a crystal ball through which she gains privileged access to secrets adults cannot or will not see. She clutches the large ripe globe in her tiny distorted fingers and smiles archly into the distance. She seems to imply that, as members of the banal adult world, we are tragically denied the hidden secrets of youth forever.

Detail from *Two Little Girls* **(1890)**
Courtesy of AKG. (See p. 240)

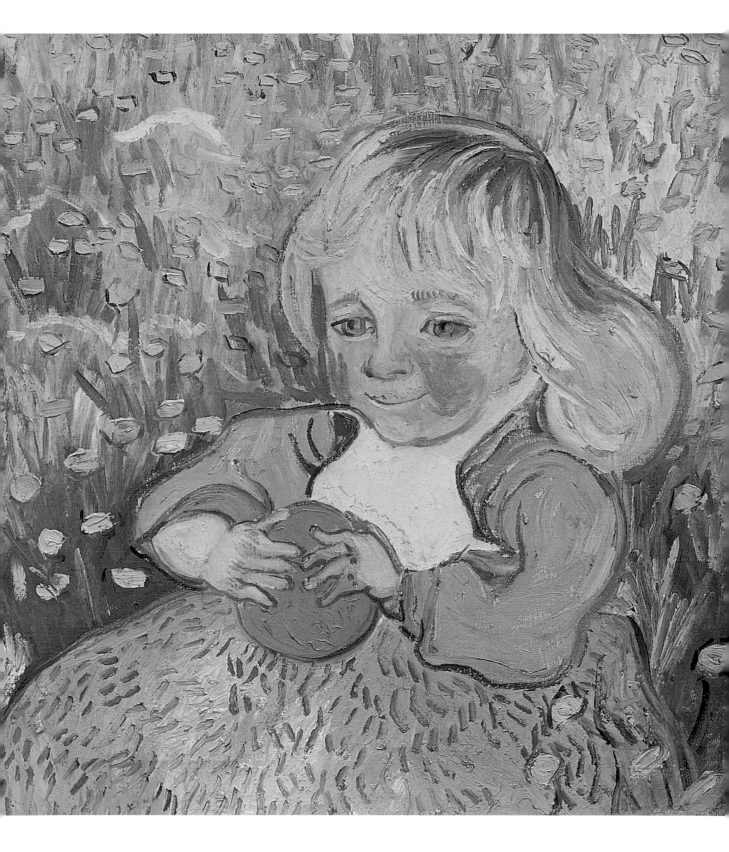

STILL LIFE WITH CARNATIONS (1890)
Collection Fausto Capella, Paris. Courtesy of Christie's Images

*V*AN GOGH only really began painting flowers with a vengeance in Paris, four years prior to completing this picture, which was one of his last, in Auvers. The progress he made in the intervening period was truly remarkable. Comparing his rendition of carnations here with the flowers executed in Paris in 1886, for example, the difference is striking. Whereas the earlier work is stiff and formal, the composition here is loose and dynamic. Gone is the academic contrast between a rich brown background and luminously bright foreground blooms that jump out from it, replaced by a totally new conception of pictorial space. The greeny-grey wash that surrounds the still life forms at once a uniform backdrop and two distinct spatial planes. The curved sketchy blue mark that distinguishes the table from a theoretical rear wall epitomises the painting's overall stylisation. The heavy shadow cast by the vase and flowers, which stops just short either side of an intersecting green stem also appears stylised.

This is an image which emphatically asserts its status as a painted object rather than an illusion of reality. In fact, everywhere you look, any suggestion that this picture might represent a window on to the world is immediately contradicted. The blue outlines (as seen in *Still Life with Potatoes* (1888), the vertical brushstrokes on what is supposedly a horizontal surface, the vase's dramatic lurch to the left: all these speak of Van Gogh's artistic maturity and, by extension, modernity.

ADELINE RAVOUX (1890)

Courtesy of Christie's Images

ADELINE RAVOUX was the beautiful daughter of Van Gogh's landlord in Auvers. She sat for the artist on several occasions. Recalling her sessions with Van Gogh some years later, she said of him: '[Van Gogh] tended to be reserved by nature and in consequence rarely spoke, but he always had a little smile on his lips which sometimes, very rarely, relaxed into open, happy laughter'. This hardly seems to be the description of someone contemplating suicide, yet many still insist that his torment, preceding his death, must have manifested itself in some form or other. Adeline Ravoux's failure to pick up on any brewing angst or tension was not unusual among Van Gogh's other contemporaries – few did. People have thus turned to his art for clues about this particular aspect of his biography.

Judging by this particular image, painted only a month before Van Gogh took his own life, it would be tenuous, at best, to claim a link between the two. One could equally as well argue that the painting's predominant

Mourning Old Man (1890)
Courtesy of AKG. (See p. 216)

blues (a popular colour for Van Gogh's models) are a sign of calm and tranquillity as they may be of profound despair. Similarly, the girl's pose could be described as, on the one hand, serene and collected, or, on the other, as wistful or disconsolate. In the end, all such speculation remains futile. The only purpose they serve is to further the mythologising process of the artist.

STILL LIFE WITH ROSES AND ANEMONES (1890)

Musée d'Orsay, Paris. Courtesy of AKG/Erich Lessing

WHILST in Auvers and St Rémy Van Gogh painted a whole series of still lifes with flowers. His prolific output has been attributed by some to a 'bout of creative fever' comparable to Friedrich Nietzsche's (1844–1900), whose life also ended in insanity.

This picture typifies the more decorative style of Van Gogh's art in mid-1890. Nature is rendered as a series of objects whose intrinsic beauty is less important than their potential for artistic transformation. Thus the roses and anemones here are heavily stylised and their shapes clearly defined. Van Gogh was following his own advice 'not to copy nature too slavishly'. The starkest evidence of this comes in the black, diamond-shaped leaves, to the left. Their emphatic flatness is further enforced by being placed against the similarly two-dimensional plane of the table, whose impossible perspective rears up to become a means

of display rather than a hard surface on which things could feasibly rest. Everywhere there is similar proof of Van Gogh's commitment – in art-history speak – to 'retaining the integrity of the picture plane'.

As with *Still Life with Irises* (1890), the rose on the right seems to have been added later. Its rougher, more heavily outlined rendition sits uneasily with the rest of the flowers which are painted in a delicate, Japanese style.

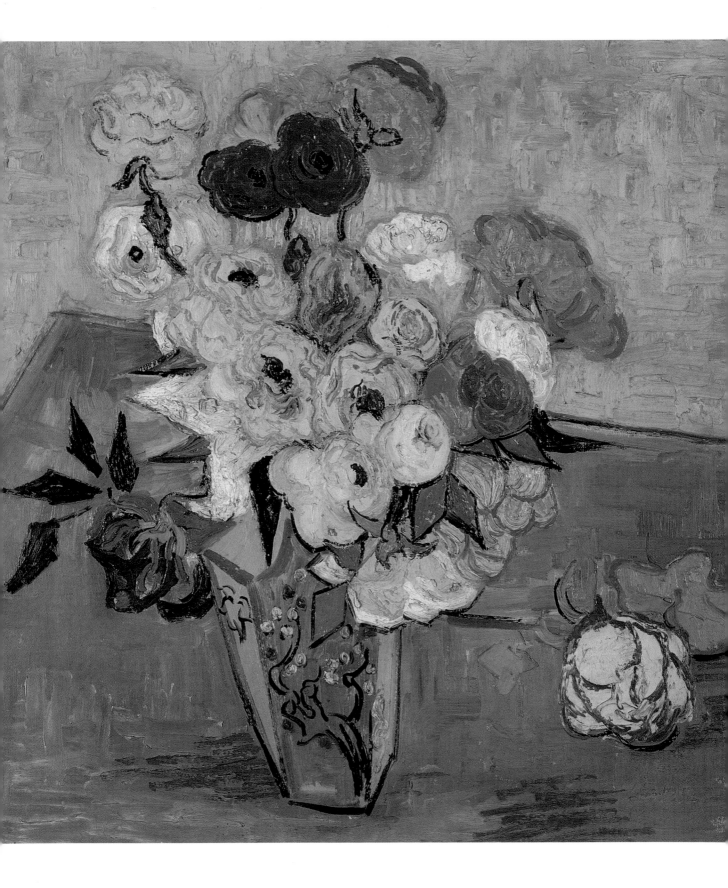

THATCHED COTTAGES IN AUVERS (1890)
Toledo Museum of Art, Ohio. Courtesy of AKG

*A*UVERS had an unassuming character that appealed to Van Gogh at this point in his life. Suitably peaceful and out of the way, it was an ideal retreat from his recent limited successes. Although he had sought critical acclaim in the early days, now that it was almost a reality, Van Gogh shied away from its consequences. As he lamented to Theo: 'Success is just about the worst thing that could happen'. He even went so far as to ask the Dutch critic J J Isaacson who had spoken favourably of his work in local Dutch newspapers, to cease his written approbation. Maybe he was worried about his mental stability and the effects that too much praise may have had on it.

Certainly Van Gogh shunned most forms of excitement at this time, preferring instead the gentle and relaxing life of the country in places such as this. For all the scene's wholesome rusticity, though, this is not the country as a haven of calm. On the contrary, all is wild activity, swirling with barely a straight line in sight. Perhaps it is understandable that the sky and vegetation take on organic forms, but when the cottage roof is also subjected to this treatment, the painting takes on highly symbolic connotations. The image no longer reads as a realistic depiction of nature, but as a visual indication of Van Gogh's tormented soul.

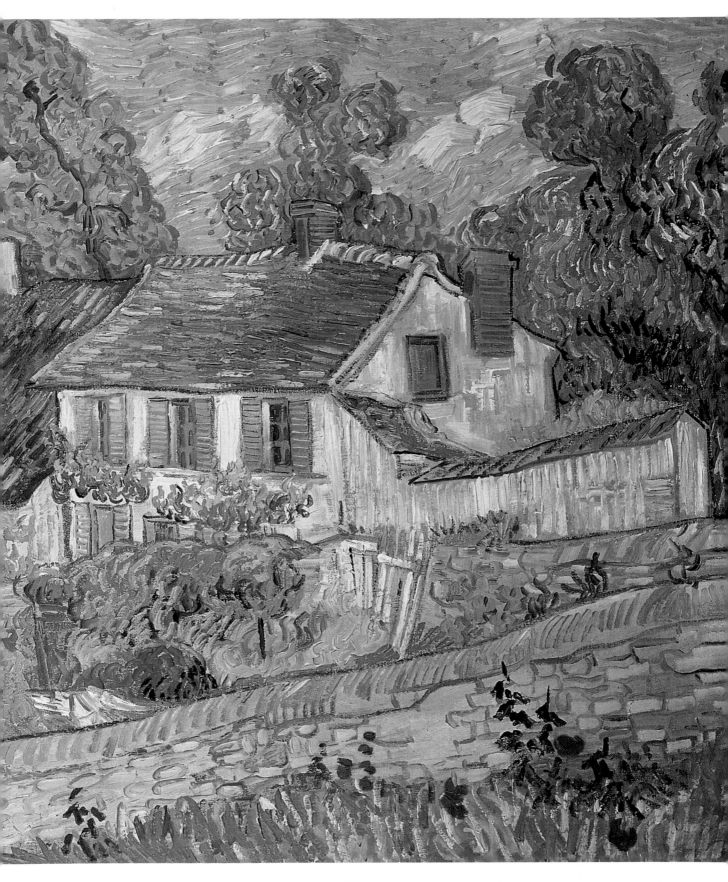

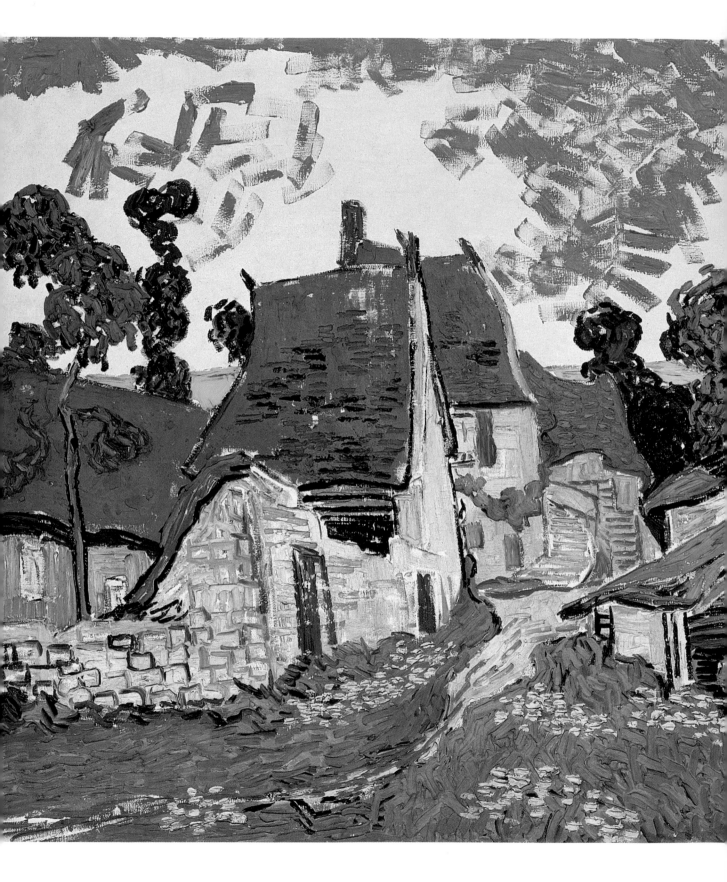

VILLAGE STREET IN AUVERS (1890)

Ateneumin Taidemuseo, Helsinki. Courtesy of AKG

SIMILAR in composition to *Street in Les Saintes-Maries de la Mer* (1888), painted two years previously, this is a similarly conventional picturesque scene in which the perspectival device of a central street entices us into the pictorial space. Here it is flanked on one side by the sort of village architecture that Van Gogh became so enamoured with in Auvers. It is '[the] cottage with its mossy straw roof and sooty chimney' that Van Gogh felt epitomised the rural idyll. In its quaint, vaguely primitive air, he often contrasted the kind of image represented here with 'the things of Paris seen à la Baudelaire'.

Although Van Gogh's paintings often have bare canvas showing through, the amount revealed here is unprecedented. This has led critics to suggest that the unfinished sky of *Village Street in Auvers* marks it out as Van Gogh's last-ever painting. Whether this is the case or not remains debatable, but it was certainly begun towards the end of his life. This makes it fitting, therefore, that he should have returned to a well-loved theme from his early days in Holland.

WHEAT FIELD WITH CROWS (1890)
The Van Gogh Museum, Amsterdam. Courtesy of Art Resource

THE identity of Van Gogh's last canvas remains unknown, but this is generally assumed to be it. The reason for such wide concurrence has been determined more by the painting's ominous mood than as a result of any substantial evidence. Van Gogh himself described the image as representing 'vast fields of wheat beneath troubled skies'. He added 'I did not need to go out of my way to try to express cheerlessness and extreme loneliness in it'. In the same letter, however, he wrote that the picture expressed 'the health and forces of renewal that I see in the countryside'. Despite these conflicting messages, the former appears to hold sway. The painting undoubtedly contains elements of Van Gogh's extreme melancholy. A major source of his depression was the fact that he remained a financial burden to Theo, who now had a son to support. The vigorous, frustrated brushstrokes bear witness to his troubled mind. A short while after painting this scene, Van Gogh walked into these fields and shot himself in the chest. On 29 July 1890, he died in his brother's arms and was buried the following day in a cemetery nearby.

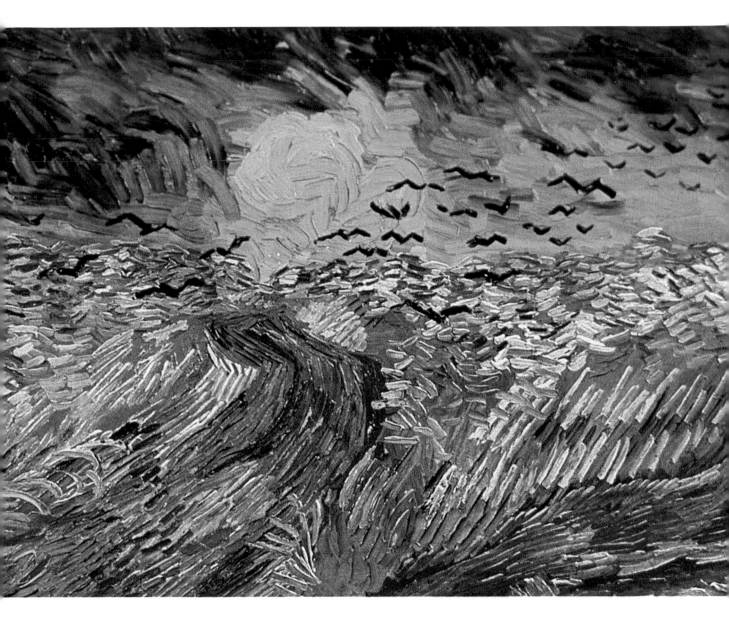

AUTHOR BIOGRAPHIES AND ACKNOWLEDGMENTS

For Alf, another great Francophile.
Josephine Cutts and James Smith studied History of Art at the
University of Sussex and Goldsmiths College, London, respectively.

For Katie with love.
Lucinda Hawksley was born in 1970 and lives in London. She is
currently working towards a post-graduate thesis in Literature and
History of Art.

While every endeavour has been made to ensure the accuracy of the
reproduction of the images in this book, we would be grateful to receive
any comments or suggestions for inclusion in future reprints.

With thanks to AKG, The Bridgeman Art Library and Christie's Images
for assistance with sourcing the pictures for this series of books. Grateful
thanks also to Frances Banfield, Bridget Tily and Sasha Heseltine.

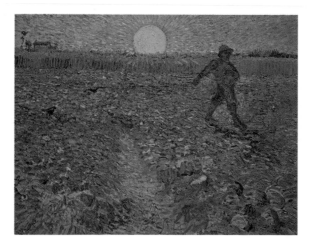